SMASHING IT

WORKING CLASS ARTISTS ON LIFE, ART & MAKING IT HAPPEN

EDITED BY SABRINA MAHFOUZ

The
Westbourne
Press

CONTENTS

INTRO-
DUCTION

Sabrina Mahfouz grew up between London and Cairo.
She is a playwright, poet, screenwriter and performer
who has recently been elected a Fellow of the Royal
Society of Literature and is the recipient of the 2018
King's Alumni Arts & Culture Award for inspiring change
in the industry. She has been shortlisted for the Arts
Foundation Award for Performance Poetry and has won
a Sky Arts Academy Award for Poetry, a Westminster
Prize for New Playwrights and a Fringe First Award.
Sabrina is also the editor of the anthology *The Things I
Would Tell You: British Muslim Women Write*.

Sabrina
Mahfouz

SOCIAL CLASS is a confusing identity marker. Every person I have ever spoken to about it has their own beliefs about how it should be defined. This book came about after I was interviewed by a magazine about a forthcoming project. It was my sixth interview that month, and it struck me that I had once again been asked about the obstacles I faced as a woman forging a career in the arts. Several of the other interviewers had queried what difficulties I had faced in the industry as an ethnic minority (Egyptian/Guyanese). Despite the fact my gender and ethnicity are hugely important to me and my work, I found it odd that nobody had asked me about the difficulties my social class presents, which, when intersected with other factors, has certainly been the biggest obstacle I have faced. It is also a part of my identity that I share with almost every character I have ever written.

When I tweeted words to this effect soon after the interview, I was immediately flooded with responses from other artists expressing the same frustrations. It was overwhelming, and it stirred a level of anger in me that I hadn't acknowledged before. This is in spite of the fact that I had read various damning reports on working class representation (or the lack of) in the arts. The State of the Nation Report showed that social mobility has been 'virtually stagnant' from 2014–2019; the 2018 'Panic!' Report by Create London and Arts Emergency revealed shocking data about the percentage of people working in in arts industries from working class backgrounds: in publishing 12.6%; in film, TV and radio, 12.4%; and in music, performing and visual arts, 18.2%. All of which is hugely under-representative of the population, approximately a third of which is regarded as working-class, according to the report.

Positive action is something I always try to do if I can. That day I announced that I would host free workshops on accessing arts funding. It was something I knew I could do as I have applied and won funding for projects since I first started to write. (I have also worked in the Civil Service and know my way around forms and government-speak.) The next day, 600 people signed up to the first workshop. It made me realise that despite the growing discussion around working-class representation, access to the opportunities that are out there must be improved so that it can be taken up by those who need them the most. In short, working class artists do not feel supported.

After five months of facilitating these workshops, the most frequent message I received from people was, 'Thank you for showing me what is possible.' There are few other phrases that make me so emotional. This is the point of our struggles for fairer representation and greater equality: to give each other the freedom to achieve all that we can without being crippled by injustices, institutionalised bias and prejudices. This is what this book is for, to show what is possible and to provide guidance on how to make that possibility a reality.

A number of organisations have been doing incredible work around access to the arts for a long time, such as Arts Emergency, Create London, Open Door and COMMON (whose founder David Loumgair writes his 'Letter to British Theatre' in this book). There are an exciting number of projects that showcase working-class writers, with a growing number of literary anthologies (eg. Know Your Place edited by Nathan Connelly and Common People edited by Kit De Waal) and two inaugural working-class writers' festivals (one founded by Natasha Carthew and planned for 2020); the second, Breakthrough Festival, was founded by writer and contributor to this book, Kerry Hudson, in 2019. My hope is that this book adds to these offerings and encourages new ones because, as Javaad Alipoor wrote in an excellent article for The Guardian, 'The arts world has turned working-class people into a problem to be solved rather than audience members or artists to be developed'. This absolutely must change, not just for future generations, but for us all, now.

In preparing for this book, the one question I asked the contributors to reflect on was, 'Do you identify as working class?'. In personal, moving, challenging pieces, they have each shared what this means to them, and they also ask you to consider your own definitions. As you will see, these artists, writers, performers and practitioners are up for the discussion. Join them! But, whatever you conclude, this book isn't here to set boundaries. It is here to:

- Showcase the exceptional art currently being created by some of the most inspiring artists in this country.
- Say to those working-class readers who want to work in the arts but have been made to feel that it's not for them that IT IS. A creative industry worth having can't exist without us. These artists are opening doors: stride through and hold them wide for those coming next.
- Remind those in the industry how absolutely essential it is to be investing in working-class artists because – this can't be said enough – a creative industry worth having cannot exist without us!
- Offer some honest guidance, inspiration and motivation to keep going, to get started, to create the work you need to create from those who have done it and are doing it. Most of us still struggle to keep it all going. The art world is difficult to get a foothold in regardless of who you are – let alone when you have socio-economic barriers blocking your way. Nobody is likely to break through with just a few well-meaning aphorisms. What we need – among other basic essentials like support, talent and tenacity – is the truth.

Writing and editing this book has moved me to reflect on my own experiences in the arts. Getting to where I currently am in my career quite literally brought me to the point of bankruptcy. I am still in the final years of an Insolvency Agreement, the last legally ratified option before bankruptcy. How did I get to this point? There is never just one reason, but the rough outline is that I wrote, produced and paid the vast majority of the costs for my first two Edinburgh Fringe theatre productions (Dry Ice in 2011 and *Chef* in 2014) myself. I had some crowdfunding money for the first and some organisational funding for the second, but to make sure everyone was paid and to produce them in a way that was true to my vision

cost me A LOT. Around £45,000 altogether, over five years. I had a cocktail waitressing night job and various day jobs, and also took on writing jobs during my breaks. It meant the shows were a success. Not financially – because that's unheard of in fringe theatre – but professionally.

After winning a Fringe First Award for *Chef*, I was offered commissions that I was genuinely interested in on topics I deeply cared about. I had put honest work out there that had been filtered through no organisation, no theatre – because they hadn't wanted them, not in the way I had wanted them to be – and I got the love back. And some money. Enough to quit the night job at first and then by 2015 the day job. I was living frugally: no car, shared housing, no shopping except essentials. I had zero savings. The concept of savings has never existed in my life, as working-class people with a love of travel and Moschino will understand. I had no financial cushion from any other area of life, which was fine; hand-to-mouth is how people live, how people I have known have always lived. But then I got pregnant and couldn't work (write/attend rehearsals/edit/research) as much as I was used to, which was all the time.

Even though I returned to work two weeks after my son was born (excruciatingly exhausting at best, traumatising at worst – for the both of us), I couldn't make enough money to make ends meet and eventually had to file for insolvency. I accept that I used the money I earned in my various jobs to produce my shows, and it was a privilege to be able to do so, to invest in the career I wanted so desperately. But I say this because, as a working-class woman, I have only got to this point in my career because I was willing to take myself to the point of bankruptcy to get here.

I am not AT ALL endorsing that anybody else do so. Don't. In fact, it is for this very reason that I have included a guidance section on how to successfully apply for funding at the end of the book. I want to encourage aspiring and working practitioners to look everywhere possible for financial support for your work. It is out there, and it is for you. It is public money, mostly. Public money paid disproportionately by working-class people through taxes and national lottery funding. Never think that it is not for you, or for your stories. I made the mistake initially of believing the funding wasn't for me. I only approached the theatres I had heard of with my scripts and ideas, and when they turned them down, I thought that was it – finance it myself or give up. Sure, the DIY option is exhilarating if the costs can be kept to an absolute minimum: you have a team in it for the same aims,

and people have donated space and resources so that your work can reach the audience you intended. But Arts Council England, Wales and Northern Ireland, as well as other funding bodies, are here for a reason, and they need new artists to apply to ensure they fulfil their remits to provide access to the arts for everyone, not just for a small minority of our society.

It can be daunting to seek funding if you have lived your life undervaluing your work, your story, yourself. It can be intimidating to answer questions made up from a vocabulary that hints at the closed, lofty world of the 'proper' arts. Hopefully, the guidance section will help you negotiate this process.

Today more than ever, let's celebrate the genre-shifting, world-changing art being made by working class artists in the UK. Let's remind ourselves that for every crucial article detailing the depressing lack of working-class representation across the creative industries, we need to celebrate the working-class artists leading the way in their fields, telling their stories the way they need to be told.

Some of these artists feature in this book. Multi-award-winning writers in various mediums such as Malorie Blackman, Maureen Duffy and Michaela Coel offer a glimpse into their struggle to stay true to their vision, to be able to tell the stories they wanted, in the way that they wanted. Leading artists such as acclaimed illustrator Rebecca Strickland and Ted Hughes Award-winning poet Raymond Antrobus treat us to brand-new works that highlight the depth of working-class talent energising the arts right now. Arts leaders such as Madani Younis, Artistic Director of Europe's largest arts venue, the Southbank Centre, alongside emerging geniuses of multidisciplinary arts, including Travis Alabanza, offer direct, honest advice on how to stay true to yourself while navigating an industry in which you are hugely underrepresented. Their contributions are organised into three categories: the 'Life' pieces explore the artist's relationship to their career and other aspects of their daily reality as a working class person; those in 'Art' are striking examples of works in various forms, from poetry to photography, illustration to lyricism; lastly, the pieces in 'Making It Happen' show us a way forward.

Smashing It is a companion to replace the imposter syndrome; to show that we do belong in the spaces that might, for a million reasons, make us feel otherwise. It is to shout in our own accents a big old thanks those that have opened doors and paved ways and shown us what can be achieved. And they have achieved this in spite of seemingly insurmountable obstacles in a notoriously low-paid and exploitative industry, especially for those like us who don't have the contacts to make a smooth transition from 'hopeful' to 'professional'. Many non-working-class arts practitioners take for granted subtle influences – such as a family-wide involvement in the arts, university-educated relatives, ease with the vocabulary and phrasing of institutions, and experience in interviews, public speaking and meetings. Of course, many working-class people may have experience of some or all of these. For those who don't, never forget that you have experience of so many other things which are of equal if not greater value.

Go smash it up.

Smashing It

TEN CRACK COMMAND-MENTS

(Ways to protect yourself as a human who identifies as working-class, whilst trying to negotiate arts fuckeries and systematic privilege)

Madani Younis

Madani Younis is the Artistic Director of Europe's largest arts centre, London's Southbank Centre. He was previously artistic director and CEO of the Bush Theatre for six critically acclaimed years. During his tenure, he delivered the largest capital project in the theatre's history, tripling audience capacity, produced work that has toured both nationally and internationally, and delivered the theatre's first West End transfer in over a decade.

1. Tell them that you come from good stock. Tell them of your history, of the cloth that you are cut from and of the blood that runs through your veins.

2. If they tell you you shouldn't, you really should.

3. When they tell you that class doesn't matter, tell them that it has never mattered more.

4. Remind yourself that you are not the first. Take strength and courage from those who have walked this long road before you – before you ever took your first breath.

5. Say to yourself every morning, 'I need the liberal guilt of the arts as much as I need crack'.

6. Say to yourself every night, 'I am surrounded by love and I am the hero of my own story'.

7. Always pay it forward.

8. Don't be fooled when they say, 'We are all in this together'. They have a different definition of the word 'we'.

9. Remember that civil disobedience is a compliment to any successful democracy.

10. If they tell you that you can't, it's because they never could. It was always meant to be you.

LITTLE RASS

Raymond Antrobus is a Jamican-British spoken-word poet from Hackney. His collection *The Perseverance* won the 2019 Ted Hughes Award, was shortlisted for the Jhalak and the Griffin Poetry prizes and was selected as a PBS Winter Choice and a *Sunday Times* and *Guardian* Poetry Book of the Year. Antrobus is the recipient of fellowships from Cave Canem, Complete Works 3 and Jerwood Compton. He is one of the world's first recipients of an MA in Spoken Word Education from Goldsmiths University and the first poet to win the £30,000 Rathbones Folio prize. His other published collections are *Shapes & Disfigurements* and *To Sweeten Bitter*.

—

Raymond Antrobus

Yo... Here we are, 7,330 days, 10 months and 7 hours since *Doo wop* (*That Thing*) entered music history as the first single by a rapper to debut at number 1 on the billboard hot 100. Meaning, it's been 7,330 days, 10 months, 14 hours and 18 minutes since meeting T- Boy, the boy who made me quit rapping forever, who'd studied the dictionary so closely that he could turn to any page and rhyme the random words with meaning.

T-Boy was a rapper I met on a council estate in Archway. A group of friends, all boys, had introduced us. My rap name was Little Rass. It's what Dad called me when I annoyed him (yuh lil'rass yuh!). Every one of my public rap performances had to begin with disclaimers – just so you know I'm half black, my Dad is Rasta, so if I say nigger, it's ok. My rap style was unnecessarily aggressive, as if my voice was in a fight with all the air in the world. Dad never saw me rap, I think he'd be puzzled, think he'd say, 'calm down and stop dat foolishness yuh lil'rass yuh'.

T-Boy's rap style was laid back, fluid, flow full of loose-logic wordplay. Compared to him, my raps were literal, neurotic, glorified journal entries about girls that wouldn't let me touch them. After hearing T-Boy I felt competitive and eager to impress. I knew I couldn't use my sad, creepy-boy verses; they would reveal my vulnerabilities and if T-Boy turned this into a rap battle, I knew he had a spark that could flame my thin tissue boyhood. I had to come up with something on the spot, still, my verse began with my usual disclaimer, just so you know I'm half black, my Dad's Rasta ...

YO...
LIVING IN HACKNEY / NO ONE CAN JACK ME / I GIVE NIGGAS ACNE / IF THEY TRY TO ATTACK ME...

I wasn't wearing my hearing aids that day, I only now realise how loudly I must have been shouting. As soon as my breathy verse finished, T-Boy laughed, then other boys standing around the council flat balcony laughed and then I heard people on other floors laughing. The entire block lit in laughter. I stood there nervous. T-Boy started slamming his fist on the wall, unable to catch his breath. I stood inside all that laughter, looking around, not yet sure what it meant.

ART LIFE MAKING IT HAPPEN

COMING IN FROM THE COLD

Raymond Antrobus

MY DAD WOULD OFTEN ASK my sister and me if we were going to attend his funeral when he died. He spoke about his death so often that my most frequent nightmares as a child were of this day, burying my father. My Dad was often the one who woke me from those dreams in the morning with his heavy footsteps and the stench of tobacco fuming from his clothes. The relief of opening my eyes and seeing him in the world was always euphoric. He held me often, cooked Ackee and Saltfish, the Ackee soft but not dry, the Saltfish, easily slipping off the bone, the boiled potatoes and rice and peas, steaming from the plate with a dash of West Indian hot sauce. He would watch me eat, wait for me to finish, smile and say, 'I love you Ray'. These tender moments merge now in my memory of him after he'd been out drinking, returning home with a gravity that made the stairs shiver as he slowly staggered down them. Both my sister and I had witnessed him beat our mother. He would black out and the next day he'd have no memory of the smashed windows, the bruises, the burning milk bottles on our doorstep. When he needed care it was hard to measure how much of myself I could give to him, considering that terror. I was there when I could be, I changed his bed sheets and brought him ice cream, I sat by his hospital bed, I held his hand, I hugged him after he broke down crying when I asked him how he was, I fell asleep in his arms while Brook Breton sang 'Rainy Night In Georgia'.

How do you dress for your father's funeral? I'm wearing his bright orange blazer, thick padded shoulders, moth eaten on the inside. I'm sitting in the back seat of the black Volvo next to my mother and sister. 'In this life / in this life / in this life / in this oh sweet life', wailed Marley through the iPad on my lap. The sky is white and sealed over by cloud. I ask the car to stop outside the William Hill bookmaker shop where Dad gambled on the horses. The years he spent walking to William Hill, the only other place I would find my father if he wasn't in his council flat on Laburnum street. I walk into the shop and my father's friends are there. Ninja is what everyone calls one of them, I don't know why. He's a short, bald, black man with a slightly squashed face and thick patches of grey beard that move around his mouth when he talks, most of which is incoherent mumbling because half his teeth are missing. Then there's Desmond, a slightly taller, lighter

skin man in a cream coloured jacket and light brown bowler hat and Barry, a tall, slender black man in a white Puma t-shirt, a smart black blazer, a red baseball cap and a grey goatee. All were standing in front of the TVs. These were the West Indian men Dad sat around the table with, drinking, laughing, and shouting at the horses. If they'd forgotten about the funeral, my bright orange blazer with my Dad's folded handkerchief in my breast pocket reminded them. 'Yuh old man funeral today?' said Ninja, then called the other men over. 'Dis Seymour's son'. The men gathered around and shook my hand, 'him gone, him gone, but him still here'. I look up at the TVs as the gates open and the greyhounds shoot from their cages. I walk to the counter and put down a fiver on a dog. I think even my Dad wouldn't be surprised that his friends at the bookmaker shop would miss his funeral. I take the betting slip and left my Dad's friends shouting at the row of screens.

At Manor Park Cemetery some friends and cousins I hadn't seen in years show up. Everything about them belongs in the past. There is a Jamaican flag over my father's casket. My sister and I give speeches. That must've been awkward for her; she'd stopped talking to Dad the night he showed up at the house drunk and my sister had to defend our mother. She picked up two bricks from the garden and swung them in his face and fractured his jaw. My Dad couldn't speak for a month without the pain connecting him to that night. My sister was fifteen and was forced to grow up quickly so she could help raise me and support our mother. I think she will always be resentful of that, but her speech was gentle and diligent, she trembled through it. My pain was watching her, the strongest woman I know become a hurt child, once again, keeping her head up for her brother, her mother as well as herself.

I look out over the crowd at my scattered Jamaican relatives, different families sitting in their own sections of the church. My Dad lost contact with many of the families years ago and that distance expressed itself in how far back they were sitting.

'I have yet to find a Jamaican restaurant that can make Ackee and Saltfish, sweet potato, green banana with rice and peas like my father. He would always give me a spoon to eat with and call me "white bwoy" if I asked for a fork.'

Everyone in the church laughed at that, except the priest who was the whitest man in the world.

'My father lived to seventy-five. He was a smoker, a drinker and a gambler; my theory of his longevity is his sense of humour. Every joke he made gave him back the three minutes of life he lost to a cigarette. Not all his jokes were even funny. I remember sitting on the train with him at Dalston Kingsland when he said, "Son, did I ever tell you the funny story about the suicidal train driver who drove his train into a station and killed a hundred people? Hee-hee-haha". I said, "Dad, that's not funny, why are you laughing?" and he'd say, "what you want me to do, cry?" and he'd laugh again.' The congregation laughed too. There's nothing like laughter at a funeral.

After the service everyone walked to the gravesite with the pallbearers, my cousins still keeping their distance. My Dad's casket lowered. I take out the betting slip and drop it into the earth.

RESOLUTIONS FOR THE COMMON, BLACK, QUEER, YOUNG KID (AND ANYONE ELSE WHO MAY NEED IT)

Travis Alabanza is a performer, writer and theatre-maker. In the last two years, they have been noted by numerous publications including *Artsy*, *ID Magazine* and Mobo Awards as one of the most prominent emerging queer artistic voices. Alabanza was also listed in *Out Magazine* as an influential queer figure. They have appeared in campaigns with MAC X ASOS and performed across the country and internationally.

Travis Alabanza

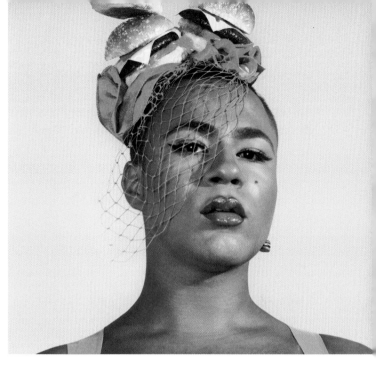

Travis Alabanza Burgerz, photography credit Elise Rose

A T THE TIME OF WRITING THIS I'm twenty-three years old. I was going to say, 'I'm at the young age of twenty-three', because everyone always places 'young' before my age in introductions. I never get to hear just my age, but always a prefix that tells the room a lot about how they should view me, my position and my stance. My feelings about this go through many different phases (well, at least I still look young). The reason my feelings change is because in some ways it's like, 'yeah, I'm fucking young, I have so much space to live and compared to those around in my field of work, I'm a baby'. Sometimes I do not get angry because I'm like, 'yes, I'm twenty-three years old and I'm sat here headlining a festival, or on a panel, or on a residency, or in a meeting, with people double my age and with much lighter skin', but other times it really angers me and I couldn't tell you why. I couldn't tell if it was just my age showing. If it was just my age that was showing in my frustration, and that if I reached an older age, I would look back on this age and see that I was being angry for no reason. But that may take ... ages, right? So, I might as well look at the feelings of annoyance I have now, and figure where they come from.

I am certain that these feelings come from doubt. A questioning. A sense of 'you're not quite here', that I feel is often given to people who are young. When I was given the artist residency at the Tate at the age of twenty-one I lied in my application and told them I was older, because I knew they wouldn't give me the job if they found out my age. My skills, my CV, my ideas and the talent that got me the residency didn't change, just the number. I can't count the number of times people have put down my CV, ability or popularity to being 'just an internet thing,' as soon as they figure out my age.

People doubting my ability is not new to me. I have always been something they cannot place. A whole thing they cannot understand. And when you go against people's ideas of who you should be, what an artist should look like, how you should talk, where you should have come from, they work quickly to reinstate that power. As if reminding me that I have social media, or am young, or did not go to art school. It is another way of saying, 'well done, but this is where the big people sit and talk now'. And this doubt, this projection of what I could or couldn't be, isn't just to do with the fact that I'm young. **I'm young and common. I'm young, black, common, trans, grew up on an estate, didn't go to art school** and suddenly I'm in your meeting room, I'm your artist in your gallery, taking up space in the media and writing and selling out debut shows. **You have to re-shift that power and force your doubt onto me, and I'm going to decide not to take it. I'm done taking it. It's too heavy to lift.**

Look, I'll be honest – I'm writing this in the forced self-reflection-hangover that the new year and January bring. It's 8 January 2019 and I haven't escaped the cycle of reflection. But I realise that I have wasted my young lifetime holding other people's projections. So often we as poor folk, as outsiders, as 'others', are managing other people's expectations and feelings towards us. I just want to say fuck that. Fuck all of that. Look how much more space we get to keep for ourselves when we don't hold onto the projections that others make! We have a lot more time to make badass art and have conversations about what we want to talk about. I decided, it being January, to write myself a list of resolutions that I could pin up on my wall, to remind me of this energy I'm holding now. Maybe you can pin it up on your wall too, if it helps.

I'm calling it *RESOLUTIONS FOR THE COMMON, BLACK, QUEER, YOUNG KID* (*and anyone else who may need it*).

1. BRAG MORE. Show off. Say what you have done. I mean it. Tell yourself, others, write it down, bring it into the room. There is something the posh kids have learned and that is this inbuilt self-belief and assurance in their voice, in being quick to know themselves and (often over play) their achievements. Now I don't need us to do that, I don't want us to fill the rooms with horrible egos that smell like egg & cress M&S sandwiches. But I wish that I had known last year that I'm allowed to have confidence, pride and excitement at my achievements and I/ you am/are allowed to tell people about them.

2. STOP APOLOGISING FOR YOURSELF. Wouldn't it be amazing if we could just accept where we are at, what we bring, and the great aspects of that? So often, it is embedded in our working-class culture in the arts to apologise for taking up space. We say sorry, are polite, are the first to arrive and the last to leave. But honestly, I think we over-apologise. I know I have. Do not apologise for your grammar, dropping your ts, swearing in a meeting. Allow everyone else to thank you for waking them up.

3. KNOW THAT THE VERY THING YOU FEEL SHAME FOR IS THE VERY THING THAT THEY CAN NEVER LEARN. That spark. That thing that makes you different from the posh boys. The thing you are trying to hide, to cover up, to make quieter, is the very thing that will keep the art world alive. So often these posh walls have stolen working-class culture, aesthetic and music to make themselves more relevant. Hunny, you are the relevance! You are the thing! You are the culture! No time for shame – just to clarify – you are the shit! They may have gone to art school but that cannot teach them how to be interesting.

4. REMEMBER WHERE YOU COME FROM, BUT ALSO THE FUTURE OF WHERE YOU WANT TO BE. 'Remember where you come from' is a cliché phrase I feel we often hear as 'people from the block'. But it's kinda true and also, how can we forget it? Don't forget, but do not let it pin you down. Share your knowledge, your resources, if a door is opening for you, grab a fucking huge ass council estate bridge and lodge it open for your gang. They may have got to where they are today on selfishness and stingy rules, but that doesn't mean that we have to. The future is brighter if all the gang are allowed in too, and the gangs you don't know.

5. REQUEST MORE ART DIRECTORS TO MEET YOU IN THE GREGGS THAT HAVE CAFÉS IN THEM. This one is self-explanatory.

Maxine Peake

Maxine Peake is an English stage, radio, film and television actress from Lancashire. She made her name as Twinkle in Victoria Wood's sitcom *Dinnerladies* and has since played Veronica in Channel 4's Manchester-based drama series *Shameless*, barrister Martha Costello in the BBC legal drama *Silk*, Grace Middleton in *The Village* and starred in *Funny Cow*, amongst others. Peake is an accomplished stage actress, having played the title role in *Hamlet* and had a role in the 2014 film *The Theory of Everything*.

STRENGTH THY NAME IS A WORKING-CLASS WOMAN
The valuable lessons I learned from playing Hamlet

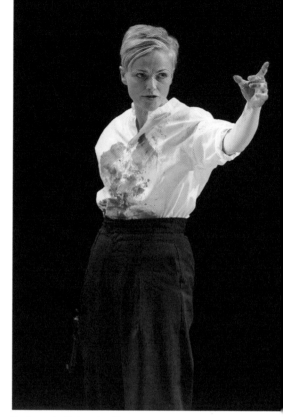

T HE FIRST COMMENT to be made is that I refer to myself as an actress. I am proud to be placed under a feminine label. It is my belief (and I'm sure yours) that in acting, as in most professions, males have always had an easier ride. In acting, simply put, more parts are written for men, especially white, middle-class men. There are more men at the helm, creating a stranglehold over female stories and the way those narratives are told. I suppose that the acting profession starkly reflects society in all its manifestations.

Recently, there has been a rise in heritage and period dramas, which evoke some proud and heroic past of the British ruling class. Although most of us know that this nostalgia for past glory offers a vastly warped version of our history, it sells shows across the Atlantic. However, it also helps to bolster right-wing nationalism.

Photographs © Jonathan Keenan

I digress. My point is that I don't want the struggle that women, or any other under-represented group, have encountered to forge a career – and more importantly, a platform – for their voices to be heard in acting to disappear. Each of us and our struggles are unique. For us to all be lumped under one very large, anonymous umbrella undermines us.

So, when discussing with Sarah Frankcom, a theatre director and close collaborator of mine, what our next endeavour together should be, we came upon the idea of staging a Shakespeare play. It initially started as a light-hearted suggestion. After an unexpectedly successful production of Strindberg's *Miss Julie* at The Royal Exchange Theatre, Manchester, we sat down over a cuppa. After struggling to find a female character that we both loved and who hadn't been on our stages recently, I threw *Hamlet* into the mix.

At first Sarah dismissed it. She hadn't directed a Shakespeare before and the only Shakespeare part I'd ever played was Ophelia, over ten years previously. This lack of experience made us nervous and it left us wide open for criticism. We were feeling somewhat underqualified. Would we have felt different if we were male and from a more privileged background? Most probably. We finished our cuppas and went our separate ways, the next venture unresolved.

Sarah then called two weeks later to ask if I was serious. I'm never serious, but that's actually what propels me forward. If I am serious, I give too much thought to things and talk myself out of most situations. 'Yes,' I lied. 'Well then,' said Sarah. 'Let's do it.'

We are in a very privileged position at The Royal Exchange, where Sarah and I have been given the freedom to pursue the projects that we have wanted to. This has come from Sarah's immense talent as a director, her ability to take something that could prove box office poison andmake it accessible and inclusive both for the actors and the audience. This ability comes from her strength to be true to herself and to follow her instincts. This is one of the many valuable lessons I have learnt from her. As both an artist

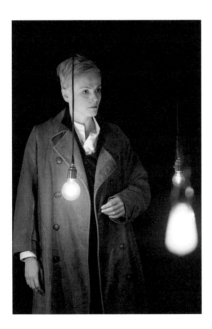

and a human, honesty, truth and staying loyal to strong instincts are invaluable. As women I feel we are encouraged to question our instincts, to apologise for our honesty and doubt our ability. Hamlet changed that for me.

Fast forward twelve months and we are about to embark upon our first day of rehearsals. Sarah has assembled an astonishingly talented and excitingly diverse cast. Sarah gets the best person for the job regardless of skin colour, class or gender.

I won't lie – rehearsals were hard. Many times, I thought I had bitten off so much more than I could chew. Even having such a

wonderfully supportive cast around me, it was lonely at times. Hamlet is a mammoth task, not just mentally, but physically. Not only did I have to learn reams of dialogue (and constantly decipher the meaning of that dialogue), but I also had to learn to sword fight (with a bit of unarmed combat thrown in for good measure). Not to mention that I had to be present almost constantly on stage for over three hours.

There were a few tears when my anxiety and lack of self-belief overwhelmed me but what I clung onto was I was a woman playing Hamlet, a working-class woman to boot. If all those actors could do it then I certainly could, even if they did have a head start with being the right gender.

I had to learn to trust myself, to enjoy myself and even if at times my faith in my ability waned, I had to hold onto to the belief others had in me, especially Sarah. I had to ignore all the nay-sayers and seize this wonderful, once-in-a-lifetime opportunity. It was the hardest thing that I had done to date, but the pride in the hard work and the achievement made it all worth it.

Whether people think it was a good performance or not, what I hold onto was the fact I conquered my fears. I conquered the negative chorus that constantly told me I couldn't. I couldn't do Shakespeare because I was born into the 'wrong' class. I couldn't play Hamlet because I was a WOMAN born into the 'wrong' class. Who are these people who tell us we can't? They are not our friends. Friends encourage. Most of the time, in current times they are nameless and faceless keyboard narcissists. People whose main issue is with themselves and their fear. They attack because they haven't the strength to overcome their own fears, or to put themselves on the line.

The more I work in this business and the older I get, I realise a lot of success is attached to having 'front' to be a confident 'blagger': to say 'yes' when you are not always sure. To accept a challenge head-on and believe in yourself. It's not about being arrogant or overconfident; it's just that if you don't say yes someone else will, and then you'll spend a lot of time and energy regretting that – the energy you could channel into doing. Of course, you need some talent, but talent is useless if you are not prepared to work hard and take risks.

So many people early on in my career told me that I couldn't make it. If I had listened, I don't have high hope of where I'd be today, instead of where I am. You have to say, 'I can,' 'I WILL'. Listen to yourself and trust your instincts.

To be or not to be? That really is the question.

MAUREEN DUFFY

THAT'S HOW IT WAS

An Extract

Maureen Duffy is an author of thirty-four published works. Her books include nine collections of poetry and sixteen plays. She is a fellow of the Royal Society of Literature and of King's College London, vice president of the Royal Society of Literature, a CISAC gold medallist and president of honour of the British Copyright Council and the ALCS. She is said to have been Britain's first lesbian to 'come out' in public and made public comments during the debates around homosexual law reform. In 2014 she won the Icon Award for Outstanding Lifetime Achievement from *Attitude* magazine.

INTRODUCTION

I T MUST HAVE BEEN some time in 1947 when I was thirteen that I said to my mother in one of our after school chats over a cup of tea: 'One day I'm going to write a book about you: what would you like: a novel or a biography?' She laughed and said: 'A biography.'

'Why?'

'Because it would be all about me.'

Always when I came home from school, and she was well enough, she would get up from her treadle sewing machine for our ritual of tea and talk, and I would show her my latest poem or essay or tell her what we had done in history. She made all our clothes, even my school satchel from canvas when I won a place at the high school. And she also made clothes for other people, since clothing was still rationed, out of off-cut remnants she picked up at the stores in the town centre. The only thing she couldn't make was the regulation school tunic with its green sash.

When the time came to fulfil my promise, with my first prose work that wasn't a play, in 1961, I had to compromise. To publish a memoir at just twenty-eight years old, even one whose real focus wasn't me but my mother, was unthinkable. Firstly, many of the people who would have to be in it were still very much alive and besides, the editor of Hutchinson New Authors wanted a novel. In any case, I needed not only the money but to be

writing and to justify, if only to myself, this mad path I had wilfully taken, down a route none of my family had ever taken, and that was strongly disapproved of.

To want to be a writer, or indeed an artist of any sort, was to throw away an education everyone had worked and fought for. It wasn't a 'steady job' like being a teacher, office worker, librarian, nurse or any of the approved professions, especially for a girl who, after all, was only biding her time until she married.

A memoir or biography would be worst of all because it would be 'telling all and sundry your business' and could be construed as committing that worst of all behavioural and social sins: 'showing off'. I can imagine how they would have responded to the age of the selfie and social media. So in spite of my Mother's preference, what she got was a barely fictionalised attempt at the truth that carries the epigraph: 'Because I said I would.'

There is nothing in *That's How it Was* that didn't happen to us in so called 'real life'. Only the names are changed although my cousin, seven years older than me who was witness to a lot of it, sometimes has a different take on events. But that is to be expected since, as the neuroscientists and psychologists tell us, memory is a retold story that can alter in the telling and impose its own version of truth in a world where, as, Yuval Noah Harari has pointed out, everything that isn't of nature like the earth itself may be just one of the fictions we humans have invented and continue to invent.

Having dipped my pen as it were in the murky ink of the novel world, I have gone on to write eighteen more, some, like *The Microcosm*, with a strong autobiographical element, others less so, or perhaps should I should say less obviously so, since the roots of creation are often hidden from the creator. Themes from my own experiences repeat, for example. Absent fathers do not tend to be present, and the never-to-be-forgotten experience of being bombed in 1940 turns up in the third part of my London trilogy, *Londoners*; again in my most recent novel, *In Times Like These* (2013) and also in a poem of similar date *Lex Innocentis*, which couples the Middle East tragedy of death and destruction with my own experience. Did my wandering childhood influence the telling of the migrant's story in *The Orpheus Trail* (2009)?

When I first agreed with the editor at Hutchinson's New Authors that I might write a novel after all, since my plays weren't finding an audience,

and that, after all, is what writers crave, I had thought it would be about a young girl growing up. What the Germans call a *lebersroman*, I had *The Sorrows of Young Werther* by Goethe in mind. I had been examining my childhood to see if there was an explanation for being me, whether it might be nature or nurture or a combination of the two. Perhaps retelling it all would provide an answer. And I had, as I thought, another motive.

The existing accounts of the childhood and adolescence of writers seemed to be all by and about young males: *Cider with Rosie*, *Portrait of the Artist* and Dylan Thomas' poems and short fiction. If there was one by a girl, it wasn't very obvious. But didn't we have the same developing sensibilities, the same problems of reconciling our outlandish aspirations with our backgrounds and upbringing, with other peoples' expectations of and for us?

I hadn't read Aphra Behn, with the exception of one much-anthologised poem, *Love in Fantastic Triumph Sat*, which I had come across in an anthology of verse from the Restoration theatre. I hadn't heard that *cri de coeur* of a woman writer in the 1680s: 'I dare say that I know of none (men) that write at such a formidable rate but that a woman may well hope to reach their greatest heights.' It still echoes down the centuries, as witness the continuing need for a Women's Prize for Fiction, in spite of the fact that we have had the first female laureate. In the same way, *The Microcosm* sprang out of a desire to depict female homosexuality on a par with the spate of studies of gay maleness, leading up to the decriminalisation of male homosexuality in 1967.

The history of *That's How It Was* embodies the history of publishing and therefore the society of which it is a mirror image. A child of the sixties, it's the story of the struggles of an unmarried mother who fell for a potential 'terrorist' in twenty-first century terms, and was left abandoned with a child she refused to give up – although she herself suffered from what at that time was a deadly incurable illness. It could therefore be said to chime with the swinging sixties of free love and the greater emancipation of women, after the 1950s post-war attempt to put them back in the kitchen, and the invention of the pill as an easily available contraceptive.

Chosen as one of the best one hundred post-war novels by Carmen Calill, *That's How It Was* remained in print, first in Panther paperback then as a Virago Modern Classic, until the huge corporatisation of publishing occurred, when dozens of middle range independent publishers were

acquired by global players. Its latest manifestation in 2015 is as an eBook, carrying on a process that has embraced stone, clay, parchment, vellum and paper.

People have sometimes asked me, especially those who heard the wonderful serialised readings on *Woman's Hour* by Eileen Atkins, to write a sequel, not realising that although the novel is about Paddy growing up, its driver is her mother's – my mother's – life, and with that end there can be no true sequel. Since it was published there have been other female *lebersroman*: Winterson's *Oranges Are Not the Only Fruit*, Lorna Sage's *Bad Blood* and Barbara Hardy's *Swansea Girl* to name a few. I am glad that, in a sense, *That's How It Was* has helped generate a series of sequels.

Again and again I have returned to the mother of *That's How It Was* in poem after poem. This hasn't been intentional of the 'now I will write a poem about ...' kind, but a sort of spontaneous combustion or, a more friendly metaphor, as if a seed had been lying dormant in this grass meadow and was called up into the light by a burst of sun or rain to suddenly sprout a wild flower. So *Salvage* is a poem about my mother's cutting-out shears, it is a celebration of her dexterity in making things out of nothing. It was recently translated into Italian for an anthology of mother and daughter poems titled *Crafty*. The other poems are *Lex Innocentis*, which I've already mentioned and *Storm*, which remembers the only thing my mother was really afraid of, and which is published in my new collection.

That's How It Was ends with Louey's, my mother's, death, and for a time it was as if I had died too. Although she had tried to prepare me I had been unable or unwilling to take in what she was trying to tell me and for a year, unable to grieve, I fell apart. Emily Brontë's words, 'I tell you hopeless grief is passionless', exactly described my state. We had planned that I would finish my education, become independent and able to support her, and then we would go away together into some bright, beckoning future. But now, everything we had planned for had been swept away. And then there was the immediate problem of what was to become of me. My aunt and uncle had taken me in, but they didn't need another mouth to feed or body to clothe.

West Ham, now part of New Ham, council, in addition to taking me on as a 'child in care', had a scheme of support for its children who stayed on after the school leaving age to continue their secondary education and supported me financially. Then I was helped by my new school, the local

grammar, The Sarah Bonnell, and its dedicated staff under the iron will of the Headmistress, old style, Dr Barnett. And I was partly rescued in my second year by the need to pass School Certificate. I stayed then on into the sixth form for A levels so that I could realise my mother's – our – dream of my becoming the first member of the family to go to university, and, by then realising my dream of being a writer, for which I received a Major County Award.

Under the tutelage of my form and Latin teacher, Eileen Arber, I managed the school's first Latin A Level, necessary if I was to read English at a major London college. Eileen Arber who even became my foster mother for a few months after I insisted, as a bolshie teenager, on leaving the family home after A Levels when I was still under age. I managed the school's first Latin A Level, necessary if I was to read English at a major London college.

I had done as she wished and people said: 'Your mother would be proud of you.' It took another twelve years of differing and distancing experiences before I could write about that life, find the answer to the final question posed in the book, and fulfil the promise that I had made to her.

And now here I am helping to give it a new lease of life, celebrating hers, because I said I would.

Child out of the womb torn I saw,
Out of the curled darkness,
Bathed in the love and pain of my birthday,
The blind awakening to my years,
The world turn in your hand...

CHAPTER 1

Lucky for me I was born at all really, I mean she could have decided not to bother. Like she told me, she was tempted, head in the gas oven, in front of a bus, oh – a thousand ways. But there I was, or nearly. She'd done the washing in the afternoon. 'You shouldn't be doing that, my dear, not in your state,' the landlady said.

'I'll be alright,' and she reached up to the line, stretching her guts on every peg. About two o'clock she woke and the bed was brimming with blood.

'Paddy, Paddy!' Quiet in the dark, shadows of stark furniture rampant in the room, he didn't stir. Not at first anyway. 'Paddy, Paddy!' Insistent now, he must hear.

'Unh!' Sleepily.

'It's coming, I think it's coming.'

'Jesus save us!' He swung his legs over the side of the bed. 'You hang on, just hang on. I'll be back as soon as I can with a doctor, if I have to drag him out of bed.'

He woke the landlady, who came running to exclaim, 'I told you so! Never should have washed and so close to your time. Hang on, dear, the doctor'll soon be here.'

And she must have twisted and writhed there in the drab, furnished room. I don't know, of course. It was all my fault after all and she could

only tell me after. Hell, I must have guessed how it could be, I was most unwilling to come.

Paddy persuaded the first doctor he found out of his warm bed with a shower of gravel at the window.

'You silly young fool. You could have broken the glass!'

'And I will yet, if you're not down here quicker than thought itself.' The head was withdrawn suddenly and presently he appeared at the door.

'Why do women always choose the middle of the night? Is the midwife there?'

'There's no midwife.'

'And who's going to help me then, boiling the water and cleaning up after?'

'The landlady'll help.'

'More trouble than she's worth, I expect.' And so he grumbled his way through the dark October streets and up the creaking stairs.

'You stay outside. You're no use in here. Say your prayers or something.' And he did.

'Holy Mary, Mother of God, pray for us sinners now and at the hour of our death. Amen.'

'She'd do a lot better with a pulley,' said the landlady.

'For heaven's sake give her a pulley and stop nagging me.' So the landlady tied a sheet to the bed-head and put the end in her thin brown hands.

'You hang on to that, my dear.'

It was six o'clock when I finally made it, the late autumn night growing grey and haggard overhead.

'I said she'd do better with a pulley.' She took me over to the fire and began to wash me.

'Are her feet alright?' my mother asked. They thought she'd gone light in the head.

'Beautiful little feet, my dear.'

'Let me see.' I was held up for inspection in the hissing gas light, bald as a coot and red as sealing wax. 'Thank God for that!' She leaned back against the pillow. The doctor and the landlady swapped knowing looks.

'You rest now, you'll feel better when you've had a sleep.' And she was too tired to tell them how brother Dick, and old Uncle Walter, and long passed-away Daisy had been born with their feet turned backwards, like the ghosts of poor Indian women died in childbirth, always trying to escape their own failures.

'What is it?' Paddy asked when they let him in.

'A girl, a lovely little girl.'

'Ah well, you can't order these things I suppose. A boy would have been fine. Michael we'd have called him.'

'She'll have to be registered,' the doctor said. 'I suppose you're the father', with a shrewd look.

'Of course I'm the father. Who else would be? I'll be along first thing in the morning.'

'No need, I'll look in later. A very narrow pelvis – you're lucky she's alive.' He left them to think it over.

The certificate was a small pink one, with some strange business about being still-born or live. It took me a long time to sort that one out.

A fortnight later, she wanted to get up. 'Other girls get up after a fortnight. Why can't I?'

'Alright', the doctor resigned himself, 'sit up and try.'

She put back the crumpled clothes and dangled her legs over the side. The room swung sickeningly, the rag rug flung its tatters in her face. Gently he lifted the thin legs, like brown sticks, the ankles permanently swollen from a childhood of chilblains, and laid them back in the bed, pulled down the pink nightdress – she would never go naked to bed and Paddy could never see why ('Oh go on, sure there's no harm in it.' 'It's not right somehow').

The doctor straightened the bedclothes. 'Now do you believe me?'

The easy tears of great weakness ran down her face.

'You've been very ill, you must understand. You're not like the other girls; you're lucky to be here at all.' In a month she was right as rain again.

They called me Patricia Mary, but fell out over the christening. My mother stood out like a little bantam, the brown eyes as big as gobstoppers darkened with determination. 'She's not being let in now for something she can't understand or say yes or no to. She wouldn't thank us for tying her up like that when she wakes up one day and finds what we've saddled her with. She shall choose for herself when she's old enough to know what it's all about.' Paddy swore and slammed the drawer shut. She was unimpressed. She knew she'd won.

'He never raised his hand to me,' she told me later, 'he knew he'd better not.' But then, no one ever did. She stood there, thin as brown paper, her bird's bones and lean flesh held together by a steel-wire will. It would

have been like trying to fight a small, fierce flame. Instinctively you knew you could only either smother it, put it out forever with a clumsy fist or acknowledge the supremacy of an elemental spirit. Either way you couldn't win. So at seven weeks I was started on the never-ending search for self-knowledge before my little cross-eyes could focus and while my lolling head was just a signal box for the reflexes of hunger, nappy rash, wind and longing for the warm, moist-dark comfort of the recent womb.

Maybe if Paddy had had his way over the matter of my christening things would have been different. My Aunt Lyddy says it would have been different if I'd been a boy. She's the only one now who'd know, but memory is a funny old thing, with one deaf ear that doesn't catch half the questions you ask and has put the answers in a safe place and now can't find it, just like my gran used to. By the time truth's been strained through someone else it's not the same colour anyway, that's why I'm putting all this down now. It's like trying to catch a flea on a sheet. You pin it down under your forefinger and just as you shift ever such a bit, it's away and the chase is on again. When you finally catch it and crack it between your thumbnails, there's a little pop and a nasty mess and that's that. So I feel that even if I do manage to pin down my side of the truth it'll probably be dead as a doornail, or hop away if I shift ever such a little. Sometimes I just can't tell any more what happened to me, and what I was told by my mother or someone else, or what I just would have liked to have happened. If there's a race memory there's certainly a family memory, a rubbish-tip of anecdotes, jokes, tinsel phrases, tarnished photographs, out-at-elbow arguments, obscure chronologies – 'If you're twenty-seven now, my mother died just before you were born and Dodge was twenty-six when she died. That means she'd be fifty-three this summer.' Only she never lived beyond twenty-seven.

'It's no good, dear, I get things so confused,' Aunt Lyddy says, and I'm left once again with family memory, that rag-bag, to sort through, and my own twisted skeins and rags of remembrance. And in this strange trade of rag-picking a kind of idealisation takes place because naturally it's the brightly coloured scraps of near poetry, the gay threads of laughter, that catch the eye, not the dull browns and dun duckerty everyday, and I remember that the night before he left they had pink shrimps for tea and he sat there stripping off their armour-plating, one of the few things he had the patience for.

'Who'll peel your shrimps for you, Alanah, when I am gone?'

She wasn't the woman to make a scene. He explained that the other woman needed him more. 'You can look after yourself, she can't.'

'If I'd been the clinging type I might have kept him, or if I'd bothered to pretend, but it's no good, I'm just not like that,' she told me. The next day, he left. I was two months old and they had lived together for nearly two years. She sat by the table, one hand nervously smoothing the side of her face from temple to chin, and thought. She looked at the oven and considered. Then she looked at me in the cot. The meter showed just under fifty and there were no shillings in her purse. Suddenly the whole idea seemed ridiculous. She wrapped me in a shawl, put on her hat and coat, laid me in the pram and walked out into a roaring December day, wild with water and wind, and fought her way against all nature crying despair, along the sea front. At Splash Point the waves threatened to fling us both into the sea but she battled on for two miles before she would turn back. Coming home, the wind bowled us along merrily like bits of torn newspaper along the gutter. She let herself into the musty, old-maid-smelling passage, already gloomy with the midwinter dusk, and took me upstairs. I howled desperately with hunger and cold. Soaked to the skin, her hair hanging in rats' tails around her small face, she took her coat and began to unhook her blouse.

'Louey, Louey!'

'Yes, Miss Seary?'

'When you're dried off a bit there's a cup of tea and a nice bit of fire down here.'

Soon she sat by the blaze, me asleep, replete, in her arms.

'So he's left you?'

She nodded in reply.

'Let him go. You don't need him. Men, they're more trouble than they're worth, I learnt that long ago. You make him pay though – there's no reason why you should be left holding the baby, though she is a dear little mite, and good as gold.' I must have looked it at that moment. She laughed, delighted with her own joke.

'Don't you worry about rent, my dear, 'til you're on your feet again. You stay as long as you like. I like the company and who could I let the rooms to this time of the year? 'Course, I guessed you weren't married when you first came, four months ago. Men.' She prodded the fire into vicious flame. She had long ago decided that there was only one sex worth bothering about.

I think even I would have gone out into the cold, cold snow if I'd turned out to be a boy. The one exception was her old tomcat, Billy. He was an old rogue with frayed ears who sprayed the passage regularly every evening before going out on his nocturnals. She would stand at the front door – the back already open – and exclaim, 'Billy want to go out the fronty or the backy?' A howling draught clawed through the house while Billy cocked his leg over my pram, parked in the passage, and deliberated. I suppose he was wondering which of his girlfriends to go yowling after that night. Billy accounted for half the old maid smell in the house, the other part came from the mothballs in which Miss Seary kept her strange array of dresses, passed down without modification from her mother, and a prized fur collar complete with fox mask and brush. The dead eyes gleamed malevolently from her breast when she went out shopping. 'Very fashionable at that time,' my mother said.

'He's left me some money. He says he'll pay a pound a week towards the baby's keep.'

The landlady sniffed. 'That won't last long, you'll see. Promises like pie-crust, they're all the same.'

But she was wrong. He kept it up for a year before he disappeared for good. Or was it for good? My mother thought she saw him once, years later, in a workmen's café sitting with a mob of Irish labourers from a nearby building site. 'I looked at him and he looked at me and I went all weak inside.' She never got over him and she never blamed him.

'What was he like, Mum?' I'd ask.

'A dapper little man, I suppose you'd call him, slim but tough, with fair hair and blue eyes like yours. Always very clean and well dressed and sang in that light tenor street-boy's voice, like John McCormack. But, oh, he was the loveliest dancer and the most terrible liar I ever met.' And that was all I could find out. Because of his love of a tall tale you could never credit a word he said.

She met him at a dancehall, so what else could you expect? You might say. She was a lovely dancer too. I only saw her dance once, when I was about ten, and the styles were all different anyway. It was a fox-trot, the real test of a dancer. Her little feet in their size-three high heels pivoted, trotted like circus ponies' hooves kicking up magic sawdust, stardust. Her partner, a young, all-American G.I., who'd done it for a laugh, suddenly grew serious, concentrated, disciplined his gangling legs to pilot her through the wash of

dancers. When it was finished, he brought her back to me and she sank down on the hard chair provided by the village hall, puffing and coughing.

'I shouldn't have done it.' The pale touch of rouge glowed against her sallow skin. 'But it was lovely. Oh, I could dance once.'

In her dancing days it was the Big Apple and the Black Bottom, strange, exotic names, and the Tango, the most exotic of them all. 'They only want to do it so they can bend you backwards and rub their legs against yours.' She demonstrated at dancehalls in the intervals and the management provided her a partner, their most skillful regular as a rule. This evening, the manager introduced them.

'Miss Miller, Mr Mahoney.'

He took her in his arms and they moved off in perfect rhythm. There was never any question of turning back. As Aunt Lyddy says, 'If a woman really loves a man, he only has to crook his little finger and she'll come running right or wrong.'

He came, he said, from the barren tip of Ireland where there was only potatoes, mist and rocks. His sisters were praying in every corner of the world – having decided husbands were hard to get they'd married God. He'd been taught by Benedictines to read and write and make plaster mouldings. Once, he took her to a hotel and showed her angels' heads and leaves in relief round the walk that he'd done, but he was such a liar. He couldn't marry her yet because he was in the army.

'The army?'

'The army of Ireland. The I.R.A. I've sworn not to marry for five years.'

One night, when he was asleep, she brushed against his coat hanging limply from the brass bed-knob. There was a smothered thud. Hardly thinking, she put her hand in the pocket, whatever it was would spoil the shape and he was very particular with his clothes, and drew out a gun. She looked at it incredulously for a moment then put it back and climbed into bed beside him. He murmured in his sleep and reached out for her. She lay awake for a long time. That night she felt my first faint kick.

She never knew where he went when he left her, often for days at a time. Once, picking her way through the streets to the churchyard, where she ate her lunch sitting on a warm tombstone in the sun – 'They don't mind, I'm sure, I know I shouldn't mind, and it's quiet in there. You can get the fresh air' – she was stopped by a crowd in the streets.

'What is it?'

'The hunger-marchers.'

She stretched her feet to their fullest extent and craned her neck. They were going past now, lines of grey shuffling men putting one foot before the other with the abstracted concentration of initiation. Suddenly she saw him, shabbily dressed as the rest, not his usual smart self at all, trudging along, hands hanging loose. She turned away quickly, hoping he hadn't seen her and lost herself in the crowd.

I would try to get her to blame him, but it was no use.

'He wasn't a bad man,' she said, 'only a little weak.'

'I'll never forgive him', I said. 'Never, and if he turns up one fine day, I'll say, "We don't need you, we're alright." I'll never forgive him.'

'You mustn't say that, he's your father.'

'I don't care,' I thought. 'I hate him. He left you in the lurch. One day I'll make him pay. I'll never forgive him.'

My mother shook her head. 'Perhaps he's dead – though it's hard to believe.'

'He's not dead. Somewhere he's walking about still.'

Maybe he still is.

DIVERSITY VS. REPRESEN-TATION

Riz Ahmed is an actor, rapper and activist. He won an Emmy Award for his starring role in HBO's *The Night Of* and has been nominated for a Golden Globe Award, a Screen Actors Guild Award and three British Independent Film Awards. Riz appeared in *Time Magazine*'s 2018 list of the 100 most influential people in the world.

Riz Ahmed

There aren't many statistics on specifically working-class representation on TV, but the most recent report (Panic! 2018) states that 12.4% of those working in TV, radio and film identified as working class, which is hugely unrepresentative. Working-class identity is essential to include within representation discussions, targets and decisions, which should always be intersectional. This is my speech on the subject, presented to representatives of the UK Government at the House of Commons on 2 March 2017:

I KNOW WE ALL GATHERED HERE to address some really important, pressing, urgent questions, and I think chief among those really pressing, urgent questions both in your mind and mine is 'what the hell am I doing here?' Or, in an age when reality TV stars can become American presidents, perhaps our typically restrained British equivalent is to let an actor address politicians. I promise to leave my political ambitions here, although as a British Muslim socialist creative type, I can't rule out the leadership bid for UKIP at some point in the future. These are topsy turvy political times – you never know which way things are gonna go. Like it or not, there's a lot that actors and politicians, creatives and those in government have in common: mainly, for better and some would say worse, we both have a big hand in shaping culture, and we both do that in the same way – by telling stories. Now, as a lot of politicians in the room might know, it's sometimes the most fantastical and unrealistic stories that made the biggest impact. But even in those stories, what people are looking for is the message that they belong, they're part of something, that they're seen, heard and – despite, or perhaps because of their uniqueness of their experiences – they are valued. They want to feel represented. That's really what we do, that's what we have in common. That's the game we're in. We're here to represent. It's that simple.

And in that task, it pains me to say, we have failed. It's been a noble failure. We've been taking large strides in right direction. Sometimes a bit slower than we would like, sometimes a bit too incremental, so we have fallen short of the mark. And when we fail to represent, people switch off. They switch off the telly, they turn away from the ballot box and they retreat to other fringe narratives, which is sometimes very dangerous.

Now, everywhere, the old order is in flames, right? Whether in film and television with the advent of streaming and globalised marketplace or at the ballot box with the 'ascendance of populism', as some people like to call it. Whether we like it or not, our new national story is being written right now, about who we are. The story we tell to ourselves, and we tell to the world, as Britain tries to redefine its place in the world, really matters. Will it be a story that looks inwards and backwards, or will it be a story that looks outwards and ahead to the future? As thousands of qualified doctors and nurses huddle on our shores as refugees, do we spot a threat or an opportunity? When Nollywood explodes, and China dominates the international box office, do we think 'okay, too much competition, let's retreat back to our tried and tested formula of all-white period drama', or do we spot an opportunity in these global developments? Do we have a look at the multicultural gold mine we're sitting on and spot an opportunity? We're in search of a new national story. It needs updating. The old one stopped making sense to people. It's stopped giving meaning to the complex reality, in the new realities that we're facing.

I'm here to ask for your help. I'm here to ask for your help, in finding a new national story that embraces and empowers as many of us as possible, rather than excluding us and alienating large sections of the population. In this, whether we like it or not, we need each other.

What's at stake? I just wanna take a moment to reframe what we're talking about. What's at stake here? I mean in this age of populism it can sometimes seem like talking about diversity is swinging against the current, going against the grain, it's 'political correctness gone mad', and all that kind of thing, right? It's an added extra, it's a frill, it's a luxury. That's what diversity can sound like. The very phrase actually turns me off a little bit. It sounds like there's a call, a benchmark against which everything is measured, and then there's a little bit of something that you could sprinkle on top. A little bit of salt. A little bit of spice. It's something you can live with,

but you can also live without. And to me, that really doesn't put me into focus how crucial what we are talking about really is. We're talking about representation, not diversity. Representation is not an added extra, it's not a frill; it's absolutely fundamental to what people expect from culture and from politics. What's at stake isn't just whether or not I get the next acting role I want, although that would be nice. What's really at stake here is much bigger than that. After the Brexit vote, hate crimes went up 41%. Against Muslims, they went up 326%. In the 1930s, we had very similar situation to what we have today. Political polarisation, economic disenfranchisement after a big financial crush, rising inequality, systematic scapegoating of certain minorities. What's at stake here is whether or not we will move forwards together, or whether we will leave people behind. That's what's at stake, if we don't step up and represent.

If we fail to represent, I think we're in danger of losing out in three ways, in three 'Es'. One is we're gonna lose people to extremism. Second, we're gonna lose out on an expansive idea of who we are as individuals and as a community. And thirdly, we're gonna really lose out on the economic benefits that proper representation can bring to our economy. Let me just start off with this first point, extremism. I remember when my mum and my sister would be watching TV downstairs and I'd be upstairs playing my game boy or whatever, and all of a sudden, I'd hear one of them call out, when they're watching TV, 'Aaasiaaan!!' And then you probably press pause on the game boy or turn it off and run downstairs just to go and look Sanjeev Bhaskar in *Goodness Gracious Me*, Meera Syal in *Bhaji on the Beach*, Parminder Nagra in *Bend It Like Beckham*, or Jimi Mistry in *East Is East*. If you're used to seeing yourself reflected in culture, I really want you to just take a minute to kind of understand how much it means to someone who doesn't, to see themselves reflected back. Every time you see yourself in a magazine, on a billboard, TV, film, it's a message that you matter. You're part of the national story: you're valued, you feel represented. If we fail to represent people in our mainstream narratives, they will switch off. They'll retreat to fringe narratives, to filter bubbles online and sometimes even off to Syria. In the mind of the ISIS recruit, he's a version of James Bond, right? In their mind, everyone thinks that they're the good guy. Have you seen some of these ISIS propaganda videos? They cut like action movies. Where's the counter narrative? Where are we telling these kids that they can be heroes in our stories, that they're valued?

I saw an interesting survey recently. It was a Gallup poll that surveyed a billion Muslims and it took years and years to do. I'm citing Dalia Mogahed here. And it was really interesting. They asked a billion Muslims what their key grievances were with the 'West' – there are problems with that term, but – 'what are the key grievances?' Number one was the disconnect between the West's stated values and their foreign policy. We can talk about that another day if you invite me back. Number two on the list of grievances was the depiction of Muslims in the media. That's massive. Of a billion Muslims in the world, that is the number two grievance. This isn't just a signal to give me more acting work. It's something that should give us pause and realise how important it is to feel represented.

That's extremism. It's not just important to show people themselves and to send a signal that they are valued, worthwhile and represented. It's also really important, I think, to show people characters and stories that don't resemble them at all. If we don't, we'll lose out on the second game: an expansive idea of who we are. We've all had these experiences, right? Watching a film or TV show that tells a story where there's a little hero or heroine taking on a massive challenge against insurmountable odds, right? Through steep learning curves, some hard lessons and noble sacrifices, they're just about to make it through, save the day and at the end, maybe they lose their lives. We're in floods of tears. The character we've been watching is a fish, or a bunny rabbit, or an alien. The power of stories to allow us to relate to experiences that do not resemble our own is phenomenal. And every time we see those experiences, it reminds us that what unites us is far, far greater than what divides us. Culture is a place where you can put yourself in someone else's shoes. A one-size shoe shop just doesn't make any sense. Sociologists, I have been told, define nation as 'imagined community'. A community coheres only within the bounds of our imagination, as far as our imagination stretches. I believe we really need to step up to the plate and push our imagination to be as broad as our community really is. Just a quick aside, some of this is about history. Looking up at this beautiful painting over there, I'm gonna assume it's World War I? World War I, maybe? Over a million Indians fought and died for Great Britain in World War I. No one ever taught me that at school. We never learned about the British Empire. We never learned about whose blood, sweat, tears, hopes and fears are baked into the bricks in this building. If we did learn about that, then maybe we wouldn't think about diversity and

throwing people crumbs out of politeness. Maybe we'd think about giving people their due and representing them. It was only recently that I learned the first Indian MP was in the 1850s and the first black footballer was from Scotland in the 1860s, Edward VII had a black trumpeter, ironically named John Blanke. Even England's first border patrol force was a North African legion fighting for the Roman army to keep the Scots on the other side of Hadrian's Wall. Even our anti-immigration movement has been multicultural for thousands of years. That's how deeply it goes.

So, we're missing out. We're losing people to extremism and we're losing an expansive idea of who we are. But most importantly, given the big Brexit bill we're facing that we've got to pay, we're losing out on money. We're losing out on my taxes. David Oyelowo spoke about this recently in the Black Star Symposium. Idris spoke about this last year. I can also tell you from my own experience and anecdotally. We end up going to America to find work. I meet with producers and directors here. I think they're being honest when they say they wanna work with me, but they say, 'we just don't have anything for you, all our stories are set in Cornwall in the 1600s'. Never mind that Cornwall already had a really busy Indian takeaway at that point, and you're just not telling that, you just don't wanna tell that story. But it's weird, because Asians are such a big proportion of the population here and such a small comparative proportion of the population in America. Asian doesn't even mean people that look like me in America. When I go to the states, they think I'm Hispanic and they talk to me in Spanish. Then I tell them that I'm Asian and they look at me, see I'm not Chinese and think I'm crazy. And yet it takes American remakes of British shows to cast someone like me.

There was a report recently, I think commissioned by Sajid Javid MP and turned in by Ruby McGregor-Smith, about diversity in our economy as a whole. It showed that if black, minority ethnic professionals were afforded promotion at the same rate and same frequency as their white counterparts, it could add twenty-five billion pounds to our economy each year. It's not a zero-sum game. There's room for everyone out there. And if you look at the box office, a study recently by the Bunche Foundation showed that the most diversely cast films are the ones that do the best at the American box office. I think we need to take a leaf out of the book of our music industry. Drum 'n' bass, grime, dubstep. These are world concrete musical genres that are only made possible by tapping into our multiculturalism. Just to reiterate

it once again, this is about the bottom line. The creative industries make up 7% of our GDP, which is second only to the financial services industries.

So, those are the things we're missing out on if we fail to represent properly: we're losing people to extremism; we're losing out on an expansive idea of who we could be and in the eyes of the world; and we're losing out on the economic benefits. So how are we doing? Well, you've heard some figures already so I won't go into too much detail, but I will say this. Sometimes it's very easy to look at the screen and go, 'oh look, things are changing so much, look, there's Riz, there's Idris, there's Michaela Coel doing *Chewing Gum*'. These examples are often prominent because they are the exception that proves the rule. Prominent successes can mask structural problems. Obama was in the White House, but they still needed the Black Lives Matter movement. I get on a plane to LA to attend a Star Wars premier, but I still get the second search before I board the plane. By the way, if you've never had the experience of being asked for a selfie by someone who's swabbing you for explosives, I recommend it. Really quite thrilling. Do they love me? Do they hate me? Not sure. But the statistics do tell a slightly worrying story. The Skillset Census showed that between 2009 and 2012 – this is kind of crazy to me – black and minority ethnic participation in the production of film and television dropped from 10% to 3%. Gains are hard won and we have to fight hard to keep them. Only 1.5% of directors of TV dramas are from black and minority ethnic backgrounds. For period drama, which we love and make so much of, and long may it continue as it's good for our economy as well, the figure is 0%. We completely shut out black and ethnic minorities from helping to shape our national narrative and the history of who we are. Meanwhile, participation in the production of film and television of people from private school, including myself – I got a government assisted place to attend a private school – is 14%, although the privately-educated make up only 7% of the population. We've got work to do.

If I look at my own journey, two things jump out at me. One, we need to safeguard opportunities and access to the creative industries amongst marginalised and underrepresented groups. Yes, this is about mentorship. This is about skills, this is about training. I got into a private school on a scholarship where my acting was nurtured and got into Oxford. That was a big culture shock for me. Actually, when I first arrived at Oxford I knocked

on the neighbour's door – this was back in the day of Nokia chargers right? Everyone had a Nokia – and I knocked on the door, and I thought I'd use my best English, as everyone was walking around in bowler hats and bow ties, and I said, 'I'm terribly sorry, but could I please by any chance borrow your phone charger if you happen to have a Nokia?' And she looked at me and said, 'oh my god you remind me so much of Ali G, it's unbelievable'. This was the first person who I met there. I was this close to leaving. Actually I left, I came back home for a little bit. Somehow, something stubborn in me decided to persevere. As I was leaving Oxford, I wasn't gonna apply to drama school, didn't think there was any future in me playing cab driver number two. Somebody encouraged me and I thought, 'I'll apply to one drama school, if I don't get in, it's not meant to be'. I got in. Couldn't afford the fees. I applied to one scholarship fund. 'If I don't get it, it's not meant to be,' I thought. I got it. I still couldn't afford the fees. A West End Theatre producer, Thelma Holt, saw me in a play in Oxford and offered to pay some of that gap, the fees. I'm in debt to her to this day. Even when I was leaving drama school, I thought, 'I'm not represented in the culture, what am I gonna do for living?' It was the same week I was gonna send in the law conversion course application form, when I got plucked from drama school. I had to leave early and had my first film. And that's a big run of luck. I shudder to think about all the people who fell at just one of those hurdles. We need to preserve access and funding in community centres. We need to make sure that the hike in tuition fees doesn't stop people from going to drama school and pursuing careers in the creative industries. Otherwise we'll all lose.

That's the skills and training argument, but there's another argument. The other argument is that actually we've got enough people who are skilled and well trained, it's just a hiring problem. We all have unconscious bias. Ruby McGregor-Smith's report into our economy as a whole showed that unconscious bias is responsible for stopping career progression of minorities. We can train against unconscious bias, or even better, I propose, tying public money to proper representation targets so that rooms where decisions are made are representative of our community, of our nation, and tell a story that represents us all. So that when everyone ends up exercising their unconscious bias, somewhere in the wash it works out being kind of representative. It just makes sense. Centre-forwards are valued on how many goals they score. We're in the business of representation. If we don't

represent, we gotta go. It's really that simple. That is what we're here to do.

I really think that government has to step in here. It's only government that's gonna have the long view and see the really big picture, which is that what's at stake isn't whether or not you can turn out another hit period drama, or whether or not you can open a film in Russia, because there aren't any black people on the poster. People making television programs are often trying to turn out a hit and are worried about their own jobs in a competitive industry. I get it. It's only when government steps in to set the rules of their game that you will foster true innovation. The same way that you do in the arms industry. The same way that you do when you support the Olympics. And it brings a massive boom to how we're seen around the world. They'll thank you for it in the long run. You won't be handcuffing them to anything. Cause what's at stake here is whether or not we can move forwards together.

We're really at a critical moment in our nation's history. We can feel it. If we don't step up and tell a representative story, we're gonna start losing people. We're gonna start losing people to other stories. We're gonna start losing British teenagers to the story that the next chapter in their lives is written with ISIS. We're gonna start losing MPs like Jo Cox who are murdered in the street because we've been sold a story that's so narrow about who we are and who we've been and who we should be. I'm gonna lose out on all those taxes that I could've paid the treasury. We're at this critical moment. Let's not allow future generations to look back and judge us when centrifugal forces were threatening to tear us apart, cause they really are. I can feel it, and I know a lot of you can too. We need to step up decisively and act. Let's do us right. Let's represent.

HASSAN HAJJAJ

MY ROCKSTARS

Hassan Hajjaj is a British Moroccan artist. His work features in
several collections worldwide, including the Victoria & Albert
Museum, London; the Los Angeles Museum of Contemporary Art,
Los Angeles; the Brooklyn Museum, New York; and Institut des
Cultures d'Islam, Paris. Hajjaj's solo shows include 'La Caravane'
at Somerset House, London (2017) 'My Rock Stars' at the Newark
Museum, New Jersey (2015) and 'Kesh Angels' at the Taymour
Grahne Gallery, New York (2014). Hajjaj won the Sovereign Art
Foundation Middle East and African Art Prize 2011 and was
shortlisted for the Jameel Prize 2009 at the Victoria & Albert
Museum, London.

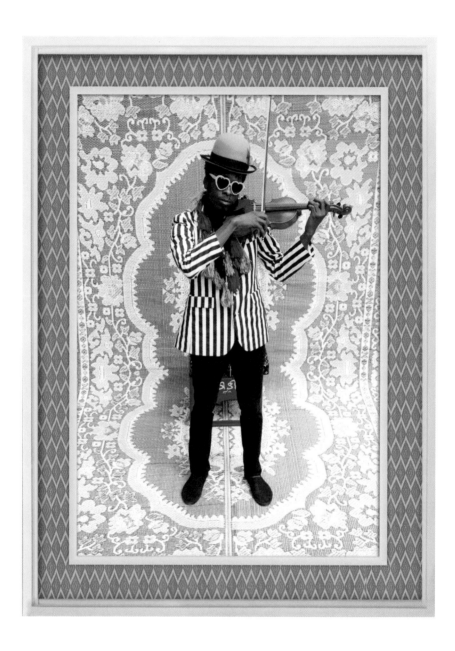

Mr M. Toliver, year: 2012/1433, courtesy of Rose Issa Projects

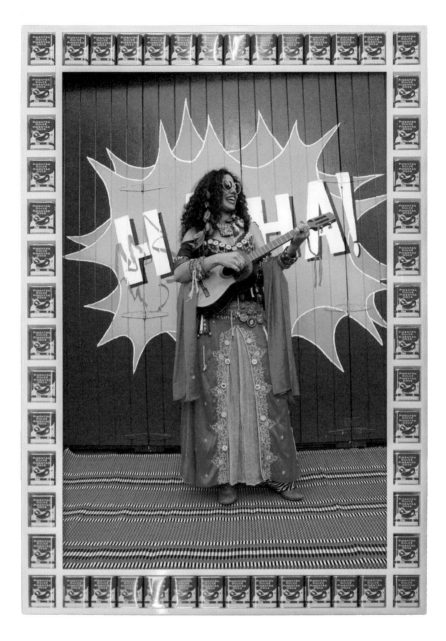

Luzmira Zerpa, year: 2012/1433, courtesy of The Third Line gallery

SPUN: WRITING A DEBUT PLAY

Rabiah Hussein

Rabiah Hussain is a playwright. Her debut full-length play, *Spun*, premiered at Arcola Theatre in July 2018 and received 4-star reviews in *The Guardian* and *The Stage*. Her short plays and monologues have been part of programmes with the Bunker Theatre, RADA, Bechdel Theatre, Take Back Theatre and Three Pegs Productions. Rabiah was part of BBC Drama Room in 2018 and the Royal Court's inaugural writer's program with Sister Productions.

'No, but, where are you really from?'

I HAVE ALWAYS KNOWN I'm not white. But I didn't always know I was working-class.

My earliest memory of racism is tied with home. At the age of six or seven, my cousin and me stood silently in the front garden as the kids of a white family from down the road walked past calling us 'pakis'. The word churning around in their mouths alongside the handful of sweets and crisps they were eating. The eldest one, at least twelve or thirteen, was terrifying to me. I used to duck when my Dad drove us past her house on the way to my grandparents' place. But that day, as her shadowy figure continued to walk away with her younger siblings in tow, my cousin and I started conferring about what to call white people. As they reached further down the road, pretty much outside their house, we nervously shouted out 'Engees!' – because English and white were interchangeable. It was at that moment that I understood 'paki' to be a derogatory word for my skin colour, one that positioned whiteness into the centre of my wider view of the world.

Our response to being called 'pakis' that day was a reflection of how we'd respond throughout our lives to questions about our identity. Not knowing the correct response to words used against us and fearing the reaction should we respond at all. The intimidation we'd always feel from the confidence of whiteness. Up until then I just looked different. But at that moment, I knew I wasn't white.

'They're gonna be in our manor, so why is everyone celebrating in Trafalgar Square?'

'Cos they're the London games.'

'Then they be should be celebrating where the games are gonna be happening. Here. The real London.'

Realising I was working-class came much later in my life, despite the fact that my identity has always been inextricably linked with home. I'm London through and through. But London to me has always been a vast estate, where people like my family live in outhouses surrounding the extravagant mansion at the centre of it. This mansion, despite being part of the same land, is guarded by wrought iron gates that we can occasionally peer

through, but only enter on special occasions. It is a mansion occupied by white middle-classes and it was a world away from where we were standing in Newham, East London. I identified myself as being a second-generation British Pakistani Muslim Woman. The class element didn't feature until I stepped through those iron gates and into that mansion.

'How is Trafalgar Square not the "real London"? Where d'you think tourists go?'
'Wherever the travel guides tell them to, and that ain't Forest Gate.'

Whenever cousins from up north visited, the London vs Walsall debate would rage endlessly. I remember being left confused when one said, 'But it's not really London is it, like the city'. They could be forgiven for thinking where we live isn't really London. Newham isn't like the London of TV and films. It's where people like my parents and grandparents created a home away from home. Where everyone in school looked the same as you and cousins all lived within walking distance. Where shopkeepers spoke the same language we'd speak at home and sold items with Urdu names. I got déjà vu in a grocery shop when I visited Pakistan a few years ago: what with the same layout of fruits and vegetable, the meat behind the counters, the same rows of Shaan Masala and the vast amount of Lux soap and Amla oil, it was like I had been transported back to Green Street.

'Have you forgotten what Forest Gate looks like?'
'Lots of shops called Choudhary & Sons. No, I haven't forgotten.'

Most of the people I knew shared the same background and experiences as me – immigrant parents, fathers working in factories, free school dinners, and the majority of white faces I came into contact with were those of our schoolteachers. Even when I went to sixth form in the slightly wealthier neighbouring borough of Redbridge, the large South Asian population spoke and dressed the same as I did. Our mannerisms, culture and the personalities of our parents were the same. In this situation it becomes difficult to think of yourself in terms of class. Of course, class is about more than just money, and even when I studied the complexities of the class structure in sociology, I didn't associate myself with it. It also meant I didn't always recognise racism either. It wouldn't be until I was much older

that I'd realise the egg thrown at me by a white man in a white van was not a random act.

'I'm on the District Line and as we go past each stop, I notice how everything changes. From Upton Park, Plaistow, Mile End to Monument. The faces, the clothes, the way people talk. Even though it's English, it morphs from "ghetto" into the "Queen's English".'

When I went to university, I started to see myself standing within the vast estate that is London and in direct view of the mansion that had always felt inaccessible to me. Getting through university by finding admin roles in small offices in central London felt like I had walked close enough to the iron gate, to be able to look through them, but I knew I was here temporarily – finding a step onto the career ladder somewhere in central after graduation would mean I had made it.

'You know what I'm looking forward to the most? Being able to walk into a shop and buying stuff I want without stressing about money.'

It was with the commute for my first job in a large organisation in central London that things changed. Walking past the lines of South Asian shops on Green Street before getting to Upton Park Station felt like approaching and walking through the iron gate that separated the outhouses to the large mansion. Travelling the district line felt like moving towards the door of the mansion, and as the train entered tunnels further into London, I became more and more conscious of myself in this alien world. I'd turn down the volume on my iPod when a Bollywood or Bhangra song would play on shuffle, so no one heard it through my headphones. I'd avoid answering my mum's calls so that I didn't have to speak Urdu on the train. Getting off at St James's Park and walking to the office, my entire world would change. I was standing in the mansion, scared to sit or touch the furniture.

'Helen is adding a new picture to her desk. Here, desks are decorated like they're bodies stamped with personalities. Always telling you something about the person who sits there. Pictures of families on skiing holidays, coffee cup stains and gym bags everywhere. A world apart from pictures of Quran passages, holidays to Pakistan and maybe a wedding in Middlesbrough. I love having my own desk.

But I haven't decided which personality it will take yet.'

In this mansion the cleaners, post room and canteen staff were mainly black, brown or eastern European, while the majority of faces sitting at the computers were white. I felt guilty for sitting among them. There were other people of colour who seemed to be comfortable, so what was wrong with me? And the answer came to me. It was, of course, class.

'You're really different.'

It was with this experience I set about writing my play, *Spun*, about two best friends from East London who leave university and embark on different career paths. One stays in Newham to become a teacher and the other finds a corporate job in central London. Over the course of a year, the politics of the outside world seeps into their friendship, changing not just their perceptions of each other but also their own sense of self.

'You spend your whole life somewhere else but hanging around posh bars with posh people is normal for you?'

Despite numerous attempts, I never quite grasped how difficult it is to tell a story about how it feels to be an outsider in your own city. I was inspired by the increasing number of stories about people of colour being told on stage, but the many iterations of *Spun* I tried to write never quite felt right to me. I knew I was writing about people of colour entering a predominantly white space, but there was a missing link that I struggled to find. That is until I realised that, for me, this story could never be just about race. The space where class and race intersect is where many like me exist. Class is always carried with me. So, this play could never just be about people of colour entering a predominantly white space – it was about being a working-class person of colour entering a white middle-class world.

'I didn't drop you. Work came up.'
'Your new life came up. Which is obviously too good for me to be a part of.'

Writing a story about class – whatever colour you are – can be daunting because these stories are few and far between on stage. I had only

experienced theatre through a few school trips when I was younger, and so there was a continuing feeling that I had no right to tell any kind of story in this space. Theatre is, after all, also very white and middle-class too.

When I was learning how to write for theatre, I continued to refer to 'traditional' play texts to imitate the voices of those who I felt belonged in this space. But this lead to an intense pressure to be something I'm not. With *Spun*, I was finally able to drop the act. To write with my voice that is undoubtedly a mixture of my experiences and identity as a woman of colour, from Newham, with working-class roots.

'Did you know, most people die close to where they grew up? That's scary, innit.'
'Why?'
'Cos both our birth and death certificates are gonna say same thing.'
'What they gonna say?'
'London.'
'No, they're not.'
'What then?'
'They're gonna say Newham.'

When *Spun* was performed at The Arcola Theatre in summer 2018, the response from audiences, particularly those from a similar background, gave me the confidence to know that my voice is valid, even if it doesn't fit with the voices of those around me. *Spun* wasn't an autobiographical story, but it was a combination of all the experiences and feelings that many people with a similar background as me have faced when crossing the threshold into the mansion that is London. *Spun*, for me, was a chance to write about characters away from 'extremes', existing in the middle, navigating day-to-day life with their working-class roots in their back pockets. These are our stories, and ones which I'm hopeful we'll see more of on stage, TV and film.

STORIES NOT STATS

Kerry Hudson was born in Aberdeen. Growing up in a succession of council estates, B&Bs and caravan parks provided her with a keen eye for idiosyncratic behaviour, material for life, and a love of travel. Her first novel, *Tony Hogan Bought Me An Ice-Cream Float Before He Stole My Ma* (Chatto & Windus), was published in July 2012 and was shortlisted for eight literary prizes, including the *Guardian* First Book Award and Green Carnation Prize, and won Scottish First Book of the Year. Kerry's second novel, *Thirst*, was shortlisted for the Green Carnation Prize. Published in France as *La Couleur de L'eau* by Editions Philippe Rey, translated by Florence Lévy-Paolini, *Thirst* was the winner of prestigious literary prize, Prix Femina Etranger 2015, going on to become a bestseller in France. It was also shortlisted for the European Strega prize in Italy.

Kerry Hudson

June 2018 – Eight months into writing *Lowborn: Growing Up, Getting Away and Returning to Britain's Poorest Towns:*

HE LAST FOUR WEEKS have seen me cradling a canned G&T on many, many trains as I shuttled up and down the UK. First, down south, to talk on literary festival panels about working-class writing. Then, north, up to Airdrie, where I stood outside the tenement, I turned eight in, watching children running around my old primary-school playground in the distance, while a photographer took my picture in the blustery summer wind for the cover of *Lowborn*. It was a surreal, magical thing and, as I tweeted afterwards, I wished I could have gone back and told that anxious wee girl that one day she'd be outside that damp flat, grown, happy, shooting her third book cover.

At one point, I joked with the art director and photographer that, when I became a published author, I never imagined I'd spend so much time having pictures taken down alleys or being subtly angled towards the end of the street littered with crisp packets and broken glass. I was grateful to them for wanting to tell a story that transcended those usual clichés. Grateful to them, instead, for trying to capture the image of a strong woman in the environment that had made her strong.

Earlier in the month, during the literary festival panels, I sat on stage with other working-class writers (whatever that broad term means) and much of the conversation centred around the ghettoising of our work – the not-inaccurate belief that writers 'like us' are expected to write only 'authentic, gritty realism'.

Ultimately, the consensus of those panels was that, as working-class writers, we have an artistic and moral responsibility to push against being

defined simply by our background, rather than the scope of our imagination and the quality of our words.

As the week, and those conversations, progressed, I began to feel uneasy about my own work. For, while I feel strongly that this is a pervasive problem, wasn't I doing the opposite in writing a book based wholly on my 'gritty' upbringing? Wasn't I writing entirely to 'type'?

After those events, I found I was interrogating my choices again. In writing *Lowborn*, a memoir that explores what it feels like to grow up poor, was I simply perpetuating the writing and consumption of a 'poverty narrative'?

I had thought long and hard before deciding to write *Lowborn*. I was concerned about the exposure involved, the digging up of feelings long buried, of knowing that, once it was published, people could pay a few pounds and know me as well as my closest friends, maybe even better. I know it's a particular sort of choice, deciding to write about your own life, and I have since wondered why I decided to do this when, having already written two well-received novels, I could have chosen to write about food, art, womanhood or, well, whatever the fuck I wanted.

But writing whatever the fuck I want is perhaps exactly the point. It's that freedom I've been given that is at the heart of this matter. As a girl born into poverty, I was told in all the ways, both silent and very loud indeed, that what I had to say was not worth listening to. And if I spoke up, I risked being punished. Now, I've a life which allows me not just to write – a huge privilege in itself – but to write and be read by people who generously let me converse with them through the intimate medium of those turning pages.

I have the choice to write something that might invoke insight and empathy, the freedom to say, 'This was once me. It could happen to you. Or your child. Or your neighbour'.

The more I thought about it, the more I felt that the idea that I should be expected to paint poverty in anything other than truthful colours – both the strength it can give and the bruises it leaves on the adult self – was both patronising and invalidating. To suggest that writing about those hardships is somehow 'shaming' to me and those like me implies that somehow poverty is a situation created by individuals, rather than by a structural inequality that keeps poor people struggling and offers a vast inequality of opportunities and power to those born in better circumstance. It insinuates

that the blame lies with me or others from the communities I grew up in, rather than with a society that is fundamentally broken.

Of course, there can be hundreds of different tellings and retellings of the same story and certainly I could edit, contract, expand and conflate my own childhood to make it of the 'poor but happy' variety. But that isn't my real story and I have been given the gift of being able to tell the truth. No one would ever tell a middle-class person they should not write about the hardships they've endured. My story is mine. It is human and real and my refusal to sugar-coat it shouldn't be seen as a betrayal of my community. Quite the opposite – it is an expression of agency I've earned.

In writing *Lowborn* I was given the opportunity to reach those who might dismiss people from a world they cannot comprehend. I have the choice to write something that might invoke insight and empathy, to say, 'This was once me. It could happen to you. Or your child. Or your neighbour.'

I have the ability to write a book that will sit on a library shelf, waiting to be discovered by a girl like I was, searching for books to see her life, her dreams, her very real struggles with the world reflected on the page so she might understand them. When I stop and ask myself why this book, why take my own life and present it as truthfully as I can on the page, I tell myself because of that girl looking for the book on the library shelf, because perhaps someone else might be more decent to that girl if they read that book, too. I tell myself I'm writing for that eight-year-old in that tenement in Airdrie. Because she has earned that freedom and deserves a voice that is louder than the usual poverty clichés.

JOELLE TAYLOR

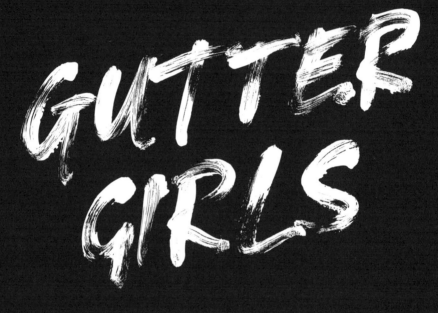

GUTTER GIRLS

Joelle Taylor is an award-winning poet, playwright, author and editor. She has performed across the UK and internationally, and has read in a diverse range of venues, from the 100 Club, 02 Arena, Royal Festival Hall and Ronnie Scott's, to the Royal Court, Globe, Buckingham Palace and various prisons, including Pentonville and Holloway. She has published three collections of poetry: *Ska Tissue*, *The Woman Who Was Not There* and her latest collection *Songs My Enemy Taught Me*.

gutter girls is based on personal experience of homelessness, poverty, drug addiction, and the uses of the female body in the struggle to correct this. The final stanza is an account of my mother's death, and the second grief of being unable to afford the funeral she deserved.

The original version of this poem was written for The Orwell Prize as a part of their transnational project, a live stream re-telling of Orwell's *Down and Out in Paris and London.*

We suspect that the true number of women who are homeless is higher than these figures suggest. Women tell us that they take care to hide themselves when sleeping rough, meaning they are difficult to find for official counts. Many more will be 'hidden homeless', living outside mainstream homelessness accommodation. Instead, they may be sofa surfing, staying with family or friends, or trapped in abusive relationships because they have nowhere else to go. Others will be squatting or living in crack houses or engaged in prostitution. (St Mungo's website, Women & Rough Sleeping)

I

Some girls fall from sunlit skies straight down into flat pack floral dresses/ grab their smiles from a hook behind the door/ skip to school/ on tap dancing tip toes/ while their shadows walk ahead of them/ get all the best job offers/ ignore them at parties.

Some girls fall/ and miss their bodies entirely/ find themselves graffiti/ their skin a pavement/ a lowlaying night/ each eye an unlit corridor/ inside a home she will never return to. Some girls/ are always

falling.

I land next to my body/ curled into a question/ I am a backward flying bird/ old sideways dog/ my cunt a car boot sale.

The first Easter of falling/ I live off sugar cubes found in a rented room cupboard/ and nose the streetdark for discarded cigarettes/ steal the pennies from babies' eyes/ eat my own words/ I had no idea

how low a higher education would bring me.

Hunger is a small thing/ that weightless heavy/ a bird with ingrown feathers/ and a song/ like your mother's hospice voice/ the Hunger Bird/ is under-eye grey/ and nests in the empty bowl of your

belly/ she pecks on the seeds of your dreams/ and cannot be tamed/ with tap water/ or promises/ she is a bird of prayer. You will never be alone now/ this pet/ this companion. The Hunger Bird followed me for years/ always scratching at the edges of conversations/ peering

between barbed wiring/ through keys holes to deserted buildings/ gawping open beak upward at the

class ceiling/ it shadowed me, pecking indifferently/ as I followed the line in a benefit office / watching it unravel into to a line on a hand wiped plate/ my cul-de-sac of a face/ the lines in this poem.

More than a third of our female clients who have slept rough have been involved in prostitution (St Mungo's website, Rebuilding Shattered Lives)

Poor women// our bodies are factories/ we stand numb-lip staring/ at conveyor belts of beds/ passing beneath us/ a carousel of scribbled sheets/ of unwashed mornings/ insincere sunsets/ red as the lit end

of God's cigarette/ He's been around here again/ but none of the girls will genuflect genitals to Him now/ and still we stand curbside/ the street passing beneath us/ as we check each walker-on/ for the correct parts. Each bed is a door to a home you do not own. Open it. You are lucky to have this body.

Your skin is currency. You are wallet. Your body, a factory. Men crowd your doorway/ desperate for sleep/ for a mother/ to bury themselves in. Your body is a cemetery.

Poor women// we ladle nothing from cradles of saucepans/ dinner plates

overflowing with the glorious empty/ we bow our heads and thank no one/ the Feast of St Giro/ and we are grateful/ trust my forelock/ we are all very grateful/ those who learn to spell our names in the dole queue/ we are grateful/ those playing job seekers lottery/ grateful/ raffle ticket bureaucracy/ food bank buffet/ we are grateful.

Homelessness, St Mungo's argued, led women to become 'among the most marginalised people in society'. (The Guardian 28 July 2017, quoting Rebuilding Shattered Lives)

V

Poor women// we keep the dark in our mouths/ tied up by an old thread of rope / we have swarms of fucks building at the back of our throats/ wild cats quietly watching you from behind thickets of teeth.

Fear us. It is simpler.

Poor women swear// and buildings fall in supplication/ finally relieved of the need to stand straight/ to act like gentlemen/ our mouths are condemned council estates/ are canals/ dive into our cold collapse/

the gutters of girls/ a hand reaches for your ankle/ you lucky boy/ a torn bicycle/ filthy deaf/ water as thick as language.

Poor women// we have planning permission for our tongues/ and build bars/ and all-you-can-eats/ and porta cabin bordellos/ we have permission to speak/ to spit/ knowing every banned word/ is a book in

our mouths/ we are freeholders of our glass orifices/ but there is a ceiling/ even down there/ and no/ not even at that price/ we will not sell/ you will not gentrify this idiom/ motherfucker.

Poor women// we search for homes like missing children/ clung to the shadows cast by tube trains/ gripped to the back strap of decommissioned buses/ lone walking with arms of stretched carrier bag plastic/ until we flat kick a front door to silent/ bite off our bras/ and whisper the secret names of the storms.

Shockingly almost half of our female clients have experienced domestic violence, and 19 percent had experienced abuse as a child, compared with 5 percent and 8 percent of men. (St Mungo's, Rebuilding Shattered Lives)

And if my body is a house/ it is a Soho club, derelict/ 4 AM/ the catchy dark/ smoke circles that you can lasso a thin dog with/ anything might happen here/ it depends what you are looking for/ it depends

when you are looking for/ strangers meet in me and admire the wallpaper/ tap tables waiting for a drink their father knew/ and the same jazz singer has been caught in the same riff/ on repeat/ since 1967/ there is no leaving when you enter my body/ I have you now/ you who thought you were taking/ I took you/ you are here still/ listening to that old jazz just before it ejaculates/ the smoke ring around your neck/ you're a very good boy/ but I guess you know that now.

My body is filled with sleeping men. All tucked up tight and waiting for morning. It will never come. My boys. My beautiful boys.

Almost half of our female clients have an offending history and a third have been to prison. Over a third of women in prison have nowhere to live on release, women are more likely than men to lose accommodation while in custody. (St Mungo's, Rebuilding Shattered Lives)

Poor women// we steal from ourselves/ all of us criminal/ the heart's petty thievery/ you can see it in the rough and scuffle of her/ the tide marks around her mouth// poor women/ we meet at the bar/

opposite the gym/ and lift drinks, lift our skirts/ until our arms are borders/ and we are standing to one side/ dodging a Russian roulette of semi-loaded kisses/ which one has your name on it/ which one/

will let you leave tomorrow. I have stolen everything I wear today/ this shirt/ crisp as a court notice/ this tie taken from my sleeping father/ the signet ring/ the centre of a small girl's eye/ before everything changed/ I stole everything I ate that night/ and this face too/ taken while the cashier's back was turned/ I shoplifted my smile/ the skin I ordered from a catalogue/ and never paid/ I have run up bills/ as though they were

ladders/ as though I were Jacob/ I have abandoned houses/ left them trailing behind me/ like breadcrumbs/ I have eaten all the breadcrumbs.

The under 45s have four times the chance of dying than their housed contemporaries, the under 55s three and a half times, and the under 65s two and three-quarter times. (Crisis.org.uk/ homelessness_monitor_england)

VIII

Poor women// we carry our own coffins/ say we have no use for flowers, love/ weave wreathes of lottery tickets and tick books instead/ plant the seeds caught between our teeth/ we build our caskets out of our chip board bed bases/ crowd fund the cremation/ pick the ceremony from a Littlewoods catalogue/ play Now, That's What I Call Funeral Music/ to the dearly/ to the gathered/ to the father of the bribed/ to the men lined like pints of bitter on a bar/ poor women// we bite the head off the Wake/ awaken in strangers' beds/ a small congregation of pills beside us/ white faces raised in mourning. In revelation. There is no death. Just less of this. My body is a cemetery anyway.

Poor women we say// this is just how she would have wanted it/ no fuss/ eyeing the empty/ the ashtray eyes/ the cigarette spirits/ the ghosts of brothers/ we don't look behind us at the deserted pews/ we did not invite God/ but someone said they saw Him anyway. Little well washed boy. He should know better than to turn up today. God is a bailiff.

Poor women// are born into a death/ so soft/ so luxurious/ so fine woven/ that life is almost worth it.

Our research indicates that a mixed-ethnicity lone mother who was poor as a child, renting at age 26, who has experienced unemployment, has a predicted probability of homelessness of 71.2% by age 30. Contrast this with a white male university graduate from a relatively affluent background in the rural south of England, living with his parents at age 26, where it is a mere 0.6% by the same age, and you'll see that we aren't all equally vulnerable to homelessness. (Let's be honest – if you're middle-class, you're less likely to become homeless, Suzanne Fitzpatrick, published in The Guardian 28 July 2017)

Michaela Coel is an award-winning actress, playwright, screenwriter and poet, who studied at the Guildhall School of Music and Drama. Her theatre credits include *Medea*, *Home* and *Blurred Lines*, all at the National Theatre. Among her numerous television credits, she is best known for her hit series *Chewing Gum*, based on her acclaimed play, for which she has won two RTS Awards and two BAFTAs. On the big screen, she has supporting roles in Rian Johnson's *Star Wars: The Last Jedi* and, most recently, a leading role in Tinge Krishnan's *Been So Long*, for which she was nominated as Best Newcomer at the British Independent Film Awards.

PLAYING THE PART

Michaela Coel

This is an edited version of a speech first delivered by Michaela Coel for The James MacTaggart Memorial Lecture, given on 22 August 2018 at the Edinburgh International Television Festival.

I WAS BORN AND RAISED in London. Specifically, in The Square Mile – sometimes considered Tower Hamlets, sometimes City of London – home to both the Stock Exchange and the Bank of England.

Between the corporate skyscrapers and medieval alleyways exists a social housing estate. It is right there in plain sight, yet somehow unseen. Even now there may be someone rushing past it for the hundredth time, briefcase in hand, with no idea this council estate exists. It was originally built in 1977 with the aim to help homeless people in London. It is also my proud home.

We lived directly opposite the Royal Bank of Scotland HQ, which felt somehow 'other' and slightly bizarre. Not the Scottish bit, the Royal Bank bit.

We were one of four black families there at most. Not something I thought anyone gave a damn about until someone left a pile of shit on our doorstep. My Mum silently cleaned it up. But when we received a bag of shit *through* our letterbox, I had no choice but to take things into my seven-year-old hands. I walked around the estate, swung on the swings and wondered, 'Who...? Who are the enemies of my family?' I figured it was Sam, so I'd call her an ugly wanker, then Sam would call me a dirty nigger. We would fight, which was just our way of expressing our mistrust and fear of those who were visually or culturally different from ourselves. But

we also had fun. The same Sam would be at mine for Nintendo between scraps, my mum would make us scones.

The miracle of my estate was Noah. On the best of days, he'd lean out of his window and sprinkle halal penny sweets down. As they fell, *every* child of every colour and creed would scramble from the playground and scrabble for a sweet. These sweets weren't wrapped or nothing; the taste buds were fully *aware* of the pavement in the mix, but we didn't mind, the point was you got a sweet today and other people didn't.

Not far from the square mile there's a theatre, where you might say my route into TV started. Mother, a single, hardworking, immigrant to England, was a health and social sciences student and a weekend cleaner. She discovered that the theatre allowed children from low-income families to join their youth workshops for free. Free was cheaper than childcare, and at eight years old I became a part of Bridewell Youth Theatre. I was the only black person.

I loved it. We played from morning till noon, and we'd sometimes even appear as ensemble in their main plays. I didn't know or care what the plays were about, but I would cry for weeks when they ended because it meant a cast were leaving that had just started to feel like family.

Later I joined a girls' secondary school in my borough, where new bonds replaced lost ones. We were a crew of ten misfits mainly hailing from Africa and the Caribbean.

I'll never forget our first IT class. We were pretending to listen to a teacher ramble on about modems and CD Roms when the sudden sound of glass shattering out of what was a window interrupted us, followed by a girls head smashing through the remaining shards. Even more disturbing was the sound in the room that immediately followed: laughter.

We 10-year-olds learned the rules of the game quickly: from 9am to 3pm, laugh or be laughed at, and after 3pm, go home to your room and cry, whilst, in my case, attaching a head-brace.

This was a Catholic School where student prostitution wasn't a shock but a gorgeous bit of gossip to spread. A school whose teachers you could catch a rare sighting of in the middle of an East London market, on weekends, slouched on a curb on the cusp of alcohol-induced paralysis and feel as you would about a shooting star – lucky to have caught a glimpse.

This was 1999. We were the twelve-year-olds with Nokia 3310s. The 121 network would malfunction, and calls would be unintentionally free. That's

right, 'Free calls!' The most important news would fly like those Eastward Falcons: Janette sucked her own left tit, Clare had sex at the back of the bus with Bola, Martina's selling bagels out of a bin bag for 20p, 25p if you want ketchup.

By 2002 our engagement with IT lessons was taking a strange turn. This wasn't a boring waste of time, it was a training ground for the most powerful weapon a thirteen-year-old girl could have: the anonymous creation of webpages. What a faster, cheaper way to disseminate, implicate and destroy. A new age had begun thanks to this sharper knife, this silent gun with limitless bullets where the trigger-puller remained unknown; delicious, until I found myself on the wrong end of it as the 'big lipped coconut who gave three blowjobs last week'.

A coconut: an insult used to describe one who is black on the outside but white on the inside. I was the first black girl in the school's history to join in the Irish dance team; that's what I was. I performed, middle of the row, fuckin' smashed it.

But blow jobs? I was outraged. The only thing I was blowing was the clarinet. I'd been bullied about these lips for a while. As I'd fine-tuned my clarinet skills, alone in the music room, some of the older girls in my school would come in and block the door. They'd insult my lips, how big they were, how ugly they were, releasing me only when the tears became visible. Needless to say, I had a sturdy amount of baggage to fuel me into creating my own first ever webpage.

Although those sites were anonymous, I decided to sacrifice my anonymity by mentioning the unique insults thrown my way. What I threw back was an attack, not on the bullies, but on their ideals. 'imma geek so what?' 'my trainers ain't designer so what?' 'i love the Irish step dance, so what?'

I made it funny, I insulted myself. But also let it be known, I didn't give a fuck.

One day, the Queen sat next to me in science. And she really was considered by all of us a Queen; like Claire Foy. Soft, gentle, easily recognisable by her loud, brash laugh. I'd never spoken to her, hadn't dared, I just felt this intrinsic desire to respect and keep distance. But she sat there, looked me in the eye and whispered she was pregnant and was breaking the news to me in advance, so I'd keep her off my webpage. She let me feel her baby bump – the first I'd ever felt – in her fourteen-year-old belly; a baby having a baby. The webpages were brutal. Print-outs would pass

around classes and we'd giggle with the occasional laugh-snort at public destruction. I respected the Queen more than anyone I'd ever met, but even if I hadn't, even if I'd hated her, I'd no desire to put that information anywhere. May her soul rest in peace.

I was passing my main bully in the corridor. She was roaming back and forth talking on the phone, but nonetheless she had a few breaths for me: 'Look at your fat lip'. I turned to her, agreed, adding that it was the hardest part of my mum's pregnancy, pushing them out. I said she seemed stressed and asked if she wanted a hug. She never spoke to me again.

Coming from the tiny square mile and a tiny family, what carried me through those five years was the abundance of black girls, white girls, mixed girls – misfits, my friends were *all* misfits – a huge gang of commercially unattractive, beautiful misfits, who found the mainstream world unattractive. From the outside we were difficult to distinguish, but on the inside known by name and nature. They didn't just carry me through those years: these girls made those the best five years of my life.

New bonds replaced lost ones upon finding myself in a church. I fell in love with God, with 'Jesus'; his actions, his character. I read the Bible and loved its metaphors, its *hope*. The Bible propelled me into becoming a poet.

It was clear I liked telling stories. I was told to apply for something called a drama school so I dropped out of Uni, again. In two years, I'd been to only one English lecture. The lecture was fine, was good, but I bumped into a friend on the way out and found out I'd just sat through a lecture for Law students. I'd no idea. I'd even taken notes. So I left to 'tell stories'. My Mum was concerned. She was a NHS mental health nurse at the time and what could she do but watch my future fall into uncertainty? Where was I climbing to? Why was there no clear sign of safety at the end of the ladder?

I got into a drama school. There were only twenty-three students in my year. The drama school was in my square mile – I'd been walking past it my whole life not knowing what it was and now, I was a member of its family. I was told Silk Street Theatre attracted the hottest agents from far and wide who would come to see us perform during our final year and sign the hottest talent, to partner with the hottest casting directors, to make the hottest period dramas, like kids scrabbling for a sweet from above.

I was the first black girl they'd accepted in five years, an admission coined by the head of the school as 'the elephant in the room'. This was my third attempt at university. I'd still never been into a pub, to a festival,

I just hadn't. I'd never watched *Fawlty Towers* or *Red Dwarf* or heard of the any festival in Edinburgh, I just hadn't. I struggled to converse on things I didn't know about with the other students. I was watching a lot of TV at the time: *Seinfield, Moesha, Golden Girls, Buffy* – shows no one really spoke about. I spent most of my time in the corridor, perched, like a falcon, and retreated into my hood.

I was called a nigger twice at drama school. The first was by a teacher during a 'walk in the space' improvisation that had nothing to do with race. 'Oi, nigger, what you got for me?' We students continued walking in the space, the two black boys and I whispering at each other whenever we passed, 'who's she talking to?', 'boy, not me', 'nah that was for you', passing around responsibility like a hot potato, muffling our laugh-snorts. I wonder what the other students thought of our complicity.

The second time was by a girl in my own year. After class, the same two boys and I were perched in the corridor when she passed and waved, 'see you later niggers!' We three blacks of Orient were posed with a dilemma, 'niggers', plural. This hot potato belonged to us all. I chose to act. I called her back and calmly gave her sound advice. She smiled, continued on her way and never said sorry.

Drama school was problematic in so many ways. As an Evangelical Christian, the plan was to teach the homosexuals about Jesus, but I accidentally ended up becoming best friends with some and learning new things from them. Yes, homosexual bonds replaced biblical ones. I still love the character of Jesus. I just started paying attention to the stuff written *around* Him, written by people who knew how to write and didn't care for what I read.

We were told at school that if we wanted to pursue this career, we should be 'yes' people and expect to be poor for the rest of our lives. *Climb* because you want to tell *stories*. I loved the concept! All of us united, climbing towards storytelling and poverty screaming, 'Yes!'

Once in a class exercise, the teacher commanded we 'run to point "A" if our parents owned a home, or to point "B" if they didn't'. When everybody else ran to point A and I found myself isolated at point B, I was astounded. Had land-owning taken over my blackness? Why did this class exercise even exist? I thought, then blogged about it. Not about how hard it was not owning a house; I wrote about the resilience born from having no safety net at all, having to climb ladders with no stable ground beneath you.

On top of that, all our ladders were faulty. We were born climbing a ladder before we could walk, and knew we'd better climb *fast*, lest it snap beneath your feet! I told people to keep climbing for the love of it whatever the craft, not because of financial profit, or safety. What *is* 'safety?' I wrote that such circumstances can either leave you feeling destined for defeat, or it can produce a sense of determination that gives rise to a relentless pursuit of your dream that no safe man could ever replicate. I changed the narrative, by twisting it to my favour.

Meanwhile, this profit ladder was leading to a truly desperate pursuit for money in some of those around me. Those who had no means of getting more except by committing crimes were arrested. I was aware that the proportion of black people imprisoned in the UK was almost seven times our share of the population. Seven times.

I blogged again.

One day an emergency meeting was scheduled between our year and the teachers. We gathered. Some students made small talk about the toilets not flushing, a teacher ensured they'd be fixed, then BANG, 'Michaela, what are these blogs?' I'd upset people, people who didn't see colour, or class. A year later, a friend saw me perched in the corridor. She apologised for going to the teachers back then and orchestrating a meeting that she, and many others knew would take place, long before it occurred. I also knew that already, because a homosexual gave me a tip-off in advance: Tribe.

To be honest, I didn't mind the occasional 'nigger' slip or military coup. I just loved the craft and wanted to be a lead on the Silk Street Stage. I had to get a lead part at least once. I was the first black girl in half a decade! How could they *not*?

My ego's dreams came true. I was to play Lysistrata in *Lysistrata* and my year were really happy for me. We found out later that this performance wouldn't be on Silk Street, it would be somewhere in South London, a thirty-five minute drive across the river. My mates were sad. They hugged me. 'No agent is going to come to this Michaela, not the hot ones, they simply won't cross the river.'

I lived in E1. We lived right by the river, but even we didn't cross it. There was an option to remove yourself from a main show to do a fifteen minute solo piece. Hardly anyone did this as the solo performances weren't shown in the main Silk Street theatre, they were performed in the basement. I didn't care about agents anymore, but this was a chance to

create something that wasn't a period drama in period costumes. I wanted to make something for *this* period. I wrote a dark comedy called *Chewing Gum Dreams*. A title born from a poem, a poem born from an image I had of a tall council flat, tall as the Tower of Babel, with winged falcons soaring round its highest floor in perpetual circles. The falcons watched the jet planes and helicopters fly by and were curious of life beyond their tower, but terrified of leaving it. Their wings were weighed down by gossip, dissemination, rivalry, fitting in – and by love, passion, dreams.

There's only so much a falcon can carry, so we'd offload the things society taught us were superfluous. Dreams, love and passion descend; free-falling from our tower block, already forgotten before crashing to the pavement, trampled on by our newly-acquired designer trainers, squashed into the pavement like chewing gum. *Chewing Gum Dreams*. I played eleven parts. The response in that basement was something neither I nor they had ever experienced and on that high I did what I do best: I dropped out.

A university graduate had acquired land in Hackney, which he'd turned into a theatre. He accepted my play for a four-day run despite my submission being late. Having read the script, he gave two notes; crucial notes. I listened. The rest – direction, set design, costume, flyer design, marketing – was down to me.

I advertised on social media. I said that if you met me in Tinsel Town, I'd buy you a milkshake if you bought a ticket. The milkshake bought a lot of people to the yard. I sat there from 1pm till 1am and ticket sales increased. I did this while editing and rehearsing the script. It was exciting.

My show went up and the audience went up with me on my wings. They responded, understood, laughed and cried in every place I hoped they would. People came who looked at things the way I did. They saw themselves as the ones who didn't fit in. Some felt they'd spent most of their lives being judged and disempowered before they even spoke. These misfits were inspired to create.

So I continued speaking. I remained at the National Theatre for a year in various plays. I even had a four-day run of *Chewing Gum Dreams* in The Shed; a temporary theatre. It was great. Many more misfits came. The play was read by a production company that sat under the umbrella of a huge production company. They asked if I wanted to make a TV show – 'yes of course, holy shit sure'.

They suggested I omit 'Dreams' from the title. I said, 'yes of course holy shit sure'. First, I was to write and read a twenty-minute version of what I imagined the TV show to look like and invite a small audience for a channel who were interested. I was then asked to write three five-minute TV scenes to be uploaded onto the internet. These were the first attempts at scenes I'd ever written for TV. I had no practice, obviously. I was an outsider.

'Outsider' not in a bad way, I wasn't out in the rain. I just wasn't here. When people mention 'diversity' initiatives I guess we mean taking on people who aren't watching, or making, much of our telly. Creatives 'outside of' this industry. I can't use the word diversity because I can't get clarity on it. I can't use 'outsider' because the in/out thing becomes reminiscent of Brexit. So I took on another existing word; 'misfit' and changed the meaning of it to fit my own purpose. I'd already made my own website, with a dictionary definition. Here:

The term misfits takes on dual notions; a misfit is one who looks at life differently. Many however, are made into misfits because life looks at them differently; the UK's black, Asian, and ginger communities for example. And there are many other examples.

The term Misfits can be cross-generational and crosses concepts of gender or culture, simply by a desire for transparency, a desire to see another's point of view. Misfits who visibly fit in will sometimes find themselves merging with the mainstream, for a feeling of safety.

Synonyms; Outsider, Falcon.

I'm calling any challenge to my definition Fake News.

Of late, channels, production companies and online streaming services have found themselves scrabbling for misfits, like kids in a playground scrabbling for sweets, desperate for a chew. They are not what these sweets taste like or the colour of these dreams, they are just aware that they might be very profitable.

A jet plane hovers over the tower, not sure where to land or how to land if at all. In the quest for new writers the misfit-looking people are instinctively sought after first. However, instead of nurturing them to write for themselves, they are immediately coupled with experienced writers. Isn't it important that voices which are used to being interrupted get the experience of writing something without interference, at least once? For creatives, there is a beauty in carving your own story, conceiving it, at least once, alone, *then* allowing others to assist in nurturing and maturing it.

That's why we new creators who want to make something different are a little tentative. We upload three or four short scenes or one full episode online. We use social media platforms to tell our followers, the outsiders who don't watch telly, that finally we've been able to make something for TV – online. The channel and producers study the comments on social media and investigate the audience's response. Is that important? I think so. This year, the fact that three major US shows have been cancelled and revived by social media alone confirms that a force outside of the television producers is beginning to take control of TV content. Do you let them in, to start making it with you, or do you block them out?

After the misfits enjoyed my three scenes, a producer called to say the head of the head of the Head of the Channel greenlit my series. I liken that 'yes' feeling to the standing ovation at the end of my play. They asked me if I'd like to write the show alone. I said, 'yes course, holy shit yes'. Some patrons of the National Theatre who'd once heard me perform a poem asked if I was writing anything else. They gave me the keys to their second home by a lake in America to write in, for no personal gain at all. I had no idea just how disconnected that part of America could be. Where were the people, the sirens, the noise? Where was the wifi? It was safe, so safe, too quiet. I checked the doors were locked repeatedly and social media perpetually. After a few days I had no choice but to relax and in those two weeks I wrote drafts of all six episodes. Had a Falcon never flown to a lake before?

Back in London my scripts were noted by the company. Notes were given on Friday nights and expected back redrafted by Monday. Calculating the hours, I saw that it was possible for me to reach my targets if I erased the concept of weekends and saw sleeping as something you didn't do deeply, or every night, just *some* nights, like anal.

I still wasn't getting it right. The producer rang to say the commissioner thought I needed co-writers urgently. I got the call in Boots. I found myself sobbing into the tights and discreetly leaving them there, for someone else to buy.

I was making a story about the world from my view, from the view of those misfits I'd grown up with, who looked at things a bit like I did. A view rarely found on TV. Did these co-writers know my world from the inside? Could they distinguish our nature from the outside? The Exec Producer pushed the Head of Comedy to read my scripts, after which the search for emergency

co-writers was terminated. What would my scripts have been, had they been interfered with at such an embryonic stage? I was relieved.

However, after draft twenty-nine, a friend discovered my body, on the floor, in the dark. I was looking for my brain. He asked what was my script editor was doing? I asked what a script editor was. I called the producers. They didn't want one, they wanted it to be my 'baby'. That's nice, but this was my first pregnancy. If we wanted this baby to be cute, instead of the pram the world wished it never peaked into, I couldn't do it alone and I needed a doctor.

'Things have to be episodic', said the Script Editor. I'd never heard that word before. 'And you haven't factored in commercial breaks, when you finish the first half, give them a reason to come back.' He drew a map of my storylines on a whiteboard, and simply rearranged them, almost mathematically. I was impressed, he had great tools. He thought I had great stories. We began shooting.

I chose to be on set all day even when I wasn't in a scene, doing rewrites in the trailer, assessing where I could save the producers money despite having no clue how much that money was. I'd rewrite scenes so they could take place in the same location, returning scripts to them with clever cuts. I felt like they wanted me there and I liked this feeling. But this want became more of a need: a fine example is what came to be known as Trailer-Gate.

On day one of the shoot, I approached the trailers to find five actors and actresses ranging in tones of brown and black, including the woman who plays my mother, squashed into one third of a trailer. The second trailer was occupied by a white actress, looking like a privileged piggy in the middle, and the third was mine. Prior to this I wouldn't have dared enter the Production Office, but I burst in through the door. The room fell silent, like a scene in EastEnders and I was fully in Kat Slater mode, 'You know what that looks like doncha? Like a fackin' slave ship!'

I know. I really did say that.

'I'm not racist!' a producer screamed at me. She was red with rage, wet with tears.

'I know you ain't racist! That's what makes this all so fackin' bizarre!'. I Kat Slatered the pub door.

Hours passed. There was a line: myself and the actors on one side, the producers on the other, and it wasn't crossed, for hours. We were even shooting. The mood was ... moody.

The executive producer came to me and asked, 'what do we do?' I suggested he apologise to everyone, buy my on-screen mum some flowers, and get more trailers.

They did.

I asked the actors why they'd agreed to share. They just wanted it to work, their belief in the job only matched by their anxiety of losing it. I apologised. I told them we were working for a reputable channel and a reputable production company and they wouldn't dream of recasting anyone for wanting a private space to prepare and change.

I've often been told by people in our industry that many producers in many companies 'test the waters' to see what they can get away with. I told them the opposite of what I'd learned in drama school: that the only power we have is the power to say 'no'. I apologised to the white actress too. I asked her to rid herself of her embarrassment. We shouldn't have let that happen; we were sorry.

Throughout my career I have been told 'that's just the way it is': producers negotiate with agents, and when the negotiations are done, the producers have in one hand actors willing to forego their right to privacy; and in the other, actors who say 'no'. Should the producers have noticed a racial divide? Should they have seen the slave ship on their hands before we started sailing? If so, what then? If no, what then?

As the Producer said, she wasn't racist. I knew that. I've never accused anyone at work of racism but I've been urged to understand someone 'isn't racist' on every job I've acted in since, just by pointing out possible patterns, tendencies. When I agree they aren't racist but suggest they may be thoughtless on the matter; it doesn't go down very well. But if you're not racist, or thoughtless about race, what other thing can you be? After this, and many other similar occurrences, I was left unsure of my position on set. I wanted this 'other' work I was doing to be acknowledged. After negotiations I was made Associate Producer.

Chewing Gum aired, my baby had captured an audience: The misfits.

My euphoria that it was liked made me so happy. I was suddenly fitting in! I went to press nights and parties and tried cocaine! I had no job to wake up for in the daytime, so, I'd go to more parties in the night-time! Where I'd have more cocaine! Oh, everybody wanted to be my friend. I'd see old friends, who I couldn't remember because nothing was more important than me, being an actor, on cocaine, with my actor friends.

Every snort masked the misery of losing my motherhood. Now that *Chewing Gum* had graduated, I had nothing to focus on. I saw my ex. 'I hear you're struggling with fame,' he said.

I sat alone, in silence. Five years ago, is this who I imagined I would become? I thought about it, the answer came: *no*. I grabbed someone and asked for help. But we're not all that lucky.

Being a misfit hurts. I can recall rummaging through the gift bag after the party for my first big mainstream award. It contained dry shampoo, tanning lotion and a foundation even Kim Kardashian was too dark for.

A reminder: this isn't your house.

The lack of varied perspective among producers, the lack of misfits producing telly, can have catastrophic consequences. I'll give you an example. I got another job after *Chewing Gum*, an acting one, to be filmed for three months, in a place far, far away. I was immediately anxious, I searched online, 'being a misfit like *me* in this place far, far away'. My anxiety grew. I was told not to worry.

One day, whilst shooting in this place far, far away, which happened to be my birthday, another misfit and I were carrying groceries home. I felt something sharp on the back of my ankles. What was that? I turned around to see four men hurling stones at us, their brisk walk turning into a light jog, reloading from the ground whenever their hands emptied of stones. The producers told us to keep calm and carry on, just a few months left. Could this have been managed better? Did it have to be on my birthday?

I call that a catastrophic consequence. The producers saw shooting in 'that place' as a low-cost haven. They didn't consider the experiences of the brown and black cast to meet the morals of their diversity compass, because they didn't think to see things from our point of view.

A white actress in the cast later contacted me. She also felt alienated – people were also pointing and staring at her. She hadn't felt that before and just wanted to talk. I asked what she thought the root of it was. After some silence she said, 'I think it's the colour of my hair'. I think it was too.

I searched online what being 'an outsider like her' might be like 'in that place'. The website for a giant hair company came up first. The top article was titled: 'How To Bleach Hair; The Ideal Technique'. I quote: *Your hair is not really blond? This is true for 95 percent of all people...nature has given only very few of them blonde hair. All but these few women have spirited the natural*

pigments out of their hair. Among the colour treatments, bleaching is still number one on the list. I wondered why if 95% of us didn't fit something, we would encourage each other to aspire to it?

Chewing Gum was offered a second season. My agent and I thought my being credited an executive producer would be simple. She called to say I would not be made an executive producer. Instead I was made 'Creative Co-Producer'. We began shooting.

There was a moment during the shoot when something just didn't feel right. What was it? The location? The staging? The writing? I approached a producer: 'Is this good? Why does this feel like shit?' I was visibly anxious. 'It doesn't feel very good, is it good?' The Producer told me that it was 'really funny' and 'great'.

During post-production, it became apparent the channel didn't like the look of that story sequence either. In fact, they despised it. We lost an episode. The channel said that they couldn't give us any more money, which forced the umbrella company to make it rain.

I was to write a new episode of *Chewing Gum* that could only take place in one location, with a maximum of two leads, and one series regular as cast. It was to be inserted as the new episode four with episode two becoming episode one, episode this, that, ligaments and limbs of storylines just tossed around to make a version that did look fucked, but was still semi-recognisable as a TV Show. They said I didn't have much time. I went to write in Zurich. I got thrush, and only when I couldn't afford to buy Canesten did it became clear to me that I'd accidentally travelled to the third most expensive city in the world. Another birthday passed out there. I got so hungry I went into McDonalds and asked them for fries, they gave me fries. This is a real-life story. Somebody gave me something for nothing in return. I wrote that episode in three days.

I realised that the show may look more human if we switched things around and made the new episode as episode one, moved a ligament here, swapped the right tit with a testicle and boom, I proposed a version of my child that seemed more 'her', which we all agreed worked better.

My Executive Producer offered me a production company under his umbrella. He offered this through tears. I'd never seen him cry before. I wondered if he really wanted to offer me this and was emulating a boss above him, whoever that was and whether that boss was emulating his boss. I used the only power I had and declined.

Chewing Gum Two aired. I don't know anything about the online acquisition as I wasn't part of those negotiations, I was just told all rights had been sold to them. Kinda like your Dad coming home and saying 'this is my new wife Netanya', and Netanya has no face. That's how impossible transparency seemed.

This year, Netanya heard I was pregnant again and wanted to acquire my new unborn for one million US dollars, wow. I've no mortgage, no credit card, no *real* kids, no car, happy with my bicycle. Money's nice, but I prefer transparency. My stories are my babies, I wanna look after them, so I asked to reserve a portion of my parental rights in the form of my copyright. 'No, that's not the way it is,' said No-Face Netanya. I used the only power I had and declined.

New writers aren't often made executive producers in the U.K. I understand, 'that's the way it is'. We're not experienced enough to know the budgets. So when and how do we become more experienced? This isn't about me – this is for the new writers coming after me, so that for them, the process of learning isn't harder than it should be. Why not be transparent about the budgets, the figures, the Netanyas. We need producers to be more transparent with new writers about the health and life of the child they're having.

I offered my first ever contract to a few writers and some sent theirs in return. It was nice, to be transparent. I spoke to Heads of channels, old and new Heads of production companies, Heads of Heads, more Heads, loadsa Heads. My research raised questions: I wondered whether someone should investigate how the shows of new writers are budgeted each year, within channels, to look for patterns. It may be that 'Business Affairs' have found it easier to get away with more on certain shows, sometimes budgeting way below what is commonly held as acceptable.

When a budget is lower than standard it leaves production companies saving and scrimping and that save is often taken out on the writer; for example, the erasure of script editors. I was told 'that's the way it is, you wanna put as much money as you can on the screen'. Without a healthy writing team, and a great story, what do you have on the screen to inspire misfits? Oh, *Love Island*.

Being more transparent in our industry has led those accused of misconduct to courts. We know this because they're powerful people who generate click bait, so the news makes the papers. But are we protecting

those abused by these producers? Some say our industry is a microcosm of the world. It's a delicate dance, isn't it? The world reflects us and we in turn, the world. We have to remember that there are people here who are outsiders to this industry, being raped by men and women, who lack any celebrity status or public power to dissolve.

I'm going to share two experiences in order to discuss their effect on our industry.

I won an award for writing. At the after party a London producer introduced himself to me. I said, 'oh yes, nice to meet you'. 'Do you know how much I want to fuck you right now?' was his chosen response. I turned from him and went home so quickly I left my plus one. He called, upset. Someone had called him a nigger. It was the same man. Could my silence have encouraged this producer to push boundaries with women and black people further? This thought is uncomfortable, but I cannot block it out. I have to face it.

The other experience was more life changing. I was working overnight in the company's offices because I had an episode due at 7am. I took a break and had a drink with a good friend who was nearby. I emerged into consciousness typing season two, many hours later. I was lucky. I had a flashback. It turned out I'd been sexually assaulted by strangers. The first people I called after the police, before my own family, were the producers.

How do we operate in this family of television when there is in an emergency? Overnight I saw my colleagues morph into an anxious team of employers and employees alike; teetering back and forth between the line of knowing what normal human empathy is and not knowing what empathy is at all. When there are police involved and footage of people carrying your sleeping writer into dangerous places, what is your job?

Writing felt as though I was cramped in a third of a trailer, a mind overcrowded by flashbacks. I needed to push back the deadline. It was already tight, but just like those actors, I wasn't sure how damaging it would be to the company so couldn't ask. Someone was transparent with me. 'They won't offer you the break,' a colleague said. 'That's not the way it is. You have to take it.'

I asked to push the deadline back and for the channel to be informed as to why. The deadline was pushed back, but the Head of Comedy never found out why. I would also like to add that this company *did* send me to a private clinic and funded my therapy there until the end of the shoot. I

would like to stress that I was *not* raped within the offices of the company and I have never been raped by anyone at the company.

For survivors of such trauma, therapy's great. And you can get it for free. There are many specialist centres, like The Havens in London, and Survivors Trust UK, an inclusive service for sexual assault survivors who welcome those who identify as male, trans, non-binary. Anyone who feels like they're struggling can get free therapy on the NHS. My Mum has been a mental health specialist there for a decade, that's why I know. It's good to talk, and engage with someone else, transparently. I believe in treating our minds like we send cars for MOTs – it's probably fine but check in, just in case.

Like any other experience I've found traumatic, it's been therapeutic to write about it, and actively twist a narrative of pain into one of hope and even humour. Also to be able to share it with you, as part of a fictional drama on television, because I think transparency helps.

Many of us in this industry, this world, are on creaking ladders, climbing, surrounded by noise, stress, and nothing real, not even the ladder itself. This can make the future feel bleak and devoid of peace, leaving some feeling isolated to the point of suicide. I think of Antony Bordain who ended his life while shooting a series. I think of Alex Becket, an actor who ended his life mid theatre run. I'd worked with him, in that place far away.

When the narrative of climbing makes others put profits before people; fitting cheap cladding into their tower blocks, what then? How many potential artists with stories we want and need have we lost for the sake of financial profit, in thoughtless education systems, through thoughtless nurturing or just sheer thoughtlessness? Why are we platforming misfits and heralding them as newly rich success stories whilst they balance on creaking ladders with little chance of social mobility? I can't help usher them into this house if there are doors within it they can't open. That would feel complicit. What I can do is be transparent about my experiences. How can we help each other to fix a faulty system?

Being a producer, being head of department, head of the house, being a human, is a noisy job; everything coming at you, from all angles, at all hours. I think it's important to make silence for yourself for five minutes. Check that you're okay. Interrogate your own morals and beliefs in relation to how you operate. Even if you do think about these things already, why not think a little harder?

Accepting I'm wrong is hard. I recall a phone call from an exec during season two of *Chewing Gum*. I'd written a part for a Malaysian woman and one auditionee thought my story was two-dimensional so emailed me her feelings. I flailed around like an idiot. 'This isn't my department! I'm an artist not a politician! It's finished anyway, I'm not even writing that episode anymore!' I Kat Slatered the phone. And in that small gap of silence that followed, I realised the she was right and I rewrote the part.

I recall a quote from a book called *Act Accordingly* by Colin Wright. He said, 'There are as many perspectives as there are people'. I'll always remember that. I've decided to embrace as many as I can and be brave enough to update my beliefs. I am not always right. What a brilliant thing it is to discover that we've been wrong about some things. What a brilliant thing it is to grow. We're all gonna die. Instead of wishing for the good ol' glory days, about the way life used to be before Mark Zuckerberg graduated, I'm going to try to be my best. I am going to be transparent and play whatever part I can to help fix this house. What part will you play?

AM I WORKING-CLASS, OR AM I JUST BLACK?

Emma Dennis-Edwards is a writer and performer of Jamaican and Trinidadian heritage. She has been part of several prestigious writing programmes with theatres including Royal Court, Soho Theatre and Lyric Hammersmith. Her work has been performed at The Tricycle, Arcola, Royal Court and Oval House. She wrote and starred in *Funeral Flowers*, which was a Fringe First and Filipa Bragança Award winner in 2018 and is published by Samuel French. Emma was chosen as one of the Old Vic's 12 playwrights and is writing the Young Vic community play in 2019, as well as developing original comedy and drama projects for TV.

Emma Dennis-Edwards

S O OFTEN WHEN I'M ASKED to write anything, I ask my ex-housemate Janet (who is also my mum) what she thinks. Janet doesn't like that; I think she's uncomfortable with the idea of things that she says being used as anecdotes in my writing (sorry mum!). But she's so insightful and smart that it's difficult not to use her as a resource. When I was asked to contribute to this book, I asked Janet about class and our conversation went a bit like that this.

EMMA: Janet, are we working-class?
JANET: I dunno about you, but I am.

I dunno about me either, to be honest. I don't think about class that often especially when it comes to working in the arts. Before class, there's two very distinct markers about my identity that are slightly more significant in my personal experience; I am a woman and I am Black. Janet and I didn't speak about class while I was growing up. We talked a lot about being Black, but class wasn't really a factor in our household. However, I do remember one conversation we had. I was about six and we were in the car on our way to do the shopping.

JANET: Emma, please don't ask me for anything while we're out. You're not to put anything in the basket.
BABY EMMA: Why?
JANET: Because we're poor and I'll feel sad that I can't afford to buy you anything.
BABY EMMA: (thinks) Like Oliver Twist?
JANET: Well, not quite.
BABY EMMA: Good, I don't like soup.

And that was the end of it. I knew we didn't have a lot of money, but the lights and heating were always on, the fridge was busy and I had lots of nice clothes. Class, like sexuality, are not things that you can look at me and see straight (pun) away and, like sexuality, I think class is a spectrum. Like being Black, I'd never really thought about what class I was or was not in until I went to drama school. I think that's largely because, growing up, everyone I knew was black and everyone was working-class, to varying degrees.

I am often cast as quite clearly working-class characters, which I think is actually more to do with my race than my own class background. There is a strange misconception in British theatre that all Black people are working-class and this narrative translates to the stage, so it is what we see. Often when we see Black actors playing characters from middle-class backgrounds, the character hasn't been specifically written Black, or they're not British. This is odd because most people in our industry are middle-class and I wouldn't say that Black actors are exempt from that. Many of my Black industry peers are privately educated, grew up in the countryside, have a house with a garden and probably a kitchen island. Doesn't that combination make them middle-class? I don't really know. But the 'road' narrative is the dominant one, the one that the white gaze exemplifies when it comes to Black and other people of colour.

When I think of my own class background, I'm not sure where I belong. Several key indicators mark me out as a working-class gal:

- I grew up in noughties Hackney;
- My dad is an immigrant;
- I went to a state school;
- My mum's house has a telly in every room, apart from the bathroom;
- I had free school meals (albeit for maybe two terms);
- I own a lot of Burberry items of clothing.

But the line becomes blurred when I take some of these factors into consideration:

- My mum is homeowner;
- My dad has a degree;
- I work in the arts;
- I listen to Radio 4;
- I describe people's children as 'delightful';
- I own a lot of Burberry items of clothing.

Despite what white liberals would have us all believe, more often than not my race and gender have been much more at the forefront of my mind over class when talking about my personal barriers to accessing opportunities as an artist. However, now I think about it, I recognise how being from

a working-class background has affected the way I make art in ways that being Black has not. An example of this is how I think about money. Money is a factor in nearly every artistic decision I make: I don't have the luxury of it not being one. I consistently ask about fees in a way that I don't hear my middle-class counterparts doing, even those who do not come from money.

There is also a lack of comfort, a sense of not belonging in this industry as a working-class artist. Any industry that requires so much unpaid time to be put into it is obviously not set up to accommodate people from working-class backgrounds. The worst thing about that particular aspect of the industry is that gate keepers are well aware of this barrier to access and yet continue to do little about it and watch with faux dismay as working-class artists disappear and our stage and screens continue to be over populated with those from upper-middle-class backgrounds who can afford the waiting game. It seems to me that more often than not it is other working-class artists supporting and uplifting each other whilst those from privileged backgrounds seem almost afraid of making any attempts to make the playing field fairer, as if our presence in some way threatens their existence. Which is doesn't, there will always be a place for the Sams and Bellas, but we have to start making space for the Saharnas and Bilals and if it's not given then the Hackney girl in me will simply take it.

My role isn't to inspire a Black girl, from a sketchy area, with aspirations of being an artist. My role is to make that girl's route to becoming an artist accessible. The longer I stay in the business the more I realise that my presence as a Black working-class artist isn't enough. So what do I do? Do I start my own network, a Young Girls Network where we encourage and 'bring in' other working-class, Black girls onto projects that I'm working on? A kind of reverse nepotism. Cos at the moment that feels like the best way to do it. But why is it down to me, an artist who exists in an intersection of oppression, to do that work? I'm constantly being told to 'lean in', yet no one's telling those in position of power and privilege to 'pull up'. I'm not afraid to do the work and I care about accessibility so if that means I have to start a Young Girls Network to counteract the Old Boys one, so be it.

Let's put our Burberry thinking caps on and get to work.

FRAN LOCK

COHORT

Fran Lock is a poet and author of poetry collections *Flatrock*, *The Mystic and the Pig Thief* and *Dogtooth*. Her work has appeared in *Ambit, Poetry London, The Rialto, The Stinging Fly* and in *Best British Poetry 2012*. She was the winner of the *Ambit* Poetry Competition in 2014 and won third prize in the Poetry Society's National Poetry Competition in the same year.

There will be no poetry. I will not rise in light the colour
of medical waste, with blood's black cartridge low on ink,
to sing the aggrotastic wassail of working-class catchment;
to sing the asymmetric faces of all those truant youth who
dined on fire. There will be no poetry, or only for those
petrol-headed prodigies of somnolence, boys on gaunt
corners, solanine and gobshite, gasping in alleyways, their
hands sweating currency at three a.m. when blue light
bathes the deviated streets like Tiger Balm. If there is poetry,
it will be in the lowbrow necromancy of estates, terraces
that shape themselves from bloated gloaming, broken
windows; from chain-smoking and pallid stagnation;
from crude, two-fingered benedictions, dispensed by
Holy idiots. If I sing, I will sing for the boys whose lisping
chivalries the upright boroughs shun for fear of plague; for
frail and vacant boys, howling in a solvent ague, chafing,
baste in sweat and wasted again through all the hungry
hours we knocked on wood to. My boys, who, keening in
the paralytic standstill after curfew, balk at love's fraudulent
portion, when summer's heat defrosts a sorry longing in
the heart. Do you understand? For the boys whose raw,
shop-lifted nerve trembles with a desperate jetlag;
whose breath is a silvery pesticide, who wear a chemically
tenderised skin. There will be no poetry, unless for them,
folding in their locust limbs in doorways, treating their
secrets with bleach in cemeteries underneath the cherry
blossom. Boys who break in grimy waves along the South
Bank of the Thames, their narrow backs arching like bardic
harps, who walk in staggered jackets, the tired, unvaried
tedium of August; who crawled the body's slow-witted
acre, pining, in a forest, on a carpet of needles, ostracised,
besotted; their yellow faces caving in like sandcastles, brains
behaving like hydrogen. This is the music of my witness.
Friends I have lost to the maledicted mufti of unemployment
blackspots. Boys, whose stooped regalia gave them away,
dressed in poverty's erring fashion: ashy face and earring;
friends, whose desolated smiles disgorge a hardboiled fist

of stars, an anti-English spit embracing broken teeth. These
are the boys with numb lips bending local cant like spoons,
swept up in grief's swooning pheromone, horny and crooning,
a little in love with violence, fizzing with an aggravated
lambency, forsaking clinics for Brixton, the lairy aquarium
light of bars, of clubs. Boys, whose sooty humour groomed
itself in station toilets; lived by hooch, by gear and by the
wheedling grammar of an underpass at Elephant. I will sing
for them, as they fall between London's grim chimneys;
the shrill and mildewed air of social housing, days spent
nursing hung-over hemispheres, digesting regret in the
microwavable guts of melamine kitchens. Cold potatoes,
newsprint on the fingers. There will be no poetry if not for
a limping, malingering kiss; for afternoons immense with
vendetta, the hoary feuds they bristled with in car parks
and in stairwells; courting the moribund alchemy of smack
or of meth or jellies, downed with vodka's dicey clarity.
A neat buzz they tilt at windmills. I will sing this song, no
other. This city does not want them, its poetry a tide of
numbers, zeroes replenished like dry martinis, like artisan
coffee, a cool you'd split your lip on. A cup you crumple
into waste; the dregs they've scried the depths of. This
city does not want us, who file like black ants along
the crisp green edge of need, who are naked inside
of need's skirmishing velocity, who come apart at
the speed wet paper tears. There will be no poetry.
You cannot cross my palm and reconcile a coin.
I bear my misaffection like a grass's scar. I wear
disgust like a velvet glove.

<p style="text-align:center">***</p>

This one goes out to Martyn: saint, martyr, satyr, waking
lame to Monday's malnourished perdition; dizzied by
the business end of inquisition, at the hospital, the job
fare, his illiterate skill dismissed where men count up
his felonies like calories. His arms are ink and inhibited

uptake. The suits recoil from pasty slang, the bravado
of hard time pulled like teeth from a busted mouth
that slurs its larcenous melancholy; his lips wear white
blisters, baccy burns like seed pearls, semi-preciously
encrusted, a treasury of eczemas. This is his song, who
makes vocation of his cravings, climbing panic like
a ladder to Benzedrine epiphany. He'll say he's chasing
safety, not bliss, in an opiated Arcady; swirling a drunk
shadow like a matador; a listless Icarus who's thin
wings rustle into fire between nicotine fingers. What
clocks will stop for him? For any of these refugees,
our symptomatic heartland banging gavels in our sleep.
For boys whose persecuted synapse is an arrow shot at
space, who have no inside voice, who fill with more
exile than with cunning. Martyn, who'd stamp
love's squealing tyranny with steel-toed DM boots.
Martyn: scuppered, not stricken in grief, unlovely, in
the wincing dereliction of his shame, a peace he
pawned for sodden pleasures, Saturdays, lobotomised
and luddite, his wrists in the philistine slings of self-
harm, sickly and grimacing. Who stops a clock for
him? For bed's defeatist furrow, days upon end, who
listens to the drip of a leaking tap, all through winter's
fidgeting vicissitudes, no money for the meter, inhaling
a stark heat up through smoke. Martyn, in a disowned
ambiance of damp plaster, scutty linen, excuses worn
with sheets and soles, and scaling peaks of spiking
fever while his kidneys cease to function. While his
liver ceases to function. Whose all or nothing cohort
lives by creeds of calamity or dominion, with fuck all
in between. Our instruments agree. I'll stop this clock
for you. For all of us. Stop time's blind clamour dead in
its scrabbling tracks. Depression curls us in on ourselves
like trigger fingers; balled on the floor like dead wasps,
like – like nothing I can throw a motor-mouthed metaphor
at. Instead I hollow out a place to fold your name in
orange flowers and paper. Martyn, yes. And all the rest.

And who would torture poems out of this? Poem as
a trichophobic eyelash tweezered from the red rim
of wakefulness. There is no poetry, only the dream,
pulled from sleep's stuttering pre-history; the dream,
polluting the pillow like hotel lavender, the reek
of week-old sweat. I rise through this, peel back
the full-fat skin of morning, reeling an unclassified
exhaustion, scent of petrol and wet heather. I rise,
boil kettles into breathlessness, and watch kestrels
aviate on unmade wings the bosky fields and scrubland.
I do not sing. I do not speak. Affinity is only telepathic
habit, a redundant and encumbered love that will not
change the world. Oh boys, who vanished over a lean
extremity of water, stirring a sulphate dust in your
veins, skirling, and flirting the limits of extinction,
when sky is oblong lilac vivisected tissue teased
to atomic splendour over the underpass. And the White
Star Line, and the Blackrock Road, with sun and moon
and space dust flaunting the stupored ceiling over Divis,
the botanic gardens, Queen's Quarter, red brick houses
coddled by curfew, and the boys nodding out in
the Student Union bar they went to cadging coin. I do
not sing, I cannot, for those who gave up life to boneless
vertigo, fritzing in the pristine light of hospitals, retching
black emetic against memory. For those who spun their
saturated disciplines in London clubs, in pubs, in
the gutters they groped for stars. Who danced the night's
misshapen shellac, then walked the hairline crack
of Camden canal at six a.m. Boys, who are gone in mind,
screaming in the killjoy iridescence of headlights, whose
vocabulary is choking, whose tongues retarded turbo-folk,
an ill-intended psalm. I cannot sing, unless my song is
leaving. Unless my song a disappointed seed I sow
and grow a better love than this for all my ugly
impotence. And if I sing, say this: that I am you.

Girl, whose contrariness is crutches; who tried
to be bigger than herself on days when fear's
slow-moving motive pointed all knives inwards.
Oh boys, who loved a mainlined radiance Holy,
the dreaded head-rush, high on Sunday's wire.
Disoriented sorceries. When we would sing together,
when we would sack abandoned streets for charity
and silence. Haggard, clamant, knowing only what we
ran from: priests, phone-tapping bogeys, the God-
bothered prerogatives of home. Which is only broken.
Which is never whole. I am you. Cold girl, inclined to
armour. But you would risk intoxication's promise on
a dare. This is for you, a voice whose weight will sprain
your wrist. The brick in the fist. The one we are born
with. There will be no poetry.

IN THE BOOT OF A CAR

Chimene Suleyman is a writer. She's the co-editor of *The Good Immigrant USA* and a contributor to the multi-award winning *The Good Immigrant*. Her debut poetry collection, *Outside Looking On* was mentioned in a *Guardian*'s Best Books list of 2014. She has performed at the Royal Festival Hall, Book Slam, Literary Death Match, Bush Theatre, Latitude, Secret Garden Party, Standon Calling, Stratford Circus, Tongue Fu, Outspoken, to name a few. She also represented the UK for poetry at the International Biennale, Rome 2011. She has written on race and gender for *The Independent*, *Media Diversified* and *The Quietus*.

Chimene Suleyman

I SHOULD NEVER HAVE MOVED. I know this – had known then, yet dislocation comes to those of us with migration in our bones. It had taken the length of a sticky and unpleasant New York summer, our first in our small, modern Brooklyn apartment, to arrange each shelf – to order my books with a kind of innate precision, to display kitchenware we had spent years collecting. The sky may well have been Brooklyn but our apartment was London. There was also the Netherlands, where his family came from. And the handmade Turkish ashtrays, bowls and woven trays, gifts from my parents, or myself. There was my grandmother's wooden spoon from her kitchen in North Cyprus after she had died. There was the artwork my parents had painted when I was a child in Saudi Arabia. I cared more than he did – but, if I am honest, I had hated that Brooklyn apartment, with its small square rooms that made our life seem cluttered within it.

He had wanted us to leave it all behind, in more ways than one. He had thought to sell our things to friends in London, or to store them in the New Cross flat he owned and where we had lived when we were first married. He had seen little point in spending the relocation fee on shipping when, he argued, we could buy them all again. I had refused. You cannot buy the life you have built again. Even if we found the same bespoke carpenters in a small neighbourhood off Flushing, say, and showed them the mango-orange cabinet, its sleek pale legs that raised inches above ground, the wooden slats across two doors that slid to open it; even if they built it in just the same way – every inch, scratch and bend – how could we buy the moment when it first arrived in our South London flat, the morning after we were just married?

I insisted that I would take our home with us, every last piece of it. I would recreate it – a shrine amid the feverish chaos of a city I did not want to live in. So I packed every last item – every cushion, notebook,

picture frame and half-burnt candle – and sent it by boat halfway across the world. In Brooklyn, I carefully organised and then rearranged them. This ritual continued for months. But it would not feel like home. It wasn't the apartment, you understand. It wasn't Brooklyn. It was me. I wasn't home anymore. That is to say, whatever it was to be your own residence, your skin as four walls, your very being as habitation, no longer existed within me.

The year had not been a smooth one. He worked late, perhaps drank late, and I rotated behind a window high up on the seventh floor. Most days I would stand at it, photograph the sun, the rain, sky over the tip of the Empire State, the Chrysler, Manhattan and Williamsburg bridges. We were lucky, I thought. This should have been a good life, and instead we had come to New York for our marriage to end. I had no work visa at this time, no regular income, and we would carry on living together until I did. This is a peculiar thing. A stasis. But we are family, we told each other. We had brought home halfway across the world. Everything changes, but nothing does, and the stillness of limbo has its appeal in such a breakdown. I watched a plane above his head, from the window, as we each admitted defeat. The Empire, the Chrysler, and those two bridges hadn't vanished simply because we had.

We prided ourselves on being a couple who recognised our failings as husband and wife but knew our strengths as friend and friend. We have buried loved ones, we told each other. We have celebrated births, we navigated the world until we landed here together. It felt remarkable to enjoy living like this again. To remember what it was to cook dinner, to watch our favourite shows, without argument. We spoke of moving to a two-bedroom apartment, living as housemates, a fantasy, an absurd one at that.

Remember once more: the years required to finely tune a home, painstakingly building each layer with plates, white or grey, every lamp, cutlery, the paintings – a centimetre to the left, no, a fraction more, just there – each rug, pillow case, the flat-packs and allen-keys strewn across the living-room floor. In a matter of minutes you will pull it apart: *You always did prefer that armchair … you keep it … I paid for the bookshelf, so I will have that …*

Is there not something deeply perverse about the unfairness of time. In one conversation you have assigned years, decades, to two separate piles.

The dress she wore when I saw them is of no consequence, yet, I remember it to be light, short, a floral pattern across its skirt. His lack of expression as he took his cigarettes from her handbag, then returned her black leather bag to her. Let me tell you, a man who is not any good at lying to his wife lies even less well to his ex-wife. Although, I am not sure he said a single word as I stepped away from our building and saw them there. She walked hastily past me, her neck bent back as though surveying a road-side accident. Later, I would try and joke when recounting the moment. She was a woman with a guilty expression, fearful and out of her depth, although she was none of these things. She was a woman on the doorstep of my home, and she was about to come into it. This was, simply, the only fact.

It was impossible to not see it as an invasion. The sole place where my marriage, although over, remained. This was no-man's land. It was time before time. It was London, and North Cyprus, and the sofa of my therapist's Borough Hall office, it was three past relationships, and everyone I had ever loved who had died, it was my first book, and depression, my three godchildren, it was Stormzy music videos, and Kano, Frisco, watched on repeat.

It was mine. Really, it was the only thing I had left. For never give up a job, or career, friends or family, your country, for a person who does not value home.

This entire occurrence took me from fury to fear then rage again. I had forgotten the rules of being a woman, a brown woman, whose every public utterance of anger would add to our collective biography, our typecast. I forgot my way as a person who had worked in middle-class industries of rooftop publishing parties, of an *acceptable* accent I had grown so comfortable in using I no longer knew which words were mine. My voice changed and London was full in my accent. That is to say, 'I am not your wife in this moment, I am not a writer, nor a woman who has learnt to make

small talk with editors and agents, nor a person who is careful to retain my ts and round my vowels as one whose accent is 'English', whose slang does not pass in these New York streets'.

There is a pub under the bridge of East Finchley tube station, where two large men of Italian and Irish decent complain about the quality of beer. I have known them since we were teenagers, and there is scarcely a time they do not offer to break a man's legs if I need it, or to fold someone into the boot of a car. I will spend evenings that spill into early mornings politely refusing these offers. Simply, we had grown like this. In pubs and on road. Disrespect someone, step to them, and watch what happens.

One of them describes an altercation with a man who climbed into his girlfriend's garden, then refused to leave. The other lists half a dozen names of Finchley boys, people they could round up if the situation further needed. Watching them from across a beer-garden table, I understand how I became the sort of woman that empties her ex-husband's account when I caught him bringing another woman into my home, how I came to smash his coffee cups when I returned alone into the apartment, and why I have now become someone who sends a message saying, 'if you bring her back to my yard I will break more than your fucking cups'. No, I am not proud of it, but fuck it, I am also not ashamed. London falls out of my mouth. That is to say, 'here I am, here I have always been, driving Finchley in the boot of a car to every argument, then unleashing it'.

The suburbs rely on boredom as safety from gentrification. In the Tally Ho pub you may still hear old Irish men recount tales of IRA guns buried beneath the floorboards of what was once Victoria Wood's townhouse in nearby Highgate. It is Chinese whispers of a nostalgic kind. When you walk these streets under the shadow of Margaret Thatcher as MP, the singsong of 'Thatcher, Thatcher, milk snatcher', repeats like a nursery rhyme. You are accustomed to the bombs of white vans beneath bridges, or train station carparks. This was 90s Finchley. And in the short walk between Nether Street and Moss Hall Grove, a man in green army jacket and rose-tinted glasses will open his coat to reveal the handwritten sign 'I'm IRA'. Maybe he was. Maybe he wasn't.

Of course, some of this had become mythology at play. These were tales from the mouths of drunks. What I am saying is that there are rituals in war. I heard these first in the looped vocals of RIP Groove and 'It's the Way', pumped from car speakers that knew only the half-beat of fast-mouthed emcees. And so they spoke of the tribulations of a relationship with a woman who sings back, 'You used to love me, now you don't, (I remember, I remember, baby baby, I remember; when you) would hold me,' and Monsta Boy who had not meant to sleep with her best friend, just as Rowena Johnson told us of fast moving men who she would push back on. And hadn't there always been uncertainty in these streets, which Jaheim had warned us of, just as Tubby T sang of his weariness for guns and drugs over a flawless Sticky beat. Remember the puffed chests of Pay As You Go Cartel, More Fire, and Heartless crews, each spitting to us their credentials.

Had any London beat ever been written without a hand that bounced gun-finger to it? I suppose not. These were anthems of negotiation and territory. And the boy who smoked zoots and sold Mitsubishis behind the Bull N' Butcher knew this, just as well as the girl whose baby hairs stuck to her forehead as she snatched from her ears the hooped-earrings.

A society decides the code of honour by first understanding the narrative of disrespect. A futile joke about someone's mother may see you knocked out in Hackney, say, ahead of a man who takes your parking space. The laws of the street are guided by those very same streets. They are changeable by neighbourhood and pertain only to them. You cannot merely walk into the ends and claim to understand its nuance, or what constitutes respect, by having learnt the rules elsewhere.

It is likely that my husband hates my accent. That is to say, it is the one thing that still belongs to the neighbourhood I grew up in. It arrives in the boot of a car, and always has done.

JENNI FAGAN

PLURI-POTENT

Jenni Fagan is a Scottish novelist and poet. Her first collection *Urchin Belle* was nominated for the Pushcart Prize and her second collection, *The Dead Queen of Bohemia* was named the 3AM Poetry Book of the Year. Her first novel, *The Panopticon*, was selected by Waterstones as one of the best worldwide debuts of 2012. Her work has been translated into eight languages. She has been longlisted for prizes including the James Tait Black, Impac Dublin, Sunday Times Short Story and Desmond Elliott Prize, and was named as one of Granta's Best Young British Novelists in 2013.

S HE LOST HER VIRGINITY last Friday and it was shit. It wasn't shit because it hurt or 'cos she was too high to remember why she thought it had been a good idea to lay down, except the stars had looked prettier than she had ever seen. It wasn't shit because she didn't wait to do it with someone she loved, or someone who she felt comfortable with, or even knew, for that matter. Louise doesn't give a fuck about any of that bullshit. She has observed the so-called adult world for years and has no delusions regarding happy ever-afters, movements in the Earth or any of that other crap. It was shit because he filmed it and he never said he would and after she stood up, she felt like a bit of his thing had fallen off and that it was still in there. No-one told her that happened. Perhaps it would come out later. Too embarrassed to ask her sisters who she knew would say that if she's old enough to lie down and spread her legs then she should know these things. She spent the first three days in pain but like most things it subsided, leaving a residual embarrassment and a lingering confusion. Also, a tiny little part of her, a much ignored, resented part, kept on repeating at random, *you didn't even wait 'til you were thirteen*. You threw it away on a cherry-hooked closet-junkie prick and even if you said no, he knew you meant yes, because you wear 'whore' all fucking over you just like all your blood relations.

It was shit.

It's all shit.

Today she is thirteen and this morning her mum gave her a silver necklace with a heart on the end. She kissed her at the breakfast table and looked kind of teary. Tonight Louise will go home and act surprised at the bought cake and her older sisters will stand around bitching in the kitchen but they'll be nicer than usual which means they'll just be averagely

disinterested. She keeps touching the necklace to make sure it is still there. She finds the feel of the cold metal underneath her shirt reassuring. All the way to school she scuffs her feet and they make a gentle swooshing sound on the wet pavement.

The lead weight in her spine gets more intense the nearer to school she gets, until she feels her back must be stooping and people in the street are probably staring more than ever because she is obviously a total freak.

The three girls in 2c that said they're going to kick her head in and film it 'a la happy slap' for complete humiliation factor are standing by the school gate smoking. She swerves sharp left and wriggles her way into the middle of a bush. She doesn't feel the twigs scratching her legs and hands as she pushes in. Just now she is numb with cold and the heavy emptiness that sits inside her, growing ever larger by the day. She struggles to pull out a Regal that she'd stubbed earlier. She can smell the rich, burnt-metallic scent from her pocket and on her fingers as she lights it. It takes three matches to light the half fag as her fingers are numb and look like raw chipolatas from the cold. On the third shaky strike, she catches the blue flame and inhales, savouring a fleeting victory. If anyone was standing far enough up the hill behind the school, they would see smoke coming out from the top of the bush. Nobody climbs up there except for at night to get fucked or every once a while for a fight after school. Her legs are covered in goose pimples. It's only October but it's freezing. She's still wearing summer clothes because the only winter coat she owns is a skanky duffle. Her physics teacher who everyone thinks is a total paedo has one just like it. He took a class yesterday morning on how long it would take for both a feather and a car, dropped at the same time, to hit the ground. She thought that he should try weighing varying sizes of emptiness. She has an empty chasm in the middle of her chest, which she imagines is probably where her heart should be. It grows heavier by the day. Nothing shifts it. Not throwing up. Not Es, not speed, not smoking till she whiteys and feels she's left her body behind. She did that on the Friday after–. After you know, she'd left him standing in the street wearing a non-committal smirk. She'd never felt scared by her own anger before but for a second she wanted to take out the pen from his shirt pocket and stab him through the eye, stick it in real deep and twist it and then walk away, throwing over her shoulder her own cool, non-committal smirk. She didn't. These fantasies always come later. She replays them at leisure adding a flourish here, an extra cool cutting biting

remark there. She always comes out on top: clear, concise and hard as fuck. Not like how it happens in reality. Fuck. She watches as the girls go into class and sighs, as that means she'd better skip. She can see them already in the Home Ec. department.

They arrange themselves on the tables with their shorter-than-short skirts, re-applying lipstick and glowering at poor Miss Henry who has a heavy moustache and the shadow of a beard. They pose, sticking their flat tits out and riding their skirts as high as they can. They roll their eyes and perfect their practised-bored look, blasé, permanently unimpressed. She pictures them walking in naked and licking each other out 'cos they all think they're so fucking amazing. Fucking cows. She will not live in fear. Avoidance is just a survival strategy, for now, anyway. She shuffles backwards out of the bush and one long branch slaps her near her eye as she emerges back onto the path. She touches her face and there is a smidgeon of blood, a tiny shock of colour on an otherwise bleached out morning. She keeps her head down and nimbly picks her way through the crowd, pushing against the tide. Yeah on the Friday she had gone and stood in the bus stop shelter to come home. It had been raining and she'd smoked joint after joint 'til she couldn't feel the E anymore and she just felt all her limbs turn into a big angel delight sogginess that crumpled her up until she lay on the floor of the shelter staring along the road. The road was slick and wet with rain and the streetlights were reflected in it like large, orange, shimmering, alien orbs. Every time a car went by it sent a little tidal wave through the reflection that distorted the orange light outwards. But the light always contracted back to its original, round, shimmery shape. She felt already that she perhaps too could distort her mind and body with chemicals as much as she chose but somehow she would always come back to her original shape, self, reality. Fuck it. Was worth a try. Like the rectangle guy – she doesn't know why they call him that – who everyone knows took too much and never made it back. He got taken away after smashing up the bookies and trying to batter the garage windows in. They put him in the nuthouse. Now when he stops at the garage to say, 'alright', everyone looks sorry for him but also kind of edgy 'cos they don't want to catch it. They nod and then try and ignore him as they smoke themselves blind and shovel whatever they can afford down their throat or up their nose or into whatever receptacle. She doesn't like needles and her eldest sister lost her baby on the smack and she thinks smackheads are fucking

boring anyway they just nod and sleep and doze 'cos they're all fucking zombies. Crackheads are the opposite with that demonic power-energy, followed by an all-consuming paranoia.

It's all shit.

She has decided to go and skive at the river all day. First, she will walk quickly to the garage so she can get ten fags, two packets of pickled onion Monster Munch and a bottle of cream soda for lunch. Those are three of her favourite things, although lately a cardboardy taste has crept even into them.

The leaves on the forest floor are wet and soggy so she walks until she finds a flat tree trunk to sit on. It's wet also but she sits anyway, and the damp immediately seeps through her skirt. She smokes three cigarettes in quick succession double drawing each for a cheap and easy morning buzz. She wonders if she should stop now. During her homework tutorial on Tuesday she had gone online pretending to find out stuff for class but really it was so she could look up the cellular development of the foetus. Apparently, the human desire to form a functioning mammal out of cells is so strong that it begins from the first embryonic instant. The heart that she feels beating now against her chest may in fact not be the first heart she manufactured. It may be the second or third, or perhaps even fourth heart. The others deemed not good enough or strong enough would have been discarded as the cells tried again and again to regroup into the strongest, healthiest version of themselves possible. She is the result of the most perfect amalgamation those cells could muster. Somehow, she feels cheated. She feels ugly. Not good enough. She continuously tries to better herself in subtle ways, such as stopping biting her nails and giving up eating chocolate, to clear her skin and whittle down her already-narrow waist. Louise cannot see that her own eyes are pretty. She may be somewhat plain compared to other people, but she has an honest face and an athlete's figure. She does know though that she doesn't want to end up like her middle sister, full of plastic and silicone and cow's arse fat; bleached-blonde locks and extensions from some poor fucker who had to sell their hair and for all that she looks like a sickly, badly manufactured doll.

She feels her waist. Sticks her thumbs into the grooves of her jutting hips and stares into the water which gurgles and races over a large stone cleansing it again and again and again. She thinks of the cells and how somehow, she knew they were there straight away.

Does this make her a cliché? Or a to-be cliché? Not the youngest though, not by quite a way. This is comforting. It's not that she thinks it won't be hard as she knows it will and she will certainly have to hide it 'til after they can make her get rid of it. Probably she'll wait as long as she can, just to be safe. It's her body though. She was old enough to lie down and spread her legs and she knew it could happen. She knows a fact like that would enter the void in her heart and expand it into a vortex that would swallow her whole. She will nourish the cells. She has kept the money she would have spent on hash and is going to buy folic acid, which she saw advertised online on the cells page. She will buy calcium next week and vitamin supplements the week after. She will stop eating coleslaw and mayonnaise. She doesn't want to lose hair like her Mother said she did, or bone density or teeth or develop big ugly veins. She thinks that she probably will get some of those silvery marks that still snake across her mother's hips and stomach, but she knows it won't be so bad because her skin is tight and will snap back like elastic. It is day six now and the cells have the ability at this point to form virtually any type of cell. These kind of stem cells that have the potential to develop into any human cell type are called Pluripotent. She rolls the word around in a whisper and it disappears through the whistle of the trees. The sun is dappling the path now and she stretches her bare legs toward it. She wills the cells to strive for perfection. She says in her mind over and over again, 'you can do it! Don't settle for less. I'll settle for less if you promise never ever to do so, not even from day one'. She thinks this is a fair deal.

She flicks a cigarette butt on the forest floor and resolves to quit after this pack. She sucks on each Monster Munch, the pickly goodness producing a flood of saliva to wash away her acidic reflex. There is still an hour and ten minutes to go before the lunchtime bell will ring and she can go and hide in the school library and read up some more.

Somewhere in her throat the threat of tears present themselves as an angry persistent lump that keeps returning. She forces it back down.

It wasn't meant to be like this.

It's all shit.

Except the cells. The cells will not be shit. They will be perfect. Each and every atom. Each and every tiny striving fibre. Complete perfection. It gives her hope. Her embryonic secret makes her smile.

LONDON UNDER- GROUND

Courttia Newland is a novelist and playwright, born in London to parents of West Indian heritage. After initially working in music, Newland published his first novel, *The Scholar*, in 1997. He has since written several more novels, as well as editing multiple anthologies and publishing two of his own short story collections. In 2007 he was shortlisted for an award from the Crime Writers' Association and nominated in 2011 for the Frank O'Connor Award. As a playwright, he was shortlisted for the Alfred Fagan Award in 2010. He is also an associate lecturer in Creative Writing at the University of Westminster.

Courttia Newland

I WANT TO TALK ABOUT LITERATURE that was once 'underground', which I take to mean marginalised and not part of mainstream culture, with a particular focus on Black working-class fiction. In thinking about *that*, I began to dissect my own literary practice in terms of the formation of my aesthetic and to do that, I had to analyse two things. First, how I might escape the aesthetic confines of literature and embrace a broader view of the arts in general. Second, the reality that to truly take stock of how I did this, I had to go back in time and share my personal journey through art – what I was exposed to, why I was exposed and how that in turn informed the art I produce. So if you can bear with me, I'm hoping that'll take me right up to where we are today and what I am attempting to achieve, mostly through cross-genre forms, although I must stress I'm not suggesting that's anything new – indeed, artists worldwide have done this for centuries.

A few years ago I attended the 'Teenage Kicks' conference at Keele University, where I saw *Made In Birmingham* by Jez Collins, a documentary on the rise of Punk, Reggae and Bhangra in the city of the 1980s. While many reggae bands such as UB40 and Steel Pulse cite John Peel as a major facilitator of their entry into mainstream culture, I remember hearing the distinctive voices of Tony Williams and later David Rodigan on Capital Radio in my childhood, who played the reggae hits my parents loved. Back then, I believed it was the only mainstream radio station to play this strange form of music, which I rarely saw on *Top of the Pops*. As I was only six or seven I'm not sure how well my memory serves me, but I know it was my first introduction to Rodigan, the now longstanding reggae DJ.

Rodigan played on a Sunday, around lunchtime. It was an almost a religious experience for my family and me. We would eat a dinner of rice and peas (I hated peas) and most probably curry mutton or chicken, while

Rodigan played loud on the radio and my parents danced and reminisced. Music came from artists like Sugar Minott, Dennis Brown, Gregory Issacs, Peter Tosh, and also 'toasters' – later known as DJs, or MCs – Yellowman, Big Yout, Eek A Mouse. Yellowman was the star, a latter day equivalent of Shabba Ranks, Beenie Man or Vybz Kartel. In hip hop terms, read Kanye West. For that Sunday afternoon, Kingston, Jamaica came to Uxbridge, Sussex. We were one of two black families in the neighbourhood. Even though we listened to Capital, I was fully aware how different the world that came through the speakers was to my immediate surroundings and how isolated that difference made me feel. It was a monumental shock when I picked up an album cover to learn Rodigan was white, years later – but that's probably a whole other essay.

I was very conflicted as a child. I disliked the singing form of reggae, much preferring the toasters. Eek A Mouse's falsetto crooning style was a favourite. I also liked Adam Ant and Shawadywady and I watched Big Daddy on *World of Sport* every Saturday morning. None of my Uxbridge peers listened to the music my parents played and so it became a secret, one I guarded seriously, keen to keep my obvious difference hidden from them. The only time I heard reggae played in public was at the blues parties my dad took me to and in the car, either on cassette tape or pirate radio. I didn't know that it was pirate radio at the time, but looking back, I realise how instrumental those unlicensed radio stations were to the formulation of my artistic sensibility.

Pirate radio, or community radio as it's now called, was all over the airways when I was growing up. We only picked up the stations on our dial when we came to visit my grandparents in London (which is why my parents listened to Capital at the weekends to keep abreast of what was new in the world of reggae). LWR (London Weekend Radio) and Horizon were the ones I remember most, although both worked according to the former's acronym, broadcasting from Friday evening to Sunday night. They were notoriously hard to pick up, even more difficult to stay tuned to. They mostly played reggae but also funk, disco, and very early rap. I heard my first hip hop record in the back of my Dad's car, mesmerised, straining to listen while the adults talked loudly over the song. Some of these artists made occasional forays into the mainstream charts, but for the most part what was heard on the pirates stayed on the pirates. This initiation coloured my artistic tastes forever. Much as I loved Adam Ant and much as I used to

sing Prince Charming at the top of my voice with a white ribbon held across my nose, nothing moved me like the songs I heard in my father's car. I was hooked on art that went under the radar.

A side note – many, many years later my mother exposed me at my own wedding (in front of hundreds of people, Mum) by getting the DJ to play Prince Charming and telling everyone it had been my favourite record. Thanks Mum.

Fast-forward six years to me at twelve years old. My parents are divorced and my mother, unable to live alone in a racist town and concerned that I was losing my identity, moved myself and my younger brother back to West London, where I was born. I'm in the second year of secondary school; that's Year Eight in today's terms. I'm standing in the playground and a kid has just challenged me to a rap battle. I've agreed to meet him the next day, lunchtime, in the boy's toilets. There's only one problem – I don't rap. Some kid called Selwyn, who's in my class and doesn't know me very well, escorts me back to registration assuring me that I can take my new enemy. Neither of us has any idea that we're about to form a rap crew, then years later a drum and bass production team, or that we'll be friends for the next thirty five years.

I remembering attending Notting Hill Carnival, where I'd sat on my father's shoulders and heard Grandmaster Melle Mel's *The Message* blast over a rippling ocean of heads stretching along Portobello Green, under the Westway and away towards Notting Hill. I'd heard Dougie Fresh and Slick Rick's *The Show* at a subsequent Carnival, dubbing a mixtape that was passed around school before they went on to perform on *Top of the Pops*. The mixtape, for me, is a blueprint that helped shape an underground culture in the souls of generations. It spoke to us in a language that, although we didn't entirely recognise, we discovered had many parallels with our own language and experiences. I was struck by how much music remained on the pirates and how much of it was just as brilliant, if not more, than the music that made it out into the mainstream. I began to sit before my own radio, twiddling the dial, pressing down 'pause', 'play', 'record', then lifting the pause button.

I won that battle, by the way. That led to parties in parks, performances by me and my DJ Selwyn, renamed Sledge and finally, in a bizarre twist of fate, me being led by another secondary school friend, a graffiti artist called Kaze, to a huge party in the Astoria nightclub called Energy. I

was seventeen years old and I was blown away. It was like being back at Carnival with bass vibrating my ribcage and it was also like nothing I had seen before. That was the early days of rave, circa 1989, which soon become hardcore, which become drum and bass, which became jungle. I could go on and say, *'which became garage, which became funky house, which became broken beat and eski or grime, which became dubstep'*. I can go on for ages about the myriad underground music forms London has undergone in the last three decades, but that's a major digression. Suffice to say, my major inspiration in art came primarily from music and that music was steeped in a sound system culture that is underground by its very nature and, I would hasten to add, by necessity. The music's survival depends on being kept in the dark, in nightclubs and warehouses, away from the debilitating glare of mainstream culture. Many a scene withered as the wider forces of commerce subsumed it. One contradiction is grime, evidenced by artists like Dizzee Rascal, Skepta and Stromzy, who became international stars precisely because, in my view, the scene they came from was driven back underground, where it was believed to have died, only to return focussed solely on its own aesthetic, and slayed.

So how does this pertain to literature? Let's return to my second-year classroom and my favourite lesson, English. There Ms Jane Youlton, a teacher fresh out of teacher training and in her first class, dumps a plastic crate of books on the table and says that since some of us like to read, here are some novels she thought we might like. She was right. None of those books were on the curriculum as far as I knew and I'm not sure if her move was down to ILEA (Inner London Education Authority) recommendations or her own choice. I'd never heard of them, or the writers, before. Technically speaking, these books were *underground*. There was Chester Himes's *Real Cool Killers*, which I grabbed and immediately loved, setting something off within me that remains to this day. There was *The Bluest Eye* by Toni Morrison who, interestingly enough and difficult as it may be to imagine now, was as unknown as Himes back then. And there was also a Black British book published by an indie press, something that spoke specifically about being of Jamaican origin and living in London, something I wish I could remember more details about, like the title or the author's name, as I think it too was instrumental in setting me on my literary path. All three books were, actually. There were over twenty novels in that crate, but that's what I remember most, those three. And of them, the one that spoke to

what I believed to be my own working-class background – the British novel, even though I've forgotten everything else about it and it remains the least well known – was the most resounding. It was a sub-subculture within a sub-culture. With regard to Black British writing, I'm not entirely sure how much has changed. It was the sincerity that struck me, the ability to tell a story I recognised *in its entirety*. I could relate without distinction. I hadn't known that was possible before.

Ms Youlton was the teacher who told me I'd become a novelist when I was older, which led me to believe she was crazy – one of many arguments we had over the years, as I did what most typical teenagers do, rebelled. Fuck that, I wanted to be a rapper. But what I find most interesting about that story is the symbolic echo between the crate of books my English teacher presented to a group of majority Black teenagers, and the hip hop term *digging in the crates*, ubiquitous throughout most contemporary music forms that mark the DJ as its central component, particularly underground music. Paraphrasing for a moment, the term loosely translates as 'raiding the past in order to find something useful for the future'. Hip hop DJs of the late 70s and early 80s New York house parties would dig in their parents' old record collections to find 'breaks' – instrumental bridges of jazz, funk and soul records that would get the crowd dancing and led to the term 'breakdancers'. Later, in an attempt to perfect their craft, they dug through record store crates to widen their musical knowledge and unearth 'lost' breaks. Unconsciously informed by this, in as much as that I had no idea I was to become a novelist, I enthusiastically leapt for Ms Youlton's crate of books, where I discovered my own future artistic template.

By the time I struck out to become a novelist, I'd been heavily engaged in digging practices for a number of years, musically at least, as I had become a rapper and producer. I was also conscious of an underground aesthetic informed by my earlier tastes. I shunned anything mainstream and went as far underground as I could get. By then the music I listened to came by way of independent labels and pirate stations such as Fantasy and Kool FM; my art was found on city walls; my parties discovered via phone calls and mile-long convoys, held in fields and warehouses where you had to keep half an eye out for police raids and undercovers. It was a vibrant, stimulating world. I was beginning to realise no one was capturing what went on. When I began to write, it was this sensibility that crept into my work, the idea that I wanted to uncover an unknown world that lay on so

many people's doorsteps. Tindel St Press first published one short story, *Sound of the Drums*, in the anthology *England Calling*. *Sound of the Drums* was later published by Peepal Tree Press in my own collection *Music for the Off Key*: note that these are both indie publishers. The story was based on an actual rave I went to in Canary Wharf that was eventually shut down by the police. When I wrote, I moved the rave outside of London and took the head count of ravers from another bigger party, Castle Morton, that had taken place a few years before and made headlines. But everything else in the story was factual, had actually happened and I believe if I hadn't written it down, would have been lost forever to underground myth and folklore.

Working-class literature today, as it was in its nineteenth century beginnings, is steeped in an existentialist ethos born from a shared sense of what Ian Haywood describes in *Working Class Fiction* as, 'exclusion, absence and denial of fundamental rights'. Artists in general, but most especially writers, thrive on the margins and so it stands to reason that the working-class author, privy to worlds upon worlds, a 'Society Within,' to borrow the title of my second novel, would feel compelled to bring these marginal spaces to life and into the realms of a reading audience. These stories are artefacts unearthed to provide answers about communities that might not have seen sunlight for many years. The underground. They are a means of communication between those who share the same experiences and also, perhaps consciously or not, go on to become the very blueprints I held in my hand when I made my first cassette mixtapes. Although literary in form, these plans are a means of viewing the world through a lens that can be contrasted and matched with our own.

Is it any surprise then, that many lost fictions of the past detailed working-class lives? The *London Fiction* anthology and its accompanying website is a compilation of essays written by writers about past 'lost' works and includes well-loved favourites such as *Absolute Beginners* and *Brick Lane*. It seems a thirst is growing for these old absent works, but what about the marginalised or underground authors of the here and now? What about those who are part of the resurgence, whether persistent or fleeting? We must value each other while we are here, or risk losing a vital part of our literary culture.

Sam Selvon's *The Lonely Londoners*, a seminal novel of West Indian working-class migrants circa 1950 was my ultimate blueprint, the final piecing-together of a fictional puzzle that pushed me bodily onto my literary

path. Set in West London, the place I lived and wanted to write about, *The Lonely Londoners* concerned the underground first generation West Indian community. In time, I would write about their descendants. Sevlon uses authentic dialogue and this 'permitted' me, in a literary sense, to use my own contemporary London vernacular that helped bring the originality and vibrancy my novel needed. I am forever indebted to him and the thousands of other novelists I read, alongside the art, the music and drama I saw.

Now, interestingly enough, there's a renewed focus on working-class writing. Yet, while writers of colour win prizes and become bestsellers and make awards lists, there seems an odd tussle for acceptance as we attempt to make space. Are we truly considered working-class, or is that term set in the stone of past definitions? When we write, do we cease to become working-class at all? Are we actually a new generation of multicultural working-class artists the literary world has yet to reckon with in any true manner? I happen to believe this last, but I also think that if we are to succeed in any real way, is will be through staying true to who we are, our multifaceted heritage and what that has made us, without allowing it to dictate where we will go, what we will do. For the first time as far as I can remember, my bookshelves heave with the voices of British working-class writers of colour. We must let the world know who we are.

WILEY

LYRICS TO LIGHT THE WAY

Wiley is a British MC, rapper and record producer from Bow, East London. He is regarded as a pioneer in the British music scene and as a key figure in the creation of grime music. Often labelled the 'Godfather of Grime', Wiley has released twelve albums and has had numerous chart hits, including a Number 1 single. His autobiography, *Eskiboy*, won the NME Book of the Year award. He has also won an Outstanding Contribution to Music Award from NME. Wiley was appointed an MBE in the 2018 New Year Honours for services to Music and also received an Ivor Novello Inspiration Award in 2019.

STORMY WEATHER

Stormy weather
Stormy weather
Stormy weather, ah, sunny day

That's why we're the best, have a conflict
Then we go and do somethin' fresh
Don't get tested, levels are way higher
I shoot for the target, call me aim high
Merk guys on the mic and up the hype like
Wiley, Wiley you're on a hype
Shut your mouth blud, I was born on a hype
See, you don't know this could be your last night
I'm passed right, I'm on another level you can't see
That's why you can't dark me, joining N.A.S.T.Y
Won't work NJ, I've heard two dubs, none of them marked me
I'm hardly touched, I've got an army though
They'll rain on, how'd you think you got your chain on
You shit bricks when I bring the pain on
Better switch your brain on, you can see I'm way gone
Look back the game's gone, you got caught up in
Stormy weather (Eskiboy)

That's why I'm a grafter, the Tai Chi master
Don't know now you will realise after
I've made my mark with permanent marker
I've made history like the Spanish armada
You can't say that my style ain't harder, hot like Nevada
I ain't dead like the Wiley and Lethal saga, nah, I'm a leader

I lead the cattle like a farmer
See a girl once, she'll call me a charmer
Stage name's Wiley, my second name's drama
I'm here for a laughter, just like Trimble
Centre court Wiley's a don like Wimble
Album's doin' well so I want a grime single
Can't wait, I just wanna do my single
Why should I listen or mingle with a label
That's not gonna do a grime single
Stormy weather (Eskiboy)

When I merk one of them twenty man back it
You won't see me in a protection racket
I know the road's hard, I know you can't hack it
That's why I've got to teach you, always back it
Even if you're scared, I'll be there, I'll back it
I'm a soldier, I'm older, I cause road traffic
You crew won't manage but wait, don't panic
Go home and tell yourself you won't have it
Guns do bang innit, I ain't sayin' go home
Get a gun and come back and start bangin' it
But if you go that way and get the hang of it
My words to you will be you're not havin' it
F the western, F the system, I don't care
I've got my own system, are you listening?
The weather won't change, there will always be some
Stormy weather (Eskiboy)

That's why I'm still a fighter, the star in the sky
That shines brighter, the east side rider
Hyper like kitchen micra
It's a shame how people ain't tighter
We can be a powerful team so what we doin' then?
Everybody tighter, gotta be a fighter
I came from the drain so, if you come from there

Then, push up your lighter
Look, there he goes, it's E3 boy
It's the second phase, more Ps for the boy
You're never gonna take no Gs from the boy
'Cause he ain't one of them boys, believe in the boy
There ain't no chief in the boy
He's got a lot of anger inside to release on a boy
That hates him for the wrong reason
Can't get along with the boy, don't chat to the boy.

ASCENT INTRO

When I stepped in the scene I was always
Gonna get achievement to my whole ways
I fought music everyday all day
Flew out to UK, got a blank CD
Sheep from a traveller
Bitch I was stable
Here we go man never on the table
I've came a long way for my plain cheese bagel
Used to go big real quick any time of the week
Have you got to be livin' it to speak it
Have you got in it if you peeking
Have you gotta be awake when everyone is sleeping
Getting double I was in no sleep
Get my CD to solo it's lonely
But then again I'm like nobody owes me
To lead or to cry tryin' all key
I don't get into what don't involve me
I ain't nosey

Time flies when you wanna help everybody
Turn around now look at your anybody
Turn it round don't look I'm a somebody
One spirit, one brain, one body
One heart, one ending, one start
Skips a beat when you hear a gun spark
Our safety's never been an option
That's why we took the other option
Only have a side of the lower back
This scar only have a side on my draw
Couldn't lead me astray, based in a cage

My time is a healer
Erase the waste, erase the bad vibe
I ain't perfect but I'm not bad man
Every dog has a day
That's why I ain't frontin'
Like I never had money

Respectful how I was raised
You ain't gotta sing my praise
I know the Lord awaits me
So let me live for the rest of my days
Guide the lost in the journey
I told him once he never heard me
I was like them hardheaded
Can't be living off all my past merits
Respectful how I was raised
You ain't gotta sing my praise
I know the Lord awaits me
So let me live for the rest of my days
Guide the lost in the journey
I told him once he never heard me
I was like them hardheaded
Can't be living off all my past merits.

FAMILY QUESTION TIME

Omar Hamdi is a Welsh-Egyptian TV presenter, comedian and writer. He has completed a national UK theatre tour, as well as performing at various festivals and clubs around the world. His work and TV programmes have been well received and won a BAFTA among other awards. He has been recommended by the National Union of Journalists as 'a talented comic commentator on topical events' and by the *Telegraph* for his 'shrewd insights into multiculturalism'. His writing has been published in the *Independent, International Business Times* and *New Internationalist*.

Omar Hamdi

C LASS IS EVERYTHING in the UK. It's our most cherished institution and I bet it will outlast everything else. In an apocalyptic future, when the few survivors scrummage to survive on an island ravaged by either climate change, war or a chicken shortage at KFC, we will still be taking the piss out of each other for our accents, and Oxbridge graduates will still be the ones deciding who gets the most rations – especially if they're organic.

Class is the last bastion of fatalism. This is probably because it's so hard to fake – the middle-class have an effortless, imperceptible way of letting you know who they are, to the point that you blame yourself for thinking it. In 2019, every other identity can be transient or blended. Gender can be transitioned. Sexual orientation can be fluid. Race can be mixed. But your distinct class signifier is always there.

Class is our social DNA and you can't help but pass on at least some of it on to your children, whether they want it or not. The way they talk, the way they walk, the way they sit, the way they shit, the way they stand, the way they stand up for themselves – that's class. But don't worry, there is a way out: send your kids to private school. If Eton is out of your price range, you can raise your kids on a

The way they talk, the way they walk, the way they sit, the way they shit, the way they stand, the way they stand up for themselves – that's class.

concentrated diet of Middle-Class Media Immersion. They can become strangely obsessed with baking, a hobby that is impossible to follow through on if you have a kitchenette and work three jobs. Or they can tune in to *Gardeners' Question Time* and pretend that tulips are as important as sectarian conflicts in the Middle East.

Your children will definitely be as obsessed with class as you are. It's impossible to get away from and almost impossible to change. Some politicians have tried and failed to change class structures: those on the Right want us all to aspire to climb the social ladder even though a lot of us just don't have the resources or know-how. Splashing, it must be said, is not the same as swimming. Those on the Left think that they can spend their way out of social stratification, not taking into account that not only is class not *just* about money, it is about almost everything *except* money (just ask a lottery winner from a council estate about this).

Not only is class not *just* about money, it is about almost everything except money.

Class is impossible to ignore, because we are in a country built on it. When the cornerstone of Britain was laid, there was a clear distinction between the man laying the stone and the man supervising him. Britain, like all modern nation states, is about power. The English asserted their military, language and culture over the Welsh, then the Scots, then the Irish. Then they got started on everyone else. If nothing else, the upper-classes know how to test a small-scale home business before taking it global.

This is one of the reasons why we don't quite get on with our transatlantic cousin, America. We are about class; they are about race. We were built by domestic and then international power; they were built by immigration which, with the very noticeable exception of slaves, offered all their citizens more or less the same start. That's why when I'm on stage in a comedy club in the UK, I talk about class, and when I'm in the States, I talk about race. Funny accents are only still funny over here if they're poking fun at someone who is from a different class to you. Take the comedians Al Murray or Simon Brodkin AKA Lee Nelson, both of whom went to top

universities and have become millionaires thanks to their impersonations of provincial chavs.

But all this intellectualisation is a sad attempt for me to put off the big question: am I working-class or middle-class? Looking at my biography, I'd definitely be middle-class except for one thing: I am not white. The relationship between race and class is complicated, abusive, even. 'Working-class' conjures up images of, well, poor white people. No one ever talks about black or brown people's class. The roots of their problems are always the backward cultures they brought with them, not the poverty imposed on them here. And we never seem to say, 'We're entitled to our chavs too'. That would be very rude. Try to type 'working-class brown person' or 'working-class black person' into your mind's Google Images. Who comes up? Is it the same thing that you see when you search for 'brown person' or 'black person'?

The charge sheet for me being middle-class is long. I grew up in a cul-de-sac in one of the nicest suburbs of Cardiff. My father is a university professor and my mother works for the Home Office (how ironic). I grew up surrounded by books and encouraged to debate a lot, both skills which I've managed to monetise in adulthood. My dad

No one ever talks about black or brown people's class.

is a fiercely political man and we grew up hosting 'Family Question Time' every night (there was no Dimbleby or Fiona Bruce. There was mayhem). So, I inherited quite a bit of what sociologists call 'cultural capital' from my parents, which has contributed to my being able to blag my way into a media career. Wait, that's the mistake. I said I blagged it. If I was truly middle-class, I would have said I'd earned it; that the BBC are lucky to have me and that my appointment definitely had nothing to do with ethnic quotas.

There's something in my emotional wiring that means I will never be a media native. I'm often asked why I'm so happy when out filming. The answer is because I work in TV! Isn't that amazing? But for a lot of my colleagues, I'm not sure it is the answer. For some of them, a glitzy media

I have no expectation that anyone will do anything for me, other than give me condescending language I can limit myself with.

career might be par for the course (I'm sure they'd appreciate the golfing metaphor).

My residency in Medialand is similar to the residency most people who come from where my parents come from get on arrival: temporary and conditional leave to remain. One foot wrong and you're out. And you can forget about the prospect of receiving the juicy contracts others get. The subtext is always, 'You should be grateful to be here at all'. And maybe I should be. Ethnics are under-represented in the media. Maybe me dreaming of any position other than 'Whacky Ethnic Sidekick' is not only unrealistic but downright dangerous. How much diversity can the average BBC One viewer handle? There's an Asian family in *Eastenders*, and surely Romesh Ranganathan has done enough TV in the last three years to make up for all the racism in the previous thirty? Shouldn't we quit while we're ahead?

A media career is tricky to begin with and requires much more than talent or hard work to make it work; what you need is patience. Patience is much easier to have when your bank balance is solid, of course. On the flip side, those of us without huge amounts of money or connections but that are still crazy enough to do it will, naturally, stand out. No one recognises how hard it was (or is) to get here.

The one thing that is definitely working-class about me is the hustle. I have no expectation that anyone will do anything for me, other than give me condescending language I can limit myself with. I have a DIY attitude: I got my first agent not by being spotted at a trendy industry showcase or by doing drugs with the cool kids: I spammed her. I got my first international TV presenting job not by being fast-tracked to my own series: I started a production company, invested my savings, then sold it to a distributor.

Of course, real working-class people will question my credentials. They'll tell me I wouldn't last a day in the rougher parts of Glasgow or Teeside, to which I would respond that they wouldn't last ten minutes in the rougher parts of Egypt. On a UK level I might be 'mixed-class', but globally speaking, Egypt is definitely the 'hood of the world. It's all relative.

David Loumgair

DEAR BRITISH THEATRE

David Loumgair is a theatre director and dramaturg. Born and raised in the Scottish Borders, his work seeks to explore the diversity, complexity and positivity of working and under-class experiences across Britain. As well as supporting multiple established creatives as Associate Director, David has directed new plays and revivals across multiple Off-West End and regional theatres, such as the award-winning rivival of *Tiny Dynamite* by Abi Morgan at the Old Red Lion Theatre, London, in 2018. David is the Founder of COMMON, a leading national arts organisation established in 2018 to support the UK theatre industry in achieving greater intersectional, socio-economic diversity.

Dear British Theatre,

When I was young, I didn't know who you were. I didn't know what you were. I didn't actually see a play for the first time until my late teens, and to be honest, even then I wasn't all that fussed about you. Put simply, when I was a child, my family had more immediate concerns than going to the theatre. I've learnt a lot about you over the years, but I realise that you know nothing about me, or the millions of others in this country from backgrounds like mine. This is why I felt the need to write you this letter. It's important that you know the reality of what it means to come from a background like mine. All our experiences are unique, and I am not speaking on behalf of everyone who may have had a similar background to mine, but it will be a start to tell you my own story, as you'll have rarely heard one like it before.

In recent years, when I've spoken to my mum about what I do and we talk about what life was like when I was younger, she will tell me that we lived a 'hand-to-mouth existence'. The worries were always the same. We worried about how to afford the next rent payment. We kept a detective-like eye on our weekly food budget. We struggled to afford the extortionate – and it was bloody extortionate – cost of my school uniform.

My mum worked exceptionally hard. Don't you dare ever try to tell me that she didn't. As a single parent, my mum did absolutely everything in her power to make sure I was provided for. She was a Marie Curie Nurse, now a palliative care nurse, and looks after terminally ill patients for an insulting amount of money. I would challenge anybody to do that job, on that wage, and not realise that something urgently needs to change in this country.

These are facts, as is this: I had the most joyous upbringing. I spent many years being raised on my grandparents' beautiful farm in the Scottish Borders; a couple who were married for over fifty years and adored our small but tight-knit family. Every weekend I would beg to be taken to the local library to swap my stack of books for a new armful ready for the week to come. My family and I would cut out holiday offer clippings from our local newspaper and go on caravan or camping trips in the Highlands which, to this day, remain many of my fondest memories. This was my culture: books, television and any free or reasonably affordable trip that my family and I could take together. You, theatre, were not part of my culture.

It is only in the last few years that I have begun to refer to myself as someone who was and proudly remains 'working-class'. When you're raised in those communities, it's just not something that you refer to yourself as. I certainly didn't run around as a child telling everybody I was working-class. Mum and I wouldn't have dinner together and say: 'Oh, isn't it brilliant to be working-class? I can't believe we got so lucky.' Being working-class is tough. That is, without question, a colossal understatement. But I wouldn't change where I come from for anything in this world. To be working-class is to feel an immense sense of pride in the values and communities that you were raised by and a connection to the fierce and ferocious history that you are a part of.

Perhaps my family and I didn't have a huge amount of time or money to spend on what you define as culture, but I can tell you what we didn't want to do with the little we did have. We didn't want to sit in silence in a dark theatre, not invited to join the conversation, listening to other people talk at us, about something that wasn't relevant to our lives. You do not represent my communities. You do not represent my lived experiences. You do not represent my class. You do not represent my family. When you do attempt to represent my class and the people I know personally, it is through a lens of insulting and quite often politically dangerous stereotypes.

It makes me unbelievably angry that drug dealers, criminals, violent thugs, prostitutes or 'sluts', chavs, racists, skinheads, benefit frauds – all parts written as unintelligent and irresponsible – are who you believe make up the working-class. What you show is not 'gritty', 'raw' or 'authentic', but base and simple poverty porn.

Fast forward a couple of decades and then some, and here I am working in theatre. If you'd have told me when I was wee what I would end up doing, it's the last thing I would have expected. My journey into the industry began with one of my closest friends applying to study English and Drama at university, and after reading about the course it sounded bloody brilliant. I adored reading and, despite knowing very little about it, I was interested to learn more about drama, so I decided to apply too. When I was accepted, I packed my bags and went with my mate to that university, but quickly realised how out of my depth I was.

I'd heard of very few of the novels taught on the course and I'd heard of absolutely none of the plays, whilst many of those around me had. I felt like an outsider. I felt like an imposter. But in the end, I buried those feelings of insecurity, of realising that I hadn't had the same 'cultural exposure' as

those around me, and I tried to soldier on as best I could.

Oddly enough, I did eventually grow to love theatre. I saw how the stories and the characters I read about in novels could be presented live to an audience and how people could watch the story unfolding in front of them and respond to it in real time. I wanted to shape how those stories were put on stage and to influence how an audience received them. It led me to decide that I wanted to work in theatre. I thought that with hard work, with determination and by continually building my knowledge and my skills, I could succeed. How wrong I was.

Today, many years later, I am trying my damned hardest to build a career as a theatre director. I've been doing it for quite a while now, and as someone from a working-class background, I'm not going to lie, it's fucking hard. I have encountered barriers that many of my peers could never even imagine. Professional barriers. Psychological barriers. Emotional barriers. Financial barriers. Ideological barriers. Social barriers. Cultural barriers. Identity barriers. Geographic barriers. I don't experience these barriers in a neat and ordered list, but as a ferocious tidal wave that hits me all at the same time, relentlessly and without mercy. I soon realised that you aren't an industry where people from backgrounds like mine – bar a few noteworthy exceptions – are able to build a sustainable career. I do not think that you are ignorant to this. Somebody made you this way.

It's no wonder then that I have made it my mission as a director to present the complexity, humanity and positivity of diverse working and under-class experiences across Britain in the work that I produce. I aim to deconstruct stereotypes and to create work which engages communities from backgrounds like my own, who typically feel excluded and disengaged from theatre as a form of culture. My work essentially focuses on trying to undo the decades of damaging work that you have already done and embedded into the fabric of the industry.

Eventually, my frustration at the lack of equal representation, access and inclusion of my communities in theatre led me to establish COMMON. COMMON is an arts organisation that I founded in January 2018, whose mission is to support the UK creative industries, with a specific focus on theatre, to achieve greater intersectional, socio-economic diversity. Our aim is to make arts and culture widely accessible to the working and under-class; whether they be artists, audiences or communities.

I established COMMON with little to no knowledge of what it was

going to be, or how I was going to achieve this mission, but simply with the understanding that an organisation needed to exist which challenged the exclusion of socio-economic inequality in the creative industries' diversity debate. At the time of writing this letter, June 2019, I have spent eighteen months travelling to meet communities of working and under-class artists all over the country. I have met over five hundred artists. I have learnt about the barriers to skill and career development that they face in their regions. I have listened to their stories.

For the first time in my career, I have finally met people whose experiences I recognise, and whose 'language' I speak. It has taken me years to find them, because we have been pushed to the margins. We have been ignored, excluded and forgotten. I recognise their feelings of imposter syndrome. I recognise their lack of any financial safety net to support themselves. I recognise the burnout effect they experience; working multiple jobs simply to survive, which leaves little to no time to focus on their creative careers and leads to mental and physical exhaustion. I recognise their inability to engage with creative opportunities, due to physical, financial, geographic, emotional, ideological and professional barriers. I have found my tribe and my community.

COMMON has begun to devise practical solutions in an attempt to eradicate these inequalities, but most days it feels like an uphill struggle. We have established an award to provide financial support to a socio-economically disadvantaged artist to take an exceptional show to the Edinburgh Festival Fringe. We are laying the foundations of a new playwriting course and directing course, specifically for creatives from working and under-class backgrounds, to challenge the lack of creatives from these backgrounds who work in these disciplines and who are able to progress their careers in the industry.

Many arts organisations across the UK have worked with COMMON, yet they do not sustainably engage with our mission. I try to respond to this as kindly as possible. I appreciate that we are living through one of the toughest cultural and economic climates in decades. I understand that staff members are overworked, underpaid and simply don't have enough time in the day to respond to all the requests they receive. Nonetheless, being on the receiving end of this lack of sustained engagement can feel like a personal affront. It can feel like these organisations aren't committed to challenging socio-economic inequality, or that they don't recognise the

severity of the issue as deeply as gender, ethnicity, disability, sexuality and other crucial areas of the diversity debate. I am trying to prove to these organisations that there is another way to operate, which will lead to greater socio-economic access and inclusion across the industry. However, it often feels like they don't have the time to listen.

I know your potential, and so I hope that fighting this fight is worthwhile. You are one of the last remaining forms of culture which has the ability to bring together communities from different socio-economic backgrounds in the same space, at the same time. That is such significant power to hold in an increasingly divided nation and within our increasingly divided communities. You have the ability to bring us together to experience a story as a collective. You can challenge our assumptions of each other; encouraging greater understanding between us and enabling us to find common values. You can play a role in healing the cracks that have fractured this country. However, this can only happen if you actually welcome all communities through your doors – both as artists and as audiences.

I need you to know that I am not trying to work against you. I know that you have the power to change the lives of those who need you the most, because I have seen it. I want you to be accessible to, representative of and inclusive toward my community. If you could see the future of theatre that I can, if you could only see the even greater potential that I know you hold to become accessible and meaningful to the lives of those from socio-economically disadvantaged communities, then you would commit to working with me. My people deserve to be seen, to be heard and to be valued. My people have as much right as anybody to be in these theatres, and if you won't welcome us in, then we'll find another way in. That would be a bloody shame though, and huge waste of all our talent, our time and our energies, don't you think? Open the door.

In the end I hope that, one day, we can set aside our differences. I hope that, one day, I can walk into a theatre and feel like I am meant to be there, that I deserve to be there, and that I am not an outsider who will soon be ushered back out into the cold. Because it's tough out there.

Yours faithfully,
David Loumgair

MONSAY WHITNEY

An Extract

Monsay Whitney is a writer and performer. Her play *Hand to Mouth* was longlisted for the Verity Bargate Award and the Bruntwood Prize. Her most recent play, *Box Clever*, was produced by Nabakov and Paines Plough for a critically acclaimed Edinburgh Fringe run in 2018 and transferred to the Bunker Theatre, London in 2019, earning Monsay a nomination as Most Promising Newcomer at the Off-West End Awards. She has written for the National Theatre, Tamasha, the Lyric and the Royal Court.

Box Clever is a one-person monologue, the performer playing Marnie plays all the other characters that are mentioned.

Marnie: I swear too much. I swear all the fucking time. I've got a nasty temper. I'm crazy. Not in an excited, bimbo sort of way. I mean I can be off key sometimes. I can't pick a decent bloke to save my life. I'm no ruddy cheeked, Mary Poppins sort. I don't live in a swanky house with soft glow lighting, a Labrador and wooden playhouse in the garden. But I don't fuck with no one. I ain't vindictive by nature. I know right from wrong. And I ain't a fucking liar. I shouldn't have to defend the truth. The truth speaks for itself.

Liam: (Beep) It's Liam. Pick up the phone. Marnie where are you?

 Silence

 I know where you are anyway.

Marnie: Goron then, where am I?

Liam: West London. Staying with Connie.

Marnie: Ha! I think! I'm closer than you think ya cunt!

Liam: I'm not gonna chase you. Look, Marnie I need a favour.

Marnie: I call them the three musketeers.

Liam: I need a bath, Marnie. I ain't had a bath since you left.

Marnie: Let me draw you a picture: First there was Danny. I'm eighteen. I'm a bit of a needy div. In fact, I tried to top myself six months ago. And they've got me pumped up on these Anti Psycotics they call Olanzopene – what make you well fat. Danny don't really contribute to this story except to say I've got a kid with him. And I could also point out he ain't done fuck all for her since the day she was born.

Liam: (Beep) It's me again. Why you ignoring my calls for? That how you're going on?

Marnie: Then there was Liam. I find him in a squat party on the Arden Estate. I'm twenty now. I'm still fucking baffed about life, but I've brushed up on the art of seduction. Playing it cool this time. Here we are, sitting on a wall,

waiting for his bus, the morning after the night we met. I've got one eye up here and one eye down there, buzzing off of six and a half Mitsubishis, and he gives me the most stunning sapphire and diamond, white gold eternity ring you've ever seen. I mean it just blows me away. He took it back a couple months later, 'cos it actually was a family heirloom, belonging to his nan and that. And she clocked it was missing. But that's neither here nor there.

Liam's banged up 'til Christmas. He's home a couple of months and he leaves me for a bird he was in care with. Not really what I intended. Wait, he's come back. Nope, he's gone again. He's toing and froing back and forth between us for a bit. Course, the other bird's gone and got herself up the duff. I've ended up in a nut house. Liam says he can't be with someone mental. Which is, you know, nice of the cunt.

It's at this point the winner in me comes out fighting. This shit's gone on almost two years. Well no fucking more. I have a bright idea. I reckon I'm gonna just sniff coke 'til I die. I give it my best shot. Didn't die, sadly. I ain't that fucking lucky. Did manage to balls up almost every aspect of my life though, which is, you know, a skill in itself. Maybe I should get some help. Or kill myself. Or go on holiday. It's a tough call.

Liam: (*Beep*) Answer the fucking phone you slag.

Marnie: And then, like an angel through my window, there was Stevie. I'm twenty-two. And this is it. This time. The real deal. Proper love. Proper in the sense that, you know, Stevie actually fucking loves me back. I sit myself down and have a word with myself; Marnie, do not fuck this up. Don't fuck it up. I'm not good at taking direction so I talk to myself twice, to ram it home.

There's this gaff in Stepney called 'The Fridge'. They call it the fridge 'cos it's fucking chilly in there. It's basically just a hall. With chairs in. Where they hold meetings and everyone sits around eating biscuits, talking about how much they love drugs but how they can't take them no

more. We call it recovery. Anyway, I'm there because I'm like a raving fucking coke head who keeps tryna do herself in. And Stevie's there because he's just got out of prison and he's had a pipe with his uncle after eighteen months off the white and ended up on his mum's doorstep crying out for his dad, who died of a brain tumour when he was fourteen. And he knows if he don't change real quick he's going straight back in the shovel. He makes me a cup of tea. And he smiles at me. I feel double lovely. And I just know this is gonna be something special. Then he makes the old boot next to me a cup of tea. And he smiles at her. Slag.

I ask him where he's from. He says:

Stevie:	Lewisham.
Marnie:	It's like this, right. When they founded London, evolution was still proper backward. They didn't know about flood banks and the river used to flood South of the Thames. So what they did, was, they stuck all the prisons and all the mental hospitals and anyone they weren't keen on, down there, in all that slush, with the hunchback rats, and basically just left them to it. Society, as it was at the time, meant that, like kids would leave home, marry someone local and move round the corner from their families. So naturally, over time, the prisoners and the mental patients pro-created. Then their children pro-created with one another. And so on and so forth. Have you ever looked into the eyes of some one from South East London? I'll give you a moment to think about it ... there you go. Normal people don't just develop the mental attributes and criminal capacity that make up a South Londoner. That shit's intrinsically bred. Stevie ain't wrapped too tight.
Liam:	Hello?
Marnie:	Yeah?
Liam:	Have you listened to my voicemails?
Marnie:	Yeah.
Liam:	So? Are you anywhere near Hackney?

Marnie:	I tell you one thing about this geezer. He's got some fucking nerve.
Liam:	Are you close?
Marnie:	He says.
Liam:	Not close, close. But could you drive here? Say, within an hour? I've been on a mad one, we've been smoking for nine days and I, I need a bath, Marnie. So can you do that for me? Can you do me one favour? You don't have to come home. Just give me the keys.
Marnie:	We can't even bath in our own home.
Liam:	Can you give me the keys or what?
Marnie:	No.
Liam:	You see how you are? Fuck ya then, I'll bath at Amy's, cunt.

Danny, Liam, Stevie, Liam, Danny, Stevie, Liam. Ever get the feeling you're going round in one big circle? Ten years back and forth between a trio of arseholes. And nothing to show for it except a baby, a pair of Argos earrings and a beat-up nose. Course a lot of women would of chose a round-the-world trip. I mean that's ideal really. If you're looking to go off in search of yourself. But um, to cut to the chase, I fled to a women's refuge.

Charlene:	What d'you want it to say?
Marnie:	Charlene's in the doorway. Next door, room five.

Just like, 'Please can you stop giving me tickets, I'm out of petrol and I can't move the thing. Come on man, it's Christmas.' Or is that stronging it?

Charlene scrolls as I speak, brow furrowed, in concentration. When she's done she hands the paper back to me, two inch letters, red crayon.

To ticket warden.

This vehicle has broken down and we are seeking recovery so stop putting ras clot tickets on n go home and res ya bumba foot.

Driver.

Charlene sashays downstairs and out the front door, sticks the letter on my windscreen, and struts off to college.

Marnie sneaks a cigarette.

I found a Johnny, in the drawer, when I got here. Sort of unexpected, given the circumstance – but useful, none the less. I stretched it over the smoke alarm. Mostly, I nose at the garden. Florence, upstairs room eight, is adding liquid combust to a smouldering settee at the minute. One of your own, Florence. Not really fair though, is it. I mean if your average mental defective dragged a donated couch out the living room and into the yard to set fire to it for the hell of it, the office would get the right arsehole. If it was me, you might say, I'd be up in the dock, Monday morning. You can't say to Florence, 'You're allowed to torch the couch', after you've said to me, 'That's the second window you've accidently put your foot through, Marnie, if you do it again we'll have a look at evicting you'. Where's the consistency? See, there. The office blinds just twitched. 'Are you gonna leave that office Fi Fi?' I say. 'Fi Fi? Can you hear me or what? Are you gonna have her up for that or no?' Like fuck she is. Who's gonna confront Florence? Not me, mate. She must be 6' 2, at least.

Door knocks.

Fi Fi: Marnie.

Marne: I'm a bit busy.

Fi Fi: I can't hear you.

Marnie: I said I'm sleeping.

Fi Fi: I need to speak to you.

Marnie: Oh for fuck sake.

It's difficult to describe Fi Fi without ripping her to bits. I ain't gonna get into it with ya. But what I will say is she's got some bad frizzy hair. I ain't just being outers. It's actually bad. It's really corse. It's wirey. It's like. I can't explain it. It's not like hair. It's not like hair, from your head. It's like, you know … pubic hair.

And before you start, I've already had a good go at liking her. It was a while before I come to my senses. I can't be expected me to go round giving preferential treatment to every woman who declares herself a feminist, can I?

Marching against the pay gap don't exempt you from being a cunt. Not in my book.

Anyway, I could sense it from the start, that it'd probably be best all round if we just steered clear of each other altogether. And yet, for reasons that are beyond the limits of my intelligence, she allocated herself to be my key worker. Which basically means she follows me around like a bad smell, syphoning whatever she can get out of me, like a mosquito on a fanny flap.

I leave Fi Fi to continue her morning rounds and slip downstairs into the office. Log into the home swapper website, read through my advertisement, hoping for a miracle. I've been stuck here for three long months. I'm pretty desperate to get out.

Salesman:	Large two-bedroom, corner house, for exchange.
Marnie:	It reads–
Salesman:	A solid, family home, with a medium sized front garden, which is paved and could be used as a driveway, and a large, very tranquil back garden which is grass, and trees and beautiful plants–
Marnie:	And all that malarky. I point out that it's got–
Salesman:	The right to buy–
Marnie:	Because a lot of people on here are moving with the sole intention of buying a council property. I say that it's–
Salesman:	Tucked away on a nice little road, that's very quiet, never had no trouble–
Marnie:	And I explain that it's–
Salesman:	On top of bus routes X, Y and Z and a trainline leading into the city.
Marnie:	I write that–
Salesman:	It needs a good lick of paint–
Marnie:	So as not to waste no one's time, because I've realised that most people ain't prepared to swap their shit hole for anything less than a show home. In the 'What are you looking for?' section, I say–
Salesman:	I'm looking for a two-bedroom like-for-like property, in London. I'm not considering anywhere further afield

	because my daughter's due to start school.
Marnie:	And right at the bottom of the paragraph, I write:
Salesman:	This is my mum's house, we're searching for a three way swap. My mum'll be moving into my flat as part of the swap.
Marnie:	Quick scan through all my replies. You know them Xfactor contestants, the ones what introduce their shit singing with sob stories, hoping to progress in the competition regardless? Yeah well that's what I'm dealing with here. I'm losing the will to live.
Marnie:	Monday morning. Still no petrol. My kid's in a different borough, waiting for me to take her to nursery. I've been stuck at the train station for fifteen minutes behind a fella who's got a fucking question for everything.
Man In Front:	Sorry, are you waiting?
Marnie:	Nah, mate. Just stood here admiring the decor, whilst contemplating the meaning of life. Make a run for the peasant wagon. I've never known any bus to hum of piss to the extent of the 279. The bird with the pink hair just guffed and it's rotten. Proper bad. About as bad as methane expulsion gets. I watch as she eyeballs the passengers to her immediate left, screwing up her face like she dunno who's arse just let rip. I take a deep breath and hold ... I can feel her shit particles seeping into my fucking pores. Take a woozy look around. The scruff cunt next to me scratches his smelly balls and indiscreetly sniffs his fingers. Our eyes meet. He chucks me an algae-coated grin. I can't work it out. That's actual fucking plants growing in between his teeth. I pick up a paper and bury my head in its centre pages. Boris Johnson says that the biggest Cornflakes tend to end up at the top of the packet. Well I say the biggest Cornflakes were at the top of the packet to begin with and the Cornflakes at the bottom got knocked about and crushed and shit. Why the fuck are we talking about Cornflakes, anyway? It's too early for this bollocks. I want a beer. I want a beer – but I settle for a coffee - my mum's a cranky bitch at the best of times.

MONEY MONEY MONEY

Bridget Minamore is a writer from south-east London. She has written with the National Theatre's New Views programme and the Royal Opera House and has been commissioned by Historic England, Tate Modern, Nike and ESPN. In 2015 she was chosen as one of both the Hospital Club's Emerging Creatives and Speaking Volumes' 40 Stars of Black British Literature. Bridget has read her poetry internationally, including at literary festivals in Rome, Vancouver and Kraków, and as a repeat guest on BBC Radio 4 and BBC Radio 5 Live. Her 2017 BBC Radio 4 documentary 'Lines of Resistance' was a *Radio Times* pick of the week.

Bridget Minamore

O FTEN, I AM ASKED about diversity in the arts. Why aren't working-class people represented in the creative industries as much as they should be? Where are the working-class artists, writers, actors, directors, producers, designers?

There are general answers to these questions, of course. The working-classes have always brimmed with imagination and creativity, and I am proud to be someone from a working-class background. Still, I cannot understate the systematic difficulties and barriers that people from working-class backgrounds have to deal with at every stage of the artistic process, from applying for funding, to securing rehearsal space, to the prospect of losing money in a box office split. Young working-class people often don't have the same institutional links to art and artists as their middle and upper-class counterparts. There is a lack of disseminated information about how to make a living as an artist and working in the creative sector. You are more likely to come from a low-income background if you are also from a non-white or immigrant family, and this means you face additional difficulties when it comes to accessing the arts. General attitudes still consider artistic involvement by working-class people as 'other' rather than the norm. The list goes on and on (and on). There are specific issues, too: accents, education, location, expectation.

These answers, no matter how true they may be, frustrate me. Most of the time, conversations about the lack of working-class people in the arts circle around one simple answer: money. Money makes the world go round. Time is money. For working-class artists, it's often all about money money money. For the vast majority of the artists I know from working-class backgrounds, the biggest barriers we face revolve around the fact our families simply didn't, and don't, have as much cold hard cash as the middle and upper-class artists around us.

Money is an unpopular answer in the diversity conversation. To many, it seems to be too simple a solution to solve such a complex problem. I understand why. To be working-class isn't always to be in poverty, and a lack of money isn't what defines someone as being from the working-classes. Saying that, ignoring the elephant (or piggy bank) in the room is pointless at best, and actively harmful at worse.

In the art world, coming from a background with money doesn't just help. Often, it's necessary. There are so many initial upfront costs, including training, space and materials, plus the time that it takes to create work before it can be monetised, when we still have to find the money to eat and sleep. Even when the work does come to fruition, whether it will be profitable or not is a gamble. Throughout my career, I've found myself trying to explain that it's a lack of money that is holding me back, and the one thing that would help me more than anything else would be a large chunk of no-strings attached cash to do what I want with. I'd probably use that money for boring things such as rent and bills, which isn't exciting, but it is true.

A money-filled safety net provides a shortcut for so many artists' journeys. Why spend your spare time applying for funding when you can rent rehearsal space or equipment immediately, and when it suits you? Why learn how to use complicated software to design gig posters when you could hire a designer to do it for you? Why crowdfund for drama school auditions when you could just pay the travel fares to get there? Money also allows you to be more selective with your creative energy. Instead of writing fluff pieces for magazines you don't care about, you could spend the time working on your novel.

If I had more money when I was an emerging artist, I would have paid for those writing retreats. I would have stayed out networking at the pub for longer. I would have seen more shows which would have given me a clearer idea of what I wanted to write. I would have taken the fast train, or hey, perhaps an uber, rather than the bus. For artists living outside central London, money has a direct correlation with access. It doesn't matter how cheap the West End tickets you can find are, if you have to spend five-times the price getting to the theatre buildings.

When I speak to artists from middle-class backgrounds, I find many of them at pains to differentiate themselves from the upper-class artists who are supported by their parents. 'I haven't received any money from

my family since I left home', they tell me. 'I'm also struggling to pay all my bills and live in London', they say. 'I'm broke too!', and I smile, and I don't mention that the difference between me and them is still huge. Like many children of the immigrant working classes, it falls on me to financially support my parents and members of my extended family. If I was only looking after myself, I'd be happy earning next to nothing like many of my middle-class counterparts. But I (alongside parents, carers and other people with dependants) need to earn a decent amount of money. As a result, I work and I work and I work – and I always have done –in 'artistic' jobs when I've been lucky, and in bars and bra shops when that's not been enough. I've heard people comment positively about my creative work ethic since I was a teenager. The truth? I definitely wouldn't work this hard or this much if I didn't need to.

Not growing up with money means it's also taken me a long time to work out how to value myself and my work properly. I spent years undervaluing my writing, mostly because I had no idea what I should charge for it in order to earn a decent wage. Growing up, a salary of £25,000 a year was more than what anyone I knew made, so that was always my benchmark for myself. It took me a long, long time to dare to make my day work rate higher than what would amount to £25k a year, mostly because it seemed absurdly high. I also didn't know how to haggle, let alone ask for more, because no-one I grew up around worked in a job where negotiating a salary was an option.

Things finally changed a few years back. A school asking me to run some workshops for them contacted me with a fee offer, but I missed the email that claimed they only had a couple hundred pounds in their budget. They took my lack of response as a sign I wanted to be paid more, so offered me almost double. I was shocked. They actually had more money the whole time? This was an acceptable day rate? Since then, I've forced myself to always ask for at least 30% over whatever I am first offered. Sometimes, of course, people say no. Most of the time? They say yes.

These days, when I think about the many organisations who took advantage of my lack of financial knowledge in those early freelance days, paying me tiny amounts of money for huge amounts of work, I feel so, so sad, but even more angry. I wish I could tell my younger self to ask for more, but I also wish I could tell some of my old employers their diversity summits and accessibility targets are pointless if their silence allows the

middle-classes to be paid more for the same work than their middle-class peers.

Perhaps the biggest issue when it comes to working-class artists is dealing with the mental toll of having little money. My middle-class friends with parents who could theoretically bail them out if they don't earn anything for two months don't understand how much pressure there is for working-class artists to have monetary success. My family and the friends I grew up with barely understand my career, which is fine, but the anxiety I feel around my bank balance is immense. I thought this would disappear when I started earning enough to live on comfortably, but, if anything, the anxiety just feels worse. It's hard to settle into my creative process when I know quantity as opposed to quality is better for my bank account. Churning out work even when I don't want to might not be best for my creative output, but the bottom of my overdraft and scrambling for rent money is a place I just don't want to go back to.

I work for money before I work for love, which as an artist feels wrong, but is the reality for the majority of working people. The working-classes are artistic and always have been, but being an artist is an easier endeavour the more money your family has. Ignoring that isn't going to change anything.

Success crept up on me: one day I looked at my bank account and to my surprise I wasn't in my overdraft. Today, after almost a decade of being paid for my art, I earn more than anyone in my family ever has done. It might not be a high middle-class salary, but I still feel overwhelmingly grateful for it. I get the chance to write and teach and absorb the art I love. However, growing up with little money, and having the background that I have, has been the driving force behind most of my artistic decisions. I would do low-paid gigs, despite the energy they required, because I felt like I still couldn't say no to what would have been a day's wage for my Mum. I would take on long-term contracts for jobs I didn't really want to do, because it felt safer than the precariousness of endless freelancing. I would avoid speaking up when organisations treated me badly, because the idea of alienating anyone who holds creative purse strings has been too terrifying to think about.

Eventually, though, that had to change. A big step in the right direction was when I started to burn out with exhaustion. I was sick and knackered all the time, and physically couldn't work as hard as I had been. Suddenly I was more selective with my time and began to plan my work further in advance, which meant I spent less energy on earning tiny amounts of cash.

For years I had been too scared to say no to any opportunity, then I got to a point when I had to. Working smarter is better than working hard, and a part of me is grateful I learnt this lesson relatively early on in my career. Plan your time better, learn to say no, ignore the people who demand too much of your creative energy and remember that we work to live, not the other way around.

As artists, no matter what our class background is, we have a responsibility to help the working-class artists around us to navigate the barriers that a lack of money puts before you. We need to push for travel, food and childcare expenses to be factored into budgets for all projects, big and small. We need to pay people promptly and pay people well, because for artists living hand to mouth, a late payment could lead to a cut lease. We need to share information about our salaries and how much organisations and events are paying us and we need to recognise the privileges we have beyond our class status when it comes to other barriers like race, gender, immigration status and disability. Money is never easy to talk about, but it is something we think about, all the time. As artists, working-class or not, it's important that we do both.

Marvell Fayose is a multi-disciplinary artist who is a writer of poetry and plays, actor-in-training, stylist, scout and creative director of A Tailor's Son. His poetry has been performed and read at Theatre Royal Stratford East, Roundhouse, Lovebox Festival and Southbank Centre, amongst others. In fashion he has worked as a junior assistant stylist for 419 Collective and Labrum London Fashion Week Mens A/W 19. He has received various honours including the Jack Petchey Award and the Princess Diana Anti-Bullying Award. He is a member of Spit the Atom, Open Door, Lyric Ensemble, the National Youth theatre and is a Roundhouse Resident Artist Alumni.

A TAILOR'S SON

Marvell Fayose

14.5" from the neck
full chest, 30"
full shoulder width 15" in length
right and left sleeve, 33"
Bicep 6" wide

I have been seamed against the throat plate and slide-slit by crafty, hard-palmed hands. An ideology sewn into Sunday Best.

You press anger into the Singer; sewing seems to ease the yards of material frustration. Like the gentleman of Bacongo, there is joy on your dark face when you are looking good.

It has taken twenty-two years for it to fit you and it still isn't perfect. Yet. Year after year the suit is ripped in order to be reassembled.

Texture feels tugged. Tailor chalk marks pale lines. The breath of the scissors when compressed, pushed – they are alive. These rugged blades with four holes for each finger. The handwheel is turned like the times you wish were returned to you.

Your fingers are thimbles to this craft.
Taped measurements are whispered by sweaty index and thumb:
wrist, 3.5". Stomach, 31". Hip, 35". Front jacket length, 25.5".
Front chest width, 33". Back width, 13.5".

Vigil prayers are mentioned in small, steel stores. Morningstar glistens in the daily remembrance that poverty must perpetuate to make fabric riches.

There are hearts that live knowing ACF, art comes first.

Under cold lights. Cut this piece, you are its master. I know it is too much to ask but make this join as if it were the last one. I know you tire in asking yourself what desperation looks like because it is found out with every in and out stitch pulled by needle and thread.

Half shoulder width right, 5". Half shoulder width left, 6". Full back length, 58".
Half back length, 29". Trouser waist, 32". Trouser outseam, 38".
Trouser inseam, 32". Crotch, 22". Thigh, 19". Knee, 13.5".

Uncouthly put fashion together again
Do it better than your Father has ever done. For you,
You are a tailor's son.

A S A POET I fully believe that words are not just written for the page but should also be a reflection of the same experience that inspired the poet to write them.

I think 'A Tailor's Son' came to life as a poem when I noticed the comparison between my life to that of the people living in the Congo, Brazzaville or the gentlemen of Bacongo. They are living in the harshest conditions but still making it work by dressing in their best clothes. Always. I grew up in a very conservative Nigerian household where the belt was held in one hand and the bible in the other. Yoruba sarcasm and insults heavy on the tongue were thrown in for good measure. My reality wasn't as harsh as those who live in the harshest parts of Africa, but I still lived a working-class lifestyle overseen by a strict father. He knew fashion from making clothes himself and from his experiences styling himself, my mother and siblings. I remember my childhood days when I would help fold clothes and learn how to measure a client. These are sweet memories but I also recall the negative ones, like the time I was given the task of ironing my father's classic trousers, which I did wrongly, and the time I got in trouble for not knowing how to properly 'gator' menswear shirts. Growing up with a father like him was pretty hard.

Before I was born my father was a tailor by trade in Ilesha Town, Osun State, Nigeria where he and my mother met. Growing up for him, too, was hard. My grandmother (his mother) taught him how to sew, which lead to him moving around from place to place to find means of trade and business to survive. As the years past, he grew in his craft and was so well respected that he taught people who soon became his apprentices and his business did well. Before a traditional occasion in the UK, my dad was the man the family would come to for clothes and sizing.

In these pictures, my father is teaching his apprentices how to pattern cut and measure with a make-shift ruler. Pattern-cutting was done without tracing paper, using only blackboard chalk. No templates, just using judgement to achieve the look to the wearer's desire. My father's customers were always happy. Eventually, he received formal training at a fashion school but then he decided to abandon his craft as a tailor to take up the reigns as a minister of God. Now my parents are no longer together.

I moved to the UK and spent almost a year working at both Charles Tyrwhitt and Reiss as a sales associate and stylist. I believe the reason for me getting these jobs was because of my experience as a tailor's son. Both brands are iconic, luxurious high-street companies that sell suits, shirts and ties. Whilst working at these highly esteemed companies, I learned about the practices behind making everything, from the visual merchandising to the customer service, effortless. As a salesperson with a passion for clothes and advising customers, I began to understand the poetics of communication through patterns, material and cuts in both womenswear and menswear. This is what sells clothes.

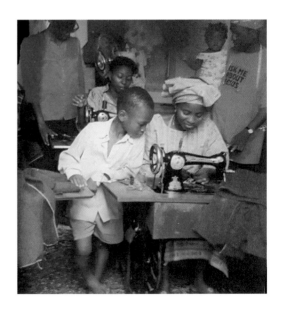

I decided to use my experience and turn it into something profitable and beneficial for the sake of people most likely to have the talent but the least likely to gain recognition for their work. I wanted to create a space for the working-class because I know what it is like to not be able to afford the very expensive items you are selling. I really wanted to bridge the gap between the working-class and people of colour creatives who create fashion-related content and the frontline of the fashion world. I wanted to build relationships with those I feel reflect the hardship of fashion. I wanted to mend the poverty line that I am so familiar with by taking my father's lost interest and seaming it into something new.

I can't sew but I definitely can find talent and source creative people in the business of fashion. This is why I created A Tailor's Son, to give People of Colour and LGBTQIA stylists, fashion bloggers, influencers, photographers, designers, make-up artists and anyone who defies the norm the chance to be discovered by high fashion brands and to collaborate with leading designers, magazines and modelling agencies. I can hone their ability, make connections and work hard to ensure this venture is strong enough to be mentioned alongside Fashion East, a non-profit organisation famous for bringing names like Liam Hogdes, Mowalola and Gareth Wrighton to light.

Behind all the glitz and elegance fashion portrays, there has always been the hardships and meticulous natures of the crafts people making fashion happen. A Tailor's Son allows upcoming talent to fully incubate their potential as artists who inspire others and who instil the hunger to strive, progress and create. In this way, we can improve on the mistakes our ancestors and parents made to create a better future for fashion and culture.

PAUL MCVEIGH

ALL EYES ON ME

Paul McVeigh is a writer of fiction (including a novel, short stories and flash fiction), comedy, essays and plays. His debut novel *The Good Son* won the Polari First Novel Prize and the McCrea Literary Award. It was shortlisted for the Authors' Club Best First Novel Award, the Prix du Roman Cezam (France) and was a finalist for the People's Book Prize. *The Good Son* was chosen as Brighton's City Reads in 2016 and was given out as part of World Book Night in 2017. Paul's work has been performed on radio, stage and television, and has been published in seven languages.

R OCCO WATCHED MISS walk around his table and stop, look at them one-by-one; backs straight, arms folded, fingers-on-lips for shush. She was deciding who got her first. On the wall behind, the behaviour chart showed everyone back to zero because it was Monday. Rocco loved Mondays. Black marks gone. Last week forgotten. Rocco's slate all fresh and so, so clean.

Miss chose, coming opposite Rocco, leaning over Tommy's head.

'Well done,' Miss smiled, 'you've really taken your time with this, haven't you?' She rested her hand on the boy's head. 'I'm sure you're going to grow up to be an artist.'

Tommy beamed the kind of smile Rocco practiced for hours in front of the mirror but just couldn't get right.

Miss continued her circuit, her hand coming to rest on Jessica's shoulder. She kneeled down and whispered things causing blushes and giggles from the little girl. Rocco could imagine what she'd said.

A breeze came through the open window and blew a strand of hair loose across Miss's face. Rocco went straight over to Miss, and with his fingertips, super, super softly, tucked the strand behind her ear.

'Sit down, Rocco', Miss said, looking at the hand he'd touched her with.

Rocco looked at what her eyes could see; tiny cuts on his fingers and thick dirt under his nails. He hid his hands behind his back. Miss smiled the way she smiled only at Rocco, with her eyes nearly closed.

Rocco went back and sat on his seat, tucked his chair right in, tummy squashed tight into the table's edge and rested his arms on the large white sheet in front of him. He'd drawn their house, just like Miss had asked, but with a pretend garden, a pretend dog (he'd even written woof! woof! above the dog's head!) and a pretend bike leaning against the door. He had drawn his mammy with a pretend daddy.

It was Rocco's turn next but one and he couldn't wait to show Miss. He wanted to fix his dirty hands so he spat on them and rubbed on his trousers. He should have washed his hands before he went to bed last night, but there'd been a party and mammy had let him sit up late. Auntie Kelly let him taste her wine and everyone laughed at him when he said it was disgusting. He made himself stay awake until everyone left so he could help mammy upstairs and so no-one would stay over. When he woke up this morning, he was already late for school so he didn't have time to wash. He'd have gotten a black mark for being late but there was no rule about being dirty. Not on the behaviour

board anyway. When he found his uniform, unwashed, still in the washing machine where he'd put it on Friday, he sprayed it with the air-freshener from the toilet. Sprayed his hair too because Miss doesn't get so close when Rocco smells of Mammy's cigarettes.

Rocco stretched and yawned and his drawing came with him, stuck to sweat on his forearms. He peeled the sheet off and saw dark stains on the fat of his arms and much, much worse, grey-black clouds of smudge on his page. He wouldn't get upset even though he'd worked so, so hard. Miss would see beneath the smudges, he was sure. They didn't change how good the work was underneath. He looked at the behavior chart. His, the only name with a special column of its own.

'Lend me your rubber,' Rocco nudged Declan.

'No. Get your own'.

Miss stopped at Sam. 'What beautiful colours,' she said. 'I-am-list-en-ing,' she sang.

'I am list-en-ing,' everyone sang back, downed their pencils, folded their arms and looked at Miss. Everyone loved drawing class, especially on a hot afternoon. All on their best behaviour then, so Miss wouldn't make them do real school work.

'Look at this,' she said, holding up Sam's book. 'Isn't this wonderful? Why do I like this sooo much, Caterpillar Class?'

'Because of the colours.'

'Because it's so neat.'

Because it's Sam's, Rocco wanted to say. Because you always like Sam's.

While Declan looked left at Miss, Rocco took the rubber from Declan's pencil case. Rocco scrubbed at the smudges but it made them worse. Each stroke made a black line and left a dirty little worm of rubber on the page. He tried blowing but the worms were stuck there and when Rocco swiped at them, they left more dirty streaks.

'That's my rubber.' Declan screamed like he'd been hit.

Miss frowned, her eyes on Rocco. She set Sam's book in front of him and rubbed his floppy hair, all washed and brushed, all perfect, as usual. Miss let out a sigh and came around the table.

Rocco threw Declan's rubber behind him and he imagined it bouncing its way across the classroom floor like a skimmer stone at the ponds.

'Miss, he threw it on the floor!' Declan's face was like a squashed sponge and Rocco was sure water would come out of it.

Rocco hated Declan. He hated them all.

'Pick that up,' said Miss.

'I didn't do it,' said Rocco, arms and head raised to the ceiling.

'Rocco, go pick it up, now. Make the right choice.'

'It wasn't even me,' Rocco said, and pushed his sheet away from him. He got up and looked around. 'I can't even see it,' he said.

He saw Miss reach for his drawing and before he knew it, Rocco had grabbed it and crumpled it into a ball.

'Rocco, why are you like ... Rocco, sit back on your seat,' said Miss, her voice tight in her throat.

Rocco threw the paper in the bin and went to his seat.

'Class, we don't give Rocco any attention when he's behaving like this,' Miss said, like Rocco wasn't even there. She walked to her desk and on the way stopped at the bin and took out Rocco's work. She flattened it out then held it up for everyone to see.

The class giggled. She shouldn't be allowed to do this to him. He would get her back.

'Declan did it,' Rocco said. 'He smudged it all.'

'No, I didn't Miss,' said Declan. 'He's lying.'

'No, he's lying,' Rocco shouted and pushed Declan who flew forward whacking his elbow off the desk.

'Awoah,' Declan cried out and then the water came.

Mammy was right, Rocco thought. Cry babies are annoying. You shouldn't cry, ever. But if you really have to, do it where no-one can see.

'That's a red card,' said Miss. 'Time Out Table. Now!'

Miss hated Rocco. He knew it. He didn't care, though. He hated her too.

Rocco sat at the Time Out Table in the dark corner of the classroom beside the bookshelves. He looked at the three large egg timers. He watched Miss as she bent down over Declan and hugged him. Whispered to him. She never hugged Rocco. Or whispered.

'How long, Miss?' Rocco asked.

'Turn over the red timer,' she said, without looking up.

Rocco spun the giant timer. Five minutes. He looked at the walls. There was the numeracy display with clocks they'd made as homework, telling time at quarter past and to. Some had used coloured card to cut out clock hands that were tacked in the centre with shiny silver pins. Who had things like that at home? Rocco had drawn the time on a digital clock face. Miss

said that was very good, really original but not what she'd asked them to do. She didn't put Rocco's up on the display because she'd said you couldn't change his time; his clock was set forever and besides, no-one could play with it because it wasn't interactive.

Rocco looked at the Extra Homework display where the smart ones, the posh ones, had done stuff they didn't even have to. He'd only done extra homework once after they'd been to Belfast zoo. He didn't have any colouring pencils at home but you could still see it was a peacock, you just had to add the colour inside your head. He knew how to do this because he had to do it with the TV at home after Mammy fell on her way to bed and knocked it over. It had been black and white ever since. Rocco wondered if the others could do what he could, making magic inside his head. He wanted to show them all his special talent but he just couldn't seem to find a way of letting them see it.

The zoo was the best day of his life even though it had rained and he'd had no coat. He didn't have a packed lunch either but to be fair his Mammy didn't really know he was going. He'd hounded her for the trip money, begged and begged, but she wasn't made of money, she'd said. He forged her signature on the permission slip after he'd gotten the money for helping out Mr Salmon from down the street.

The whole zoo was built on a hill and they walked up it looking at the animals. Miss allowed the class to go off on their own but everyone wanted to be with her. They hung from every limb, like monkeys. She held their hands, making sure they all got a turn holding some of her. She let them lean against her on the bench. She even let some hug her.

When Miss ran up the hill, they all ran with her. She stopped at an enclosure, pointed out some animal hiding in the bushes. Miss read the sign telling all about what it ate and where it was from but Rocco couldn't even see it. He went off on his own. Miss shouted for him to stay near, where she could see him.

Rocco wasn't really interested in the animals, he studied the people. He saw mummies and daddies with their wee ones. Saw how they talked to each other and pointed at things together, sort of like Miss and his class. He saw a mum and dad with their little boy and he wished there was a sign about them, telling what they ate and where they were from.

The daddy knew all about everything. And he had snacks in his pocket. Daddy unwrapped a fruit bar thing Rocco had never even seen before and

Rocco thought he knew every sweet. The wrapper said organic with no added sugar. He was going to eat one of those one day. He couldn't see the name but he'd remember the crocodile on the wrapper. He'd steal it if he had to because it wasn't even fair some people had things that other people didn't, especially when it's not even their own fault they don't!

He saw the kid's shoes. They weren't cool. Thick and leather and instead of holes where you put laces through there were little metal hooks. Like boots mountaineers wear. Rocco had seen them on the TV. There was no way this boy was a mountaineer – his mummy and daddy wouldn't let him; it was too dangerous a thing for this little boy to do. But he could probably be a mountaineer when he grew up, if he wanted. He was the kind of boy who could be anything he wanted.

The mummy looked at Rocco and smiled. She was the most beautiful woman he'd ever seen, after Miss, so he smiled at her eyes, the way he'd practiced, and pretended he was a good boy.

The mummy nodded to Rocco, put her hand on her son's shoulders and guided him up the hill. Daddy, of course, followed. They stopped together at the lions.

Rocco made his way over too and stood beside them. He stared at the mummy and when she looked, he tried his smile one more time and she smiled back, but not with the same smile as before.

'Who are you with?' the mummy asked.

'Rocco,' Miss shouted from behind him.

Rocco looked over at Miss coming towards them.

'I'm sorry,' Miss said, 'is he bothering you?'

'No, it's fine. We were just worried,' the mummy lied. She was just like all the rest.

'Come on Rocco,' Miss raised her hand and went for his shoulder but stopped just above it, floating.

Rocco shook his shoulder like he didn't want her to touch him and headed off on his own.

'Don't go far, Rocco,' she called after. She didn't even try to stop him. He even walked slowly, too.

He marched up the hill 'til he was out of breath to show Miss and the mummy just how much he didn't care about them.

'Indian Peacock,' it said at the enclosure. Rocco looked around the inside but saw nothing. He read the sign. '...also found in Sri Lanka and

other parts of eastern Asia ... famous tail plumage ... bright, blue heads and crest colourings ...'

There was nothing even in the enclosure. This zoo was crap, he decided and kicked the chainmail fence. He hoped people had seen. Then he would get in trouble. Let them come and shout. What were they gonna do? He kicked again. And again. The fencing warping, carrying the metallic wave along.

Movement on the right. This jerking bird-animal. Rocco looked to see if anyone else saw it but he was alone. The family he'd stood beside were coming up the hill. He didn't want to be near them again but there was only one way back down, past them, so he stood, staring at the peacock.

The peacock turned towards Rocco then froze. It had seen him, Rocco was sure. More, it was staring at him. Rocco stared back. Its head had little stalks, in a line, sticking into the air with what looked like tiny blue flowers on top. Like a native Indian headdress.

At first, he thought the peacock was wearing a cloak, a beautiful cloak like Joseph's – Miss had read them the story in circle time. Then he saw that it wasn't a cloak but the peacock's tail that trailed along the ground behind it, a multi-coloured wedding train.

The peacock came towards him, straight over and no mistaking. It was staring right into Rocco's eyes, he could feel it. The peacock – and he knew how stupid this sounded – the peacock ... liked him. He just knew.

Rocco felt the family next to him. He heard his class coming up the hill but didn't look anywhere but straight ahead at the peacock because they were ... friends. And they weren't going to let anyone else in. He heard his class arrive, talking about his peacock, whether it would show its special tail. They made kissing sounds, calling the peacock to them, trying to steal it away from Rocco, take his friend away. Didn't they have enough? All of them? Couldn't they just let him have this one thing?

But the peacock didn't look at anyone else no matter what sounds they made or if they were teacher's pet or even if they had mountaineer's shoes.

And neither did Rocco.

And while his class all made noise, Rocco stayed silent.

'He's staring at you, Rocco,' said Miss.

She could see. They all could see. Show them, Rocco thought to the peacock. Show them all how amazing you are. For me.

And it did. The peacock raised its tail. Bustled and shook, with the sound of a sudden wind through leaves, it spread its beautiful blue for him.

And this small thing became huge, though its body stayed the same size, it took up ten times the space.

'Wow,' he heard. 'Look at that,' they said, pushing against the fence. All wide eyes on the peacock like they were watching magic, or fireworks.

On its feathers there were eyes. Eyes all over the tail. Looking at his class who thought they were the ones looking.

It was all everyone talked about on the bus back to school. Rocco's peacock. They tried to find a new nickname for him. A funny one. Not like what they usually called him. None of the new nicknames were any good. None stuck.

He drew the picture at home that night and brought it into school the next day. Miss put it up on the Extra Homework wall. If he'd had coloured pencils at home, to really show the peacock, he knew, things would have been different from that day on. He could see the colours on his drawing, even though it was in black and white. But only he could.

'Rocco is your time up?' Miss asked.

Rocco turned away from his drawing on the homework wall and looked at Miss. He looked at the timer. It had finished. He hadn't noticed. He went over to the Extra Homework wall, ripped his drawing from the board, its corners stayed behind attached to the tacks that had held it up.

'Rocco,' Miss called.

He looked at his drawing.

'Rocco what are you doing? Make the right choice,' she said.

Rocco looked at her. At the Behaviour Chart behind her.

'Make the right choice,' she said, walking towards him.

He held his picture up to show everyone.

'Rocco don't. Don't do it, Rocco.'

He ripped his drawing.

'Not your lovely drawing, Rocco.'

He looked at her. Tore a long strip.

'Rocco, remember the peacock? Remember how he looked at you that day. Only you,' Miss said. 'You all remember?'

'Yes, Miss,' said the class.

He looked at them. Silent and staring. All those eyes.

He tore another strip. And again. His picture now long tails hanging flat from his hand. Rocco was smiling, but not like they do, not with his lips.

He looked at Miss. She was really looking at him. They all were.

ENTRY POINTS

Sabeena Akhtar

Sabeena Akhtar is a writer/editor and the Festival Coordinator of Bare Lit Festival. She is also Co-Founder of the Primadonna Festival and of Bare Lit Kids. In 2017 she partook in the BBC's coverage of the 70th anniversary of Indian independence and alongside her daughter, filmed a programme on the Partition of India for children. She is the editor of upcoming anthology *Cut from the Same Cloth* and has published a wide variety of work including fiction, non-fiction and graphic novels. She is currently working on her first novel.

I WONDER HOW TO BEGIN. Which voice to use. As a brown, working-class Muslim woman, I've learnt that accents matter, semantics matter. Should I enunciate, assimilate, stereotype break? Smashing expectations, glass ceilings and the shadowy confines of council estates. Or should I perform for you, fam? Chat in da voice they use in da ends, so dat together we look like we're smashing dis diversity ting.

Maybe I should keep it anecdotal. Tell you something funny about the well-meaning liberal artsy folk, who arrange meetings in overpriced cafes in gentrified Hackney because, you know, being in the close vicinity of poor brown and Black people somehow feels inclusive. Smashing the hegemony. But really all the inclusive goodwill in the world, doesn't stop them side-eyeing the big, battered fuck-off Lenovo you pull out in the meeting.

Maybe I should begin with Grenfell – the personal connections, the anger and unbelievable injustice of it all. Or about struggling to get by, the daily realities of living with black mould and deteriorating mental health? Intergenerational trauma? Should I collect the smashed pieces of working-class hearts and refashion our trauma into cultural currency just to get

A. Foot. In. The. Door.

But what about our joy? When you come from marginalised communities, so often the truth about making it in the arts means editing your interests, happiness, support systems, laughter and so much more, out of the story. Access comes from opportunity and opportunities are too often, only afforded for the spectacle of suffering. Our pain is profitable. Working-class artists starting out are unconsciously expected to commodify our trauma for the consumption of the upper-middle class masses, existing only to offer cultural insight to the very communities who exclude and

other us. I mean, I'm sure, we've all been told how fucking 'fascinating' we are at some point, right? There are success stories of course, there are alternative routes, but the harsh reality is that for many of us this is how a career in the arts begins. In part, it's why you hardly ever read a debut novel by a working-class Black writer that isn't described as 'lyrical', 'urban' or 'authentic' or meet a poor Asian actor that caught a break without playing a terrorist. And surely working-class white people write more than just angry polemics?

Whilst tales of achievement in the face of adversity are inspirational and tips for funding absolutely invaluable, few find the space (like this collection), to frankly discuss the ideological and psychological hurdles and hoops we navigate; or the toll that takes on creative expression or even the mental health of marginalised peoples. The pressure of taking up and maintaining space is onerous. Sometimes what we need is not just practical advice, but simply acknowledgment of the realities faced. Working-class communities are resourceful, we know how to create something from nothing. For me, flint to fire is not the biggest hurdle, it's bearing the gas-lighting, tokenising, codeswitching and box ticking. As someone working both within the arts and as a writer, I often gain the most strength and inspiration from time spent in the company of people who affirm the existence of such pressures, sharing the concerns. Often encouragement comes in the form of aspiration and achievement and other times it comes from someone just agreeing that yes, despite all the fantastic initiatives and progress, sometimes it's still a bit shit.

Historically, discussions around being working-class in the arts have predominantly focused on rags to riches tales. We know that people are happy to talk about how poor they were once they are successful. Few talk about how hard it is to break into this industry when you are still working-class and poor, that's why this feels so refreshing. For most of us, the path to success is undoubtedly paved with concession (and for the appeasement of establishment intelligentsia, preferably an Oxbridge degree). We are never so much embraced than when we are dispelling or fulfilling white upper- and middle-class stereotypes of ourselves. In the hope to create the art we are truly passionate about, we must be honest, sometimes we 'tone it down' or have to let others capitalise our struggle. Either way, working-class creators are continually forced to reduce artistic output to formulaic narratives that sit well within the mainstream, a sentiment supported

by Spread the Words, 'Writing our Future' report 2016 which, based on qualitative research showed that 'writers find that they are advised by agents and editors to make their manuscripts marketable in this country by upping the sari count, dealing with gang culture or some other image that conforms to white preconceptions'. Sometimes it happens slowly and subconsciously, other times it blindsides you. But still, it happens; you are edited, commissioned and cajoled into an abridged version of yourself. If you're lucky, rooted and keep your wits about you, success can eventually bring the privilege of creative freedom. If you're not it chips away at you until you are chiselled into a neatly packaged, yet unrecognisable version of yourself. Probably with an MBE. And who could blame you? Mainstream success in the arts is sold to us as social mobility, which by definition denotes leaving behind working-class roots. If you're not careful, all too suddenly smashing it becomes upholding the status quo.

It's funny, but no one really ever asks me about class. I often get asked to speak about the barriers race and religion pose to a career in the arts, but no one asks about class. Even though I cannot disentangle myself from it – my class identity is as intrinsic to who I am, how I live and the work I create as my race, religion and gender. Often it directly effects my experience of racism and Islamophobia. I'm more likely to be (and have been) called a Paki terrorist bitch when I walk home, because I can't afford to live in a multicultural London borough anymore or to take an Uber. But in the arts, working-class is not an identity that belongs to me. In this age of Brexit and increased hostility, the term working-class has become the preserve of the white working-classes. This racialised framing has precluded many people of colour from representing their own communities. Despite being disproportionately affected by class inequality, we are somehow seen as part of the problem.

A man once approached me after a panel I spoke on to tell me that I was lucky. Lucky, that there were now lots of diversity initiatives allowing 'people like me to flourish' within the publishing industry, whereas the working-classes were being left behind. I scanned his face for irony, but this man was serious and I believe, well intentioned. He was outwardly

empathising with the barriers I faced whilst internally screaming, 'What about poor white people?' I don't think it occurred to him that a person can be more than one thing at once; that I could be brown and poor. You can occupy spaces of disadvantage and privilege simultaneously, as indeed I do, as a light-skinned Asian woman. It also never occurred to him that perhaps the very systems that he perceives to allow 'people like me to flourish' can also hold us back.

When we talk about reinforcing power structures within publishing, we must mention how the industry is particularly adept at introducing initiatives that feel like they are fostering change, but who is actually monitoring whether they are? What starts as genuine, helpful and innovative can quickly morph into tokenism. It's important to recognise the thin line between diversity and gatekeeping, so here's my quick guide to a few publishing trends and how, if left unchecked, they can become counter-productive to aims.

Internships

The publishing industry is full of wonderful, empathic people spearheading initiatives to create spaces and access for marginalised groups. The fact that poorly paid internships are exclusionary to the working-classes is generally well established within the industry and many better paid internships are now being offered specifically to those from disadvantaged backgrounds. Organisations such as the brilliant Creative Access have led the way in creating opportunities, placing over three hundred interns into the publishing industry alone. A combination of the success of organisations such as this, in addition to calls for change, have seen big publishing houses set up their own in-house initiatives too, helping to offer a desperately needed alternative route into a largely nepotistic industry.

I wholeheartedly support and endorse any attempt to create access, but can this alone qualify as real change? The hope is that those interns will survive the murky waters of living wage (and being wheeled out for photo opportunities) and stick with the industry – although a recent Creative Access report suggests that nearly a fifth of them will leave. The

immediate and very real effect of disproportionately hiring only at entry level however, is very little. Without cultural shifts within companies and underrepresented communities hired at all levels, the ripple effect risks being reduced to just good PR for publishing houses. The onus is often patronisingly placed on the person, to 'be the change they want to see', with little thought to how untenable that in an industry that over 32% of respondents highlighted as being difficult to progress within.

I often wonder if anyone is collecting rolling data and benchmark comparisons on how many people are kept on after their (usually) highly publicised internships? Or of how many feel isolated within the workplace? The same Creative Access survey showed that more than half of those interns asked 'did not feel that the industry was welcoming towards people of different backgrounds'. Inclusion has to be more than aesthetics, we need people from marginalised groups as decision makers, not just making cups of tea and running errands.

Anthologies

This might seem like a strange one for me to list, as I am currently editing an anthology and writing in this one, but bear with me. In recent years anthologies have enjoyed a resurgence. Creators of colour, most notably Samantha Asumadu with *From the Lines of Dissent* and Nikesh Shukla with *The Good Immigrant* have turned the form into something crucial and fresh, creating a platform for multiple writers (who might not otherwise be commissioned), to become published. Done well, the hope is to launch careers and offer nuanced conversations. Anthologies like this one, put together from a place of love and artistic collaboration, can offer powerful insight into the state of the nation and raise important questions.

However, as the critical success of anthologies has risen some publishers are piggybacking on the trend and are beginning to churn out compilations with a quick turnaround. Whilst it's uplifting to see more underrepresented writers line our shelves, increasingly this need to quickly lump us all together starts to feel performative. It sometimes feels that many authors from marginalised communities are now *having* to enter

the industry through anthologies, rather than necessarily *wanting* to. We want to create and have our say, we need to earn money, so we happily do it, but what is the subconscious message being sent out to writers from marginalised communities? You're not good enough for a book deal? Or you need to jump through a few hoops for us first, to prove yourself?

Whatever the motivations, many mainstream publishers are meeting diversity quotas and seemingly broadening their lists, without ever having to offer these writers proper book deals. Writers are paid a fee and offered industry standard contracts that often don't include royalties for contributors. If you are a well-known editor (usually middle-class) with an agent, perhaps you can negotiate a better deal for your authors. But little known working-class writers and editors have no such privilege. It is often simply a choice between being published or not, of being grateful for the opportunity or not. The reality is that publishing houses score great diversity points and working-class writers remain broke. To add insult to injury, the filled quota also means that you have potentially, albeit completely unintentionally, stopped another marginalised author getting a book deal. Diversity becomes gatekeeping.

Regional diversity

In 2018, following their annual survey, the Publishers Association announced action points to tackle the lack of regional and BAME representation in the industry and a commitment to improve the figures. Whilst this marks a huge step in the right direction, BAME presence has slightly fallen by 1.4 % since their initial findings and regional diversity is still overwhelmingly skewed in favour of London and the South East.

Recently though, there has been an uptick in focus about moving beyond the London-centric confines of the industry. Northern-based publishing houses, including those who have formed the Northern Fiction Alliance have been publishing brilliant, inclusive and thoughtful work for years and have rightly called for the need to redress regional inequalities. Now, big London-based publishing houses looking to save money and diversify are finally opening shop up North too.

This is wonderful, as long as regional diversity doesn't replicate the structural and hierarchal imbalances in London and manifest as mainly white and middle-class with different accents. Regional diversity must not come at the expense of working-class people of colour who are still egregiously underrepresented. Despite being largely headquartered in one of the most diverse cities in the world, publishing is undoubtedly monochromatic and the further you move out of London, so too does the potential for it to worsen. It is shocking that in a city with over a 40% demographic identifying as being from a BAME background, publishing in London, according to the Bookcareers salary Survey 2017, is still 90% white and overwhelmingly middle-class.

Translations/ international fiction

Books in translation are popular. According to research commissioned by Man Booker International, sales in translation rose by 5.5% last year and they are steadily increasing in appeal. There are some wonderful specialist indies out there publishing beautiful and much needed international fiction for anglophone readers, which in part has contributed to its critical success and creating a devoted readership within the UK.

Following what Nielsen Books describes as 'extreme growth' in translated literary fiction over the years, mainstream publishers are adding increasing numbers of translations to their lists. Great, right? We all want to 'read the world' and expand our viewpoints, yeah? But is anyone monitoring the potential effect this has for British working-class authors of colour? Take for example, Pakistan (my own country of origin). Fiction writing in the Indian subcontinent is largely a preserve of the elite and most privileged members of society. It is the upper- and middle-classes who have access to education and the familial wealth to fund their artistic output. As an Asian in the diaspora, I love reading works in translation, they offer me a connection to a place that is part of me, but which I have never been a part of. But I also know that the sad and uncomfortable truth is that many

publishers aren't going to publish two Pakistani writers simultaneously (partly because most of the people who might commission more than one 'diverse' author are busy making tea, remember).

My case in point, the 2016 'Writing the Future' report cites in its findings that 'BAME novelists wrote that publication of their novels had been affected by the limited cultural awareness of their editors'. So, by giving that space to an often already popular work in translation, written by an already privileged author, have we unintentionally blocked the chances of a working-class British Pakistani author? Ideally, there is space (and a fundamental need) for both, but we know the reality doesn't always translate to that. There is a slippery slope between diversity and perpetuating elitism.

I've always found the language around marginalised communities/working-class achievements in the arts interesting. We are continually placed as 'ground-breaking' 'breaking new ground' or 'breakthrough'. The inference being, that we were never meant to be here, that the arts was never meant for us or our stories. Likewise, when we are told we are 'smashing it', I take it with a pinch of salt. I'm not *smashing it*. I'm struggling within a power structure that I am unable to change or decentre. I can't be the change I want to see until the fucking system changes.

Success for working-class authors can be convoluted. For me, it's not about making money, few working-class people who know the frustration of being skint would begrudge you that. True success is in the struggle not to replicate harmful power structures and become complicit in your communities own marginalisation. If I write a bestseller tomorrow, am I successful if copies are only sent out to middle-class writers? If people like me don't receive copies, don't blurb it, aren't asked their opinions and are never considered as the target readership? Am I successful if the people who edit, publish and promote my work are all of the same privileged background? Or have I become tokenised? Another poor, brown face to wheel out at diversity conferences to show that, contrary to all the data, the system is working.

I don't know how to achieve success, but I know that we continually need to challenge and interrogate what is presented to us as progress.

Often what is perceived as success in the mainstream, feels like selling out. It doesn't matter if the head of a publishing house tells me I'm lucky or flourishing; diversity initiatives are helpful, but limiting. There are people in this industry who care and want to make real change, but it's hard. The reality is that we're here, but sometimes we're the only ones who look and talk like us. We may not be smashing it but our presence is transgressive and perhaps, if we're honest about it, that's a start.

ANTHONY ANAXAGOROU

TWO POEMS

Anthony Anaxagorou is a British-born Cypriot poet, writer, publisher and poetry educator. His work has appeared on the BBC, ITV, Vice UK, Channel 4, Sky Arts and has been published in *POETRY*, *The Poetry Review* and *Granta*, among others. He won the Groucho Maverick Award in 2015 and was shortlisted for the Hospital Club's H-100 Award for most influential people in writing and publishing in the same year. He is an Honorary Fellow at the University of Roehampton, the artistic director of *Out-Spoken*, a poetry and live music night in London, and the publisher of Out-Spoken Press.

JEREMY CORBYN AT
THE DOCTOR'S SURGERY

On my thirty-fifth birthday I lay dying. Returning to the doctors
to learn what my chances were. Among the sick I waited.
Coughs. Sneezes. Croaks. Three boys bickering over toys.
The exact same ones I remember seeing as a kid.

My father says *anything too loud is probably lying*. I picked up
a paper and tried hard not to listen. Tossed gum into my mouth.
Then he walked in. The whole surgery disbelieving. Soundless.
He pulled a tissue from his pocket. Then blew his nose.

A painter had spent his whole life trying to master the sky.
When he died his daughter taped his last watercolour to the inside
of his coffin. Forfeiting the eulogy. But this was worse.
We needed proof. The lady beside me stopped drafting her email.

The elderly couple stopped rummaging for lottery tickets.
The receptionist crunched down on her boiled sweet. Even the kids
forgot their wars. While he just sat there. Basic as a tent.
Twisting a tissue. Waiting. Like the rest.

A man with a face like a glove. Walked in. Both eyes
sodden beer mats. His dog. Rhapsodic in its boxed frame
came scuttling behind. Sniffing him out. Licking his shoes.
As if somehow it knew the reason dogs were allowed in.

I explained to the doctor. Again. How my problems
started around 2016. And how Jeremy Corbyn was, in fact,
sat outside waiting to be seen. Removing his spectacles.
Exhaling. He asks, 'really, are you not exhausted by all of this yet?'

SEPARATION HAS ITS OWN ECONOMY

having fallen through the mirror in my chest, having become
my tardiest wound, I decided to invent a new me although
some things are practically impossible like trying to hurry
haze, or forcing colour onto blue; I press my cheeks onto
hot bulbs, move furniture into who cares, knock on doors
with my gums, finger phone boxes for forgotten change.

My habits consist of dialling the wrong number just to hear
myself say I'm sorry, crushing the stems of daffodils into
Ikea mugs we bought in a Dalston charity shop; each night
when the emails stop, I go on eBay to bid £306 on a key
shaped bottle opener, three MDF penguins and a soft toy
with cigarette burns. Nobody outbids me.

Things I keep because I must:
 a court summons for two unpaid parking tickets
 a tattoo of your PIN on my wrist.

For the past month I've been ripping the heads off fishes
giving each a sobriquet before French-kissing their dead eyes.

All that remains:
 a Jamie Oliver cook book,
 a date circled in red for a beginner's salsa class,
 organic wine I was sent after a talk
 on gentrification in east London.

Up for grabs is a discounted meal for two and tweezers too
 small for my hands:

On better days I envisage myself a man
who owns a house in Zone 4 with a garden,
casually mowing the lawn in early spring
the way a secular thinker might.

For the occasion I'd wear tight white shorts
combined with a salmon pink sweater
my Chihuahua named Nico
will keep tangling himself up in the lead.

On the patio will be an Aperol Spritz
half savoured while through the double glazing
my wife will be reading *Capital* to our children,
all eight of them, at exactly the same time.

This is what I envision as I saunter to Dan's flat
unfurnished and smelling of attempt.

There I ask to borrow his saw, a hammer, a rope. He tells
me to behave. I say some things are in need of fixing. He
sits me down. Says his girlfriend only got with him because
she didn't want her kids to come out too pasty. Said she told
him that in a text. Said racism is its own logic. Said he told her
to go find a white guy and a two-bed above a sunbed parlour.
Said orange is the new black, anyway.

There's only so many ways you can remember a person. My
friend Dan. Who leant me a saw, a hammer but kept back
the rope, along with his sense of humour.

Malorie Blackman OBE is the author of over fifty books for children and young adults, which include the *Noughts & Crosses* series. Malorie also writes screenplays and wrote an episode of 'Doctor Who' for the BBC in 2018. She has been awarded numerous prizes for her work, including the Red House Children's Book Award, the Fantastic Fiction Award and a Nestlé Smarties Book Prize, and was also shortlisted for the Carnegie Medal. In 2008, she received an OBE for her services to children's literature. Malorie was the Children's Laureate 2013–15.

Q&A
WITH A
NOVELIST

Malorie
Blackman

What other jobs have you had in your life other than writing and how have they ended up informing your work?

I had my first Saturday job when I was fourteen, working at Littlewoods Department Store and then British Home Stores. I had a number of summer jobs whilst I was doing my O Levels and A Levels including working as a Catering Assistant and working as a telephonist/receptionist/typist. All of these jobs involved communicating with the public in some way and were invaluable in giving me an insight into human nature – the good, the bad and the ugly! All of these experiences were and are grist to the writing mill.

My first full time job after leaving school was as a documentation assistant (a glorified filing clerk!), but then I became a junior programmer, a systems programmer and worked my way up to become a capital markets database manager. My novels, *Hacker, Antidote, Dangerous Reality* and others were all informed by my years working in computing.

Which working-class artists inspired you at the start of your career, or continue to now?

Writers such as Toni Morrison, Ntozake Shange, Gloria Naylor, Maya Angelou, Alice Walker, Toni Morrison, Rosa Guy and Buchi Emecheta all inspired me to write when I was in my twenties. To be honest, I devoured books by mainly African American writers as books by Black British writers were scarcer. These stories reflected parts of my own reality back at me. I

grew up reading thousands of books where black people like me were all but invisible. Working-class stories featuring black characters were all but absent, which in itself was a political statement giving out the message that as a BAME working-class person, my stories didn't matter. That's why books that said otherwise, stories that depicted lives I could recognise, were incredibly important to me.

It was the pioneers of film, TV, music and novels – whose efforts were often vilified – who inspired me the most. Those who marched to the beat of their own drum.

Is there a fictitious working-class character you'd love to see on the page that you haven't yet and that you don't feel able to write?

I'd like to see more stories told from the point of view of BAME working-class characters who are LGBTQA, physically challenged or dealing with mental health issues. Such characters would face unique challenges not encountered by non-BAME protagonists. While I don't believe you have to be it to write it, I feel it's crucially important to get facts and feelings right when creating characters outside of your own experience. Authenticity is a very hard essence to capture and get right.

What was the greatest class-based obstacle you faced as a writer? And what was the greatest advantage of that obstacle in the end?

I think the assumption that I had nothing to say that anyone would want to hear was the hardest obstacle to overcome. I was constantly told that white children would not want to read stories featuring black children. I believe that inherent in this view was an element of classism. The greatest advantage to this was that my stories had not been told before so immediately stood out as original and different. For example, my first novel was called *Hacker* and was a technological thriller. At the time of writing, there were very few novels about computers and computing being written for children so that worked in my favour, to the extent that child judges voted my book the winner of the WH Smiths Children's Book Award during its publication year. So don't listen to those who say there is no audience for the stories you want to write! Just write them anyway.

What would be your main piece of advice for working-class writers starting out on their career?

Don't shy away from using your own voice. It is what makes your work unique. Don't let anyone tell you that your own voice and vision aren't valid or vital.

REBECCA STRICKSON

Rebecca Strickson is an illustrator and do-er of things, based in Peckham. Her clients include Royal Mail, Kenco, Sony, Artsy.com, *Glamour UK*, Columbia Records, Agent Provocateur, *Elle Magazine*, The O2, *Toronto Globe and Mail*, WWD.com and Channel 4.

You Wretched Men

THE BASIS OF *You Wretched Men* is taken from the Order of The Bath flags from the Lady Chapel in Westminster Abbey. This beautiful, incredible, un-intelligible, bizarre heraldic design was designed only for a handful of people, ever ...

This is the full quote that accompanies the Order of the Bath flags in the Lady Chapel. I include a section of it on my drawing. The quote is attributed to Thomas Walsingham, who in turn attributed this to King Richard in 1381, after the collapse of the Peasant's Revolt:

'You wretched men, detestable on land and sea, you who seek equality with lords are not worthy to live ... So give this message to your colleagues from the king. Rustics you were and rustics you are still: you will remain in bondage, not as before but incomparably harsher. For as long as we live and, by God's grace, rule over the realm, we will strive with mind, strength and goods to suppress you ... Both now and in the future people like yourselves will always have your misery as an example before their eyes; they will find you an object for curses and will fear to do the sort of things you have done ... you may keep your lives if you decide to return to us and remain faithful and loyal.'

Nothing's changed.

Rebel Pride

Hello Sunshine

Hysterical

BROKEN BISCUITS

Salena Godden is a British poet whose electrifying live performances have earned her a devoted following. The title poem from her latest poetry collection, *Pessimism is for Lightweights*, is currently a public poetry art piece on display outside the Arnolfini Gallery, Bristol. Her self-produced live poetry album, *LIVEwire*, released with indie spoken-word label Nymphs and Thugs was shortlisted for the Ted Hughes Award. Her essay 'Shade' was published in the ground-breaking and award-winning essay anthology, *The Good Immigrant*.

Salena Godden

THROUGHOUT THE LATE SEVENTIES, money was tight and since I was settled into school, my mother had to start looking for a full-time job. These strains echoed in the outside world; on the front covers of daily newspapers, I vividly remember images of men in black donkey jackets, the miners in a furore over cuts and union strikes, I remember angry picket lines and race riots. Closer to home, the closure of the nearby Corby steel works put hundreds of people out of work, including my stepfather. Even as infants we were aware that we were living in tumultuous times. We kids hated Margaret Thatcher and we sang in the school playground with great vitriol, 'Thatcher Thatcher ... the milk snatcher!' As soon as I was at primary school full-time my mother took a job at the shoe factory. This was hard work, toxic labour and her hands became hard and scarred from the stress and the chemicals. Meanwhile, my stepfather went into a re-training programme.

During my childhood I remember we had to endure excruciating 'family meetings' about once a month. The four of us, my mother, brother, stepfather and I, would sit awkwardly in the living room together as a 'family' for an hour after dinner with the television switched off. This was a strange occurrence, my brother and I were forbidden to be in the lounge usually. We were not allowed to watch TV. We were not permitted to eat sitting down in the dining room and we ate our tea in the kitchen standing up at the counter. My stepfather ran a tight ship. In these family meetings my mum would recite catch phrases that sounded like they came from her *Woman's Own* magazine. She'd say, 'Isn't this nice, this is family time', and smile hopefully at us, then she'd make us talk uncomfortably about our day, work and school. Finally, various chores were discussed and dished out. I remember I had to clean the bathroom every weekend, vacuum and polish my stepfather's tennis trophies. In the autumn we had to sweep the leaves

and in winter help shovel the snow and clear the paths. We also had to wash my stepfather's car, do the dishes, polish our shoes, tidy our room and a myriad of other kids' chores. The notion of pocket money always came up in these family meetings and was scoffed down again. My stepfather would get dead serious and launch into the budget and then ask how come we got through so much food. He'd complain that we kept eating his cheese. I never ever touched my stepfather's cheese. For the record, it was always me that stole the cream off the top of the milk without shaking the bottle, but I promise I never touched his cheese.

My stepfather would berate us, telling us how we all had to pull up our socks and tighten our belts. We were children and looking back I am not sure we had belts to tighten, really. I can remember us walking five miles to the next village to the leisure centre to use the swimming pool in the summer because we had the 20p for the pool, but not the bus fare. My stepfather invented a rule that we would shop only once a month from the new giant supermarket out of town. I remember the novelty of this huge, white, space-age supermarket. I also remember my stepfather's unpleasant military approach to the shopping experience, bulk buying tins of cheap baked beans and marrowfat peas, massive boxes of own-brand cornflakes, huge tubs of greasy margarine, cheap frozen fish fingers, thin beef burgers and a box of broken biscuits. He'd laugh then throw this treat into the shopping trolley.

At the end of each month my mum had to be inventive. If we ran out of anything, we went without. This always came up at these monthly family meetings too, before negotiations inevitably broke down into serious arguments and fights and my stepfather yelling at my big brother about his school reports and exams and smoking and other teen dramas. There would be angry raised voices and then the strict homework schedules and extra chores were dished out and the meeting was concluded. My brother and I would be sent back to our tiny shared bedroom where we lived and slept. My mum went into the kitchen where she lived. My stepfather lit a Rothman's and sank back in front of the sport on TV in the lounge which was his domain.

My childhood could be worse, I know, I am just telling you how it was for us back then. I was a latch key kid with no latch key. We were not allowed in the house when my parents were at work. And so after school I'd idle my way homewards to sit outside an empty house or climb into my

Wendy House. In there I would find the plastic bottle of orange squash and broken biscuits my mum hid for me. The Wendy house had been given to me one Christmas by my Grandpa George. It was permanently erected under the corrugated plastic porch down the side of our house. It was yellow plastic, with a red sliding door and a blue plastic roof and two see-through plastic windows. It was, essentially, a small house-shaped tent but I put blanket on the floor and made curtains for it, I can recall me and mum sewing them on my mum's old Singer sewing machine. Inside there were two cardboard boxes: one was my washing machine and the other, a cooker. I had drawn on buttons, dials and gas rings and cut holes in the front, a circle for the washing machine and a square for the oven. During the summer, sometimes, I was allowed to have a school friend to sleep over in that Wendy House. But the truth was that it was my all-year-round after-school shelter and when it was cold and wet, the wintry wind and rain licked up the sides, making it flap open. I spent hours shivering in that Wendy House inventing stories and wishing my mother would hurry home.

Occasionally after school I'd walk across town to wait for Mum outside the red-brick leather factory. I'd have a few hours to kill between end of school and the factory bell. I'd daydream, climb trees and talk to cats along the way. Once I got there, to me that old factory smelled good, leather and glue. I imagined I could hear engines whirring, gigantic sewing machines and roaring furnaces. The windows were prison-like, small and sooty, barred and high. I'd sit on the railings, hook my legs over the bars and hang upside down. The lower steps became my beam and I rolled over the poles into somersaults. When I grew bored of gymnastics, cartwheels and endless handstands, I'd go to the corner of the car park where the wall had collapsed. Beyond the bricks, the junk, the shopping trolleys and industrial bins there were bramble patches and twisted, gnarled trees and in that wasteland I'd go seeking treasure and scrumping for crab apples, sour plums and blackberries.

As the factory bell finally rang and the doors opened there was a waft of warm air, hot leather and new shoes. I loved that leathery smell as much as some people like the smell of warm fresh bread. I'd sniff it and feel excited and look for my mum, the only brown face, among a clatter of gossip, colourful headscarves and a blur of ladies in blue matching overalls and blue fag smoke.

'What are you doing here, monkey face?'

'Waiting for you, monkey face!'

The factory ladies would all smile down at me and pat my frizzy head of hair and I'd find myself staring at the corner of my plimsoll or the kerb while they cackled about my curls and their perms. My mother would look worn out, exhausted, but happy to see me. After a very long gossip over fags, I'd prise her away and we'd get to walk home together. I loved those chats, just the two of us. I'd tell her about my day at school. I'd ask her to tell me stories about what it was like when she was a girl. If it was a good day, we'd stop at the corner shop and I could pick a treat from the pots of cheesecakes and yogurts which were my favourite. If it was a *really* magic day I could cajole her into buying me the latest *Tammy* or *Twinkle* comic. Whilst she paid for it I'd sneak a flick through the slightly older *Judy* or *Jackie* magazines which had love stories with real kissing at the end.

When Sabrina Mahfouz approached me and asked me to write something on being a working-class artist, I said yes, mostly because I trust her with this part of me and my past. However as soon as I said yes and sat to write this, I was immediately pulled back in time to this era and these memories and to this truth and hunger. When you ask me to talk about being working-class I retreat back to that Wendy House and those boxes of broken biscuits. I recall my stepfather and his hollow laughter and him saying that we were to count ourselves lucky. I remember cowering and then mirroring him and his hollow laughter about how lucky we were. I hated broken biscuits, not because I was ungrateful or because I was uppity and thought I was above it, but because they came with his unkind laughter. In many ways my brother and I were a bit like those broken biscuits in a world of perfect confectionary. We were thrown in the mixed-up box with the misshapen crumbs and biscuit dust, indistinguishable leftovers, smashed up factory rejects.

I cannot help but feel my odd relationship with money stems from childhood, this time and these memories. Money was never really available or given generously to me because nobody had any. My relationship with money is quite simple: I don't have any. How can you have a healthy relationship with a thing that only other people have? How can you

have a relationship with a thing you never really see or have or hold? I also have an odd relationship with dairy products and luxury items; nice butter, nice cheese, nice biscuits. It is complex and it has everything to do with what I or we think we deserve and what we have been taught about waste and extravagance and our relationship with our poverty and hunger, with expression and creativity, with failure and success, with ownership and struggle, with lack of privilege and opportunity. With the erasure of our wants and needs, effort and labour, and the blurry lines between representation and tokenism.

My people are poor, we are survivors and we have the best laughs. We have super skills too, like the way we find ways to look out for each other, pass jobs on to each other, cover each other and big each other up. We know how to make do and do without. We know how to blag it. Going without and making the best of a bad lot is our second language and default setting. We have got used to working hard. We don't like it, but we roll up our sleeves and get stuck in. Rule number one: If you want something done properly, you do it yourself. We wear armour, a thick skin for all those passes and rejections and little misunderstandings. Along the way we have learned to wait, to save something for later, we defer enjoyment, delay our gratification and we take our revenge served cold. We let others have a turn and we are big enough to applaud our friends' successes. We borrowed a penny for the bus fare to get here and pay it forward ten times over. Food is a big deal, we all trained for this, and we can grab and scoff a thing down in a hot second before a sibling nicks it. When you grow up skint there is a system you employ from childhood, a system that you have installed that teaches you self-preservation, that limits you sometimes because it tells you what you deserve, what little you deserve, it lets you know your place and from there I think begins the roots of this imposter syndrome that so many of us live with.

You can have a whole biscuit. Take the big one that isn't broken, it is okay!

As a freelance writer, author and poet, I regularly hustle for money even when I have earned it. In this instance I think I am repeating the habits of my kid-self trying to get paid for chores around the house. We all do it, we politely chase invoices and outstanding fees. We check our bank accounts and wait and wait. This is the freelancers' curse and it is a horrible guessing game to see if anyone has had time and remembered to pay yet. We are

all wary not to piss off the accounts and events people or they may not book us and ask us back again. Then when we are paid we say thank you, very thankful and grateful and also careful with money not knowing when the next chunk will come in. You are only as good as your last gig. I am a touring poet and often feel a bit like a travelling salesman in the way I sell my poetry books as I go along. When I come off stage, I sell my books myself. I am indie published and not signed to any major labels with big distribution deals. My books are not available mainstream or stocked in all the high-street chains and so I have a suitcase of books that I drag up and down the country. I am a hustler and it feels like this is ingrained in me. I have to do this to survive, but where did I learn it?

When I look back on my earliest recollections of navigating money and class, I go back to the beginning, to a time when my lovely mum was doing her best. My childhood was a time when I needed to be smart and learn to be inventive and creative – I made my own something out of my own nothing – and since then I have always made my own something out of nothing. I know my mum loves me and that's everything. She, too, made something out of nothing. I remember my mum cutting up one of her dresses to make a party dress for me on that Singer sewing machine. It was a dress for the school disco with a gold sequin eagle on the front. I remember my mum's inventiveness. I remember not wanting to hurt her feelings. I remember pretending to like broken biscuits.

At school I was bullied for being different. I was the only brown girl in the playground. I was teased for my appearance, my frizzy hair, my brown face, my hand-me-down, colourful, homemade clothes. I grew up knowing we could be so much worse off and that we were loved and that we were to be grateful for this. I also grew up going without and with this terrible longing to be like the pretty girls in my school. I dreamed of being accepted and having a silky, swishy ponytail. I cannot believe how much I wanted to be a plain Jane. I wanted to be like the middle-class girls who had a fancy lunch box filled with delicious snacks, the trips to Disneyland, the girls that had ballet classes, piano lessons and horse-riding. I am reminded of the shame of my child-self image. Here I am in a school photo with my scruffy scuffed shoes, my messy hair and my free school meals ticket. I stand here wearing my brother's grey socks when all the other girls wear white. I remember shivering in the cold at dusk, watching the dark creep in, sitting on the back doorstep and waiting for my real life to start.

When I arrived in London aged nineteen it was no surprise then, that I continued to aspire to belong but still felt like an outsider, that I continued to be inventive and creative, to make my own path and my own something out of my own nothing. I completely believed in the myth that starving and struggling to survive would make me a better artist and writer, that the painful mistakes and life experiences I endured would only make my work stronger. Those early years, the nineties, I feel like I mostly lived on 20p instant ramen and cheap knock-off vodka. These were not the best years of my life. If you ever hear me say they were, I am being nostalgic for my chain-smoking, punky, angst energy and not remembering accurately the mental strain, anxiety and fear I lived with then, being itinerant and sofa surfing and living as precariously as I did. I relied on the kindness of strangers, the strangeness of kindness. Thank you.

It is terrible the memory of hunger, and I mean all the hunger here, emptiness, that real belly rumbling hunger, but also that hunger that is a longing to relax and chill and to escape the hustle. Money must be like freedom, being allowed to feel safe and secure, to say no to work, to take a break from the struggle to make your own luck and your own opportunities. Hunger makes a person determined to never be that hungry again.

However nobody can ever diminish that awesome empowerment that occurs when you made a thing yourself out of nothing, 'Oh this', you say, 'this old thing? Yeah I made a coat of many colours from the curtains that kept the light out and the darkness in'. 'This old rag? Oh, I made a superhero cape from the fabric they use to separate economy class and first-class.'

The first-class elitism and nepotism, the sexism, racism, ageism, white-washing, separatism and outdated snobbery that attaches itself to books and to poetry will always be a great shame. It will always disappoint me. It will always bore me. But it will never surprise me or bring me down. If anything, it gives me something to kick and smash against. It's so antiquated, it sometimes gives us all something to laugh at. And we do laugh and we do share our rejections and failures, for every rejection adds fuel to our fires. But we never stop auditioning, do we? We love and admire each other as artists and friends, but the brutal truth is we have to compete to eat. We must elbow fiercely for that one slice of the pie which is allotted for us, the outsiders. We have to compete for payment, for funding slots, headline slots, platforms and opportunities designated for us, for my people, the people who tick 'other' or the people who are working-class or

otherwise marginalised. There's a limit of how much pie we get each and how much we can share. Then the burden of winning or taking a spot is knowing you took an equally gifted, marginalised artist and friend's place. And the burden of losing is genuinely wishing your brilliant friend well and meaning it but knowing you have to wait another year for that one slot to come up again so you can enter and try, try, try again.

In addition to this there is a constant and subtle erasure of the labour that goes on regardless, the blood, sweat and tears of the working-class, of black writers, of women writers, of the underground, of the driving force that keeps smashing through and bucking the trends. It is 2019 and right now we have all the power, the power to be our own broadcasters, we can be our own archivists, keep our own digital record and document the rise of our work and raise our voices and energy. People were doing all of this back in the nineties and way before my time and the internet of course. I am excited to see this all returning, the use of cut and paste, scrapbooks, zines or pamphlets, anthologies, mix tapes and podcasts. I feel it rising again, that old school indie DIY and make-do spirit is thriving.

Let's all take a biscuit. Well done us.

Currently the UK's bestselling and headline poets are women. I look at the lists and line ups and I am pleased to see so many are self-publishing DIY women and indie published women. I am looking at these newspaper articles and they are filled with praise for the work of working-class people, from a mix of cultures and religions, struggling women, troubled women, outsider women, gay and trans women, it is the rise of the invisible, marginalised and rebel hearted. There is a buzz in the media about this right now, a flurry of articles that state that poetry sales are on the rise and that women are at the centre of this new wave. The journalists imply that it is mainly with thanks to the internet. We are told in these think pieces that this peak in poetry sales is caused by social media. I think this is unhelpful and some subtle disempowerment happens again. When we call a poet a poet they are a poet. Simple one word: Poet! When they call a poet a 'spoken word artist,' 'performance poet,' 'viral poet' or 'insta poet' somehow the poet is not just a poet but defined by their given place or stage or label. They are street, urban, black, a fetish, a genre, a fad, a trend ... and not just a great poet and writer. The focus is being given to the machine, to the environment, to the platform, to the internet, not to the soul and roots of the work, the hunger, the drive, the connectivity and authenticity. The

credit should always go to the heart, the poet, their labour and endurance. Labels distract us. I feel strongly that the poets contributing to this 'rise in poetry' are more than a fad. They are pioneers and they are smashing boundaries. They are modern day ranters and revolutionaries. Look at the content. These poems do not go gentle, they are all about struggle, poverty and austerity, identity and empowerment, climate change and social injustices. This poetry is relevant and being read and heard, quite possibly without submitting to the rules, without completing a long boring application for a slice of pie, without ticking a box, without the audition and without permission.

Revolutionaries! Have a packet of biscuits!

There is always someone worse off than you, always someone poorer and more hungry than you are, but this does not lessen your burden or struggle or conflicting feelings. We could all do with being more grateful and humble, more thankful for what we have. We could all do with a breather, more time to stop and enjoy the journey and see how far we have already come. As writers, our empathy and our hunger and our curiosity are the sharpest and most vital tools in our box, along with our imagination to paint a better world than the one we were born into, the one we endure and the one we survive in. We write with the hope to make a better world than the one we were born into and are often running from. This is the grit in the oyster that makes the pearl. You spend years gritting and spitting to make a pearl and so often it feels like it is never quite enough. If only we could see what pearls we are to each other. The one pure thing that broke people all have in common is knowing that we can make something rise out of nothing. And this is our magic.

Now, let's take over the whole biscuit factory.

AAKASH ODEDRA

I MOVE, I TELL

Aakash Odedra is a British dancer-choreographer. He was born in Birmingham and trained in the classical Indian dance styles of Kathak and Bharatnatyam, which he synthesises with contemporary dance. He made his Royal Opera debut in 2017 as the choreographer on *Sukanya*, a co-production between the Royal Opera, London Philharmonic Orchestra and Curve, Leicester. He has also choreographed for the Royal Ballet, The Queen's Diamond Jubilee celebrations and the closing of the London Cultural Olympiad.

I can only be seen in movement.
Dance is my light, I let it shine on my stories,
the stories of others who too often stay in the shadows.

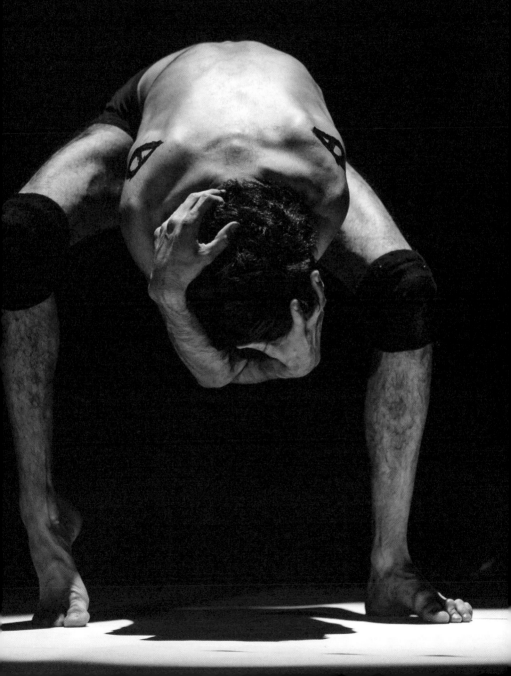

I sit and I see, people like you, people like me.
When we move, we are free.
Watched, but also, seen.

Be seen. Move. Be free.

Photography by Sean Goldberg

Lisa Luxx

THE ECONOMY OF SISTERHOOD

Lisa Minerva Luxx is a queer writer, performer, essayist and activist of British Syrian heritage. She was the winner of the Outspoken Prize for Performance Poetry 2018 and was shortlisted for both the Peace Poetry Prize in 2016 and the Sabatuer Awards Best Spoken Word Performer in 2017. Luxx was nominated for the Arts Foundation Fellowship in Poetry and has been broadcast across channels including BBC Radio 4, VICE TV and ITV.

W HAT IF THE ECONOMY isn't strictly the system you're in but rather a mindset that contributes to social structures? Anyone who has lived among the working-classes will know that generosity is a survival technique; an investment of trust; give what you can and you're less likely to find yourself isolated when you've got nowt.

If you're reading this book, probably the group or groups you identify with are not benefitting from our nation state's economic system. Working-class artists are one of those groups, as are immigrant-run businesses, LGBTQIA individuals and organisations and women. As we know, women typically earn less than white men. In April 2019 the median gender pay gap was 11.9%, and there still isn't a single sector in the UK economy that pays women the same as men (see, for example, *The Financial Times* article 'Women Still Short-Changed in the UK', 23 April 2019). When you add the racial and class-based pay gaps, the whole structure reveals itself to be a club whereby a small demographic benefit from sharing resources and wealth with one another while the rest of us generally take one of two routes; stick around complaining about it, or go live in the woods. I've tried both but now I've realised there's a third option.

When you recognise that you belong to one of the groups that doesn't benefit from our nation state's economic system, you can create a network among yourselves of sharing what wealth and resources you have. For much of my twenties my immediate group of friends was a clan of queer women in their forties and fifties, each successful in their own fields. They ranged from restaurant owner to writer, plumber, sex toy specialist, hairdresser, video editor, and so on. One day Pincus the hairdresser explained to me, 'You've got to hire within the sisterhood'. That is to say, when you

need to hire someone for a job you first turn to your sisterhood to see if someone can fulfil the role, failing that you look to the concentric circles of sisterhood that interweave until you find a woman in close proximity who can be paid for the job you were about to outsource. In doing this, the wealth that each obtains individually is circulated within the family. When you spend into this circle, you're making an investment in your community and trusting that this money has more chance of coming back to you again before too long.

The concept is a much more informal version of the Bristol Pound, or the Brixton Pound. Each of those are bona fide legal currencies that can only be spent in local independent retailers and cannot be spent outside of the city or borough from which they are associated. Nor can they be spent in chains or corporations where the quid would be lost to the wider world.

My attitude towards this manifested in my arts industry practise where I now prioritise hiring women over men. Hiring isn't just about giving someone a job, it's about who you give money and airspace to and thus who you add value to, through the consumer choices you make. Hiring in this sense might be about the article links you click on, the songs you stream, the movies you watch, the events you attend and the books you buy. In each of these instances you're endorsing the person behind the product you've opted to engage with. Your engagement tells producers 'we want more of this'. First and foremost, we have to recognise ourselves as having economic influence. By recognising your impact, you empower yourself within the everyday infrastructure. As Inga Muscio writes in her phenomenal book, *Cunt*:

> 'When you are in the music store and you pick a CD by women musicians who have your back instead of by a bunch of boys who hog all the air time on the radio, that's self-protection.'

'Have your back' is a really key point in this quote. I have worked with a lot of middle and upper-class women in the arts industries but have not once, ever, worked with a rich sis who showed me respect financially. People who always had money won't consider what it feels like to be unfairly paid, paid late, or not paid at all. So I don't include posh people in my economy of sisterhood; in my economy of self-protection.

Out there in a world where employers typically favour men, workplaces aren't set-up for motherhood (or the other multi-role responsibilities women are more likely to take on), nor are goal-oriented capitalist expectations forgiving of menstruation and menopause. Women are still often treated like little girls, regardless on whether they're musicians or commissioning editors. That is, until they embody traditional 'masculine' characteristics. Then they're treated like villains.

Conversations around the gender pay gap need to be coaxed out of the context of 'women in boardrooms' and address the fact that the burden of poverty lies heaviest on working-class women; particularly working-class women from diaspora backgrounds; mentally or physically disabled women and single mothers. From personal observation I have seen that in working-class, two-parent hetrosexual family households it's mum who carries the brunt of costs for housing, food and childcare. Yet she is typically earning less. We need to each step into a mind-set that addresses that imbalance as second nature.

A very challenging ego-stripping experience for me happened after I'd completed my manuscript for a queer feminist collection of poems and essays about love under patriarchy. The publishers who wanted to publish it were all male-led publishing houses. Why should they profit off the pain it took for me to write this work when they're already benefitting off the same system that caused me to hurt that much? I'd rather a woman make her pocket change off my ideas than any male who is already having a much easier time out there.

Here's how I channel my own gain towards those who are otherwise less represented in the working environment:

1. When a big organisation invites me for a meeting it is my rule of thumb that I use the opportunity to pass on the name, work and contact details of at least one other womxn or non-binary artist they should check out. When you get your foot in the door, prop that shit open.
2. If offered a stage for a non-specific purpose but one that promises profit, I can either put on my own show or I can program several of us. If I do that, we share wealth, resources, audience and also time together which leads to a greater sense of camaraderie and community.
3. When I need work done, new headshots for example, I'm met with the

following choice: I could pay an established male photographer who's done me good photos before; he's very cheap and that works for me. Or I can pay a sister whose career is starting out and is equally as good but costs three times the price (she lives in London, her living costs are greater). What will I do? I will find the means to pay the sister, because the brother has always and will always have a fine time finding work in the industry. We know the sister is less likely to earn as much, so she has to be where my loyalty lies.

I envisage society in the image of a web, rather than the image of the pyramid that it is currently in. The pyramid looks like this, with the rich and 'powerful' at the top and the proletariat (aka the working-class) at the bottom:

Hierarchy is based on each person standing upon a plinth of their own value (money, assets, positive attention and bias). It thrives on the patriarchy's core characteristic, competitiveness. Value is created in many different ways, but the feudal system of the pyramid does not reflect many of these. The pyramid is based on the foundation of excess versus insufficiency. One cannot exist without the other. Equally, the culture of idolisation perpetuates our economic behaviour.

The aim of the economy of sisterhood is to edge towards a sustainable community that can, over time, genuinely provide an alternative to the status quo. In the web there is shared responsibility, shared resources, shared wealth. No position is greater than the other, because to accumulate excess in the web is to weaken the web. No nodule of the web should be notably meatier, each needs to be roughly the same strength and hold the same weight for the web to work. The web here will break around the large nodule.

To accumulate excess in the web is to weaken the web. No nodule in the web should be notably meatier; each needs to be roughly the same strength for the web to work. This web here will break around the large nodule.

The web is about becoming a community, not becoming the individual at the top of the pyramid. So, within that vision I find myself getting frustrated when, for example, I came back to England from Beirut to find the daily London papers were heralding a dear poet acquaintance as the 'voice of our times'. It's not that I wasn't happy that this poet, or any poet, was being celebrated in the dailies but rather what struck me wrong was the particularity of that title. At my next talk I asked a room full of eager writers and readers who they felt to be the 'poet of our times' or indeed the 'voice of our times'. They responded with answers like 'Warsan Shire!' and 'Kate Tempest!' but I shook my head time and time again. The poet of our time is at once none of us and all of us. The voice of our time is plural.

If there were one voice that was singled out and looked up to as being representative of our time, it would undermine what our time is trying to represent.

I believe that the economic system won't change unless we, as the many, choose to change it. If we can begin to feel less afraid of redistributing wealth among ourselves, of opting to invest in community even if the cost threatens our individual place in the pyramid, then we will be strengthening the web. I'd love to see a 'localised' feminist currency that would encourage people to spend their money in working-class, independent and immigrant women-ran businesses. A currency that would survive until the gender, class and racial pay gap closes; until our resources are shared within a web, until our perspective is adjusted enough for us to step down off our plinths of personal gain and put the bigger picture first.

Applying for an arts grant can also help. When you apply for a grant you create your own microcosm of economy. You can hire as many top-class talented women on your project as you want. You can consider how, now that your fees are covered, the project can generate further income for women in industries that the state economy overlooks. For example, after realising that men shouldn't be profiting from work that comes from the pain of living in a system they already benefit from, I decided to create a chapbook called *Trust Your Outrage* as a direct response. *Trust Your Outrage* exemplifies the economy of sisterhood philosophy in its entirety. Everybody (and I mean everybody, including the printers!) who profits financially from this book is female. The tour is made up of a series of Sisterhood Salons across the UK with guest female poets and audience/group discussions throughout. Each event partners with a university, a local womxn-led arts organisation and a local grassroots women's charity (largely to bridge gaps in feminist dialogue happening in different pockets of society, but also for the ways that 'wealth' can be distributed across these three sectors in order to create something meaningful). So the university gives tech, venue and marketing resources, the arts organisation brings and then expands their networks, and all the money made at the events is given to the local charity who will also have service-users present (all women working/performing/hosting/offering psycho-social support at the event will have been paid through an arts grant so that profit can be donated without any worker being short-changed).

I'll leave you with some suggestions on how you could begin your journey into the economy of sisterhood:

- Practice releasing control over your own sense of prosperity: give an item of yours that you like to a friend, give an item you love to an acquaintance.
- Start a group chat with other working-class women in the arts, where you each share what you're up to and work out how you can offer hands-on support, time and contacts to one another's development.
- Write across your mirror in whiteboard pen: 'Wealth is a shared resource not a personal achievement'. Wipe it off when it becomes part of the furniture, re-word it and put the same sentiment back up again but fresh.
- Make women-only playlists to give all your streaming power to the sistren. Watch women-led movies (check directors and producers as well as actors). Got two options of shows to watch at Edinburgh Fringe? Ask yourself which artist your socio-political loyalties lie with and buy their ticket.
- Finally, know your worth and demand your worth because when you are truly spending with integrity your worth becomes a community tool.

Joelle Taylor is an award-winning poet, playwright, author and editor. She has performed across the UK and internationally, and has read in a diverse range of venues, from the 100 Club, 02 Arena, Royal Festival Hall and Ronnie Scott's, to the Royal Court, Globe, Buckingham Palace and various prisons, including Pentonville and Holloway. She has published three collections of poetry: *Ska Tissue, The Woman Who Was Not There* and her latest collection *Songs My Enemy Taught Me.*

SMASHING THE CLASS CEILING

Joelle Taylor

1. There is a class ceiling, and shards of it are stuck in the back of your throat. It shattered the first time you wrote a poem, and your tongue broke along with it. It is still broken. Carry it in the bowl of your mouth like you would cradle your writing award. Bring it out at literary events. Your tongue no longer belongs to you, you speak a language that you sometimes don't understand. You have to imitate your own accent, so far have you travelled from your home. You carry your class with you wherever you go, tucked in beside the Air Mac and distilled water. It rattles when you walk too fast.

2. You are a writer with a limited vocabulary. When people talk about access to the arts, they are talking about you. Nod. Seem pleased. Join a panel where the subject is whether poetry should be accessible to people like you or not. Discuss whether what you are doing is poetry at all. Focus more on your performance; they are more comfortable when you wave your arms as a semaphore that nothing important, nothing fundamental has changed. When you are asked to speak at Oxbridge or one of the Royal Somethings of Something Else make sure you flatten your vowels into shovels. Dig out the foundations of the stage you are standing on. Each word you write from now on is a brick in a new kind of building, a factory. Invite people like you to come and work there.

3. Annually there is an article published that declares what poetry is and how you are not writing it. You note that poetry

does not seem to want to speak to its audience. It is a code, a secret society, a cabal of crows pecking at typewriter keys. You study the correct way to write poetry. It is another language. As soon as you learn it, they change the vocabulary. A poetry editor tells you they like your poems, but they are too much like poems. You nod in agreement and spend the evening unlearning. Even this essay is written in a foreign language.

4. As a working-class woman writer, you cannot depend on outside access to the arts or support in becoming artists, you cannot assume access to the rest of your lives. We measure our dreams against the weight of sugar. Learn to depend on yourself and create spaces which you might think of as home. Make space for everyone like you. Collectivism is the antidote to cultural fascism. Teach, mentor, become.

5. Over the years, you become aware that the reason why the poetry establishment spends so much time mocking the simplicity, the 'formlessness', of your work is that all they have is form, whereas you have content too. They will describe your narrative as 'confessional' or 'histrionic', belittling the effect your words have on those who hear them. Keep writing. Formlessness is a form. Remember that you came before the written word. It is only because of mouths like yours that we understood how to translate the shape of words on to the page.

6. A book is a doorway to diverse worlds, but only a few people are awarded a key. The recent innovations in printing, such as print on demand, means that more writers like you are getting independent publishing contracts, and this terrifies the literary establishment. They need not worry: all of the major prizes are geared toward major publishers; some need books entering up to a year before publication, submission fees where applicable can be beyond most small press's means, the multiple copies required by some awards may seem small, but the cost of 6 books for a small press could be the difference between a book's production

breaking even or not. The conditions of entry make most working-class poet's work ineligible for entry. Online streaming of music changed the music industry and the same radical overhaul needs to take place within poetry publishing too. Spoken word poets (a code phrase for 'working-class') have already started some new prizes, free to enter, digitally accessible but we need to develop our own literary awards system that shakes up the accepted model of judging and awarding, coupled with free writing retreats and residencies based on pioneering initiatives like Cave Canem.

7. Poetry book sales can be dependent on reviews, particularly in the broadsheets or the specialist press, to sell copies. However, few poetry collections written by women are reviewed and that number decreases still further when bearing in mind the intersections of class, sexuality and race. To make matters worse, books written by women are seen as specialist interest in some indefinable way and so review magazines will tend to seek out female reviewers to look at your work. Men are writers. Women are women writers. Do you see? Make your own critical communities offering challenging but constructive feedback. Pull each other up. Do not critique spoken word with the same tools you would critique academic tiny bent over poetry.

8. Do not forget that your lips are a printing press and you have been publishing works for years on watermarked fine-woven air. You stand in front of an audience and are home. You are the head of the class. Every time you pick up a pen it is an act of courage. Every time you stand on a stage it is an act of resistance. The only way to resist the mono-literary ideologies is to do it for yourself, to teach your hand to hold the pen correctly and remind your feet which way is forward. The stage is the *TLS*, the *Guardian* and the *London Review of Books* combined. Revere it.

APPLYING FOR ARTS FUNDING: A GUIDE

Sabrina Mahfouz

E VERY ARTIST HATES FORMS. This is the phrase that gets thrown around in our industry and it is true that forms do not hold the heart like post-performance applause or the first words a character says in a writer's head. But forms aren't that bad. They are just questions, using words that not a lot of people use, to ask things that not a lot of artists ask themselves most of the time. But they should. I see filling out these forms as a brilliant way of clarifying a project in my mind. If I can't fill out the funding form then I realise the project is not ready, or perhaps is not even something that I deep down really want to do.

Pinning down abstract concepts into a few sentences or bullet points makes the project more tangible and achievable, even if in the end the application isn't successful. Answering the Big Five (what, why, how, who, when) is essential for me to know whether the project is what I want to do and also whether it will be of interest to others. Finding answers to these questions will transform your idea from an enthusiastic chat with mates and colleagues into a working project. What is the point of this project? Do I really want to dedicate my time and energy to making it happen? It may sound cynical, but I have no doubt every one of you will have seen, heard and experienced art of some kind which you felt was lacking in soul, heart or purpose. It is easy to get caught up in an idea and much harder to admit to yourself and others that it is no longer one you want to pursue, especially if there isn't a traffic jam of other ideas in your brain demanding your attention. Answering the Big Five honestly will enable you to make the right decision with confidence. And when you've done it once, you have the backbone of pretty much every arts funding application ready and waiting. All funding organisations have different sets of questions that change frequently as they update their aims and the available pot and adapt to better suit the requirements of contemporary times. So, I won't go into actual, word-for-word questions here. However, almost every single question in a funding application form stems from the Big Five, so if you get these covered, you are covered.

THE BIG FIVE

1. WHAT? (WHAT IS YOUR PROJECT?)

Is your project a play, a multi-arts public interactive exhibition, a poetry pamphlet, a song cycle with dance, a novel or a chalk drawing workshop for kids? Start here.

Next, does it deal with a particular topic or theme? I don't mean the plot or the practical elements of the project, more the spark that got you excited about the idea in the first place. What are you, the artist, exploring? Though much of the content is likely to be unknown at this stage, it is to show that you have thought about what it is you are exploring and with which art form.

If you have more detail for this, then great, add it in. If you don't, it is probably worth making some notes about your project at this stage.

EXAMPLE

This is a play.
Expand on the sentence above, adding your key idea:
This is a play that looks at the potential of comedy as a life-saving force.
Add what themes you are exploring:
This is a play that looks at the potential of comedy as a life-saving force through the interweaved monologues of veterans, sex workers and nurses.

Talk further about how you see this becoming a reality in practical terms: *This is a play that looks at the potential of comedy as a life-saving force through the interweaved monologues of veterans, sex workers and nurses. The piece will be devised. There will be three actors, a director, writer and a musician. It will tour small-scale comedy venues across the UK.*

If you stick to simple facts, you will naturally start to think about the ideal outcome, while being open to change. As with all of this, what you regard as necessary to tell others is up to you. However, whilst at least some of those assessing your application will be professionals in the same field, they are unlikely to know as much about all the elements of the specific project as you, so start from scratch with the basics, writing clearly and in a way that is true to you and your experience.

2. WHY? (WHY DO YOU WANT TO MAKE THIS PROJECT HAPPEN?)

This is probably the most important question for me and the one that I think is often not thoroughly or honestly answered by larger organisations when making new work – which might be because they don't have to answer this question for funding purposes! But I speculate …

There are many layers to this question. Why this art form? Why this subject? Why is this project any different to others? Why now? Why now in your own career? Why are you the right person to do it?

'Why me' can be seen as a difficult one because of the (outdated) assumption that British artists, unlike Americans, don't like to big themselves up. Big yourself up whenever you want. If doing so makes you feel sick or self-conscious, then an application form is the one place you need to feel assured it is expected and essential. You don't need to write in job-interview speak. There is a reason you have chosen to put your heart and soul into this. Be open about that.

EXAMPLE

Why this time and why this subject?
Over the last year, [insert name of paper/organisation] reported that mental health referrals were up by [insert number]%.

Why you and why now in your career?
After recently supporting a relative through some mental health issues, I am interested in exploring whether dramatic comedy can provide support in times of need. I have recently been involved in creating two fringe theatre productions and have gained the experience and team to now take the next step in my career.

Don't be afraid to be bold, either. Another way of saying the above could be:
Attitudes to mental health difficulties and how sufferers can be supported must change and I hope to use the shared experience of live theatre to change them. I have been working with mental health charity Mind to develop ways this can happen and these strategies will be used during the creation process. I have been reviewed recently as 'a shining talent in fringe theatre' and want to make the most of the attention I have been receiving to make the work I believe in to take my career to the next stage, with the aim of becoming a full-time theatre maker within the next year.

Both will allow someone reading the application to feel confident that the artist has thought hard about the importance of the project to themselves as a professional, a person and to the wider world it will exist within. Not every 'why' needs to be covered, but if there are any that you are really struggling to answer, then spend some time delving into this and/ or discussing with those you work with or trust before continuing. It will make your work stronger, and your life easier, in the long run. Remember, as illustrated by the above approaches, there is no one right answer. The funders are not looking for one thing in particular in each box – they are looking for an overall impression across the application that you have really considered the bigger picture.

3. HOW? (HOW WILL YOU MAKE THIS PROJECT HAPPEN?)

If you need a break from all the philosophising and introspection – answer this question. It is primarily practical.

Will you be writing for a set period and asking editors to look over your work, then making edits? Will you be doing this in any way that is unusual for you, like being a resident artist at a library, prison, park etc? Will you be putting anything out to the public at this stage and if you are, how will you go about doing that? Generally, grantors want information specifically about the things you are asking to be covered by the funding. They do not need to know about the phases after this, although you can mention these at some point if you have the word count. For example, if you are applying to cover the writing costs for the first draft of a play, you don't need to explain how the play will be staged as this is not covered by the funding.

Much of the 'How?' answer might not be how your project ends up coming to life in the end. That's fine, all you can do at this stage of an application is be as well prepared as possible. It happens that sometimes, major changes after a grant has been awarded are necessary. Each funder will have their own process for how to handle this if it happens, but usually you need to email your contact at the fund to let them know what has happened and why. Everyone understands that art is a flexible, responsive and a continual work in progress – but you have to start somewhere.

EXAMPLE

I will spend two months writing and researching, followed by two weeks devising with a director, musician and three performers. At the end of the two weeks, we will present a rough version of the show to a small audience of friends, local residents and charity contacts, followed by a Q&A feedback session, so we can evaluate how best to move forward with the project.

This brief will need to be expanded upon for some applications, but once you have sorted the basics, it isn't difficult to fill in the action plan with more detail if needed.

4. WHO? (WHO ARE YOU GOING TO DIRECTLY WORK WITH?)

Even if you're doing some solo writing time, will you have a mentor or an editor? Will you be working with an organisation or charity? If you're doing a cross-arts project, think of the people you'd love to work with and in what capacity, and ask them whether they would be interested. Put down on applications those who have confirmed their interest, although they don't have to 100% commit at this stage.

Big these people up. What is it about them that you love? Why are you so keen to work with them? What will they bring to the project? Know at least one thing they've done previously that has made an impression on you and ideally is somehow relevant to the project you are submitting a grant application for.

EXAMPLE

I will be working with [insert name] as a director on this piece. I saw her work at a comedy theatre festival in 2018 and loved the subtle way she brought out the comedy in difficult situations with her use of movement. She is currently working at [insert name of organisation or recent project] and [insert quote from media about them or accolades or another project they have done].

Involving people in the project who are more experienced than you, or who are experts in a particular area, will help your application. It shows others have committed to you, your vision and your idea already. It shows you are taking your work seriously enough to approach and discuss it with professionals.

WHO IS IT FOR?

Do not say what you think people want to hear. Don't fall back on 'this is for young people', or 'this is for people from XYZ community', unless it really is the reason why you are embarking on this project.

Your project can be for a number of different people, of course. But

most of us want to make our projects for someone in particular, often versions of ourselves that never felt things were made for us. That is fine. Say that. Who is that version of yourself? Your work might also be specific to a certain age group or geographical area. Perhaps your work deals with local history. It might be for those with different abilities. Who are they and why is this for them?

EXAMPLE

I would like this play to be performed at this early stage for those who use the services of the mental health charity we will be working with and to encourage wider discussion afterwards. In the next stage of the project, I am hoping to particularly engage elderly members of the local community who don't often get access to performance of this kind, particularly those from a working-class background with life experience as veterans, sex workers or nurses, who may have not had the chance to see themselves represented on stage before in a comedic style.

I once read a report on my work by those looking for new writers for a big theatre. I wasn't supposed to read it. A well-known theatre director had commented that she was frustrated because I 'wrote to shock the middle-classes'. I found this infuriating, but also quite funny. The content that working-class artists create is often critiqued in this way – it is either too 'shocking' or 'not gritty enough'. This expectation is narrow and damaging. Finding this report showed me what a middle-class bubble theatre people can be in, even when they are supposedly looking for 'new voices'. This director was angry at a working-class playwright for making work about working-class people. She assumed it was there to shock the middle classes because she couldn't imagine that someone would be writing FOR working-class people. There was nothing in what I had written that would shock the audience I was writing for, who were the people I knew and grew up with. After reading that comment, I realised how important it was to explicitly state in a relevant application that my project is for working-class people, and to state the importance for them of seeing a small part of some of their lives represented.

5. WHEN? (WHEN ARE YOU GOING TO COMPLETE AND SHARE YOUR WORK?)

You will need a timeline for most funding applications. When will you start? When will you be finished? Will you be working on the project part or full-time? This may well change course, but it is important to have a production schedule to work to in order to stay on track, see problems or clashes before they arise, and notify anyone working on the project with you if the dates when you need them are going to change. It is always much easier to maintain good relations with everyone on a project if you are honest and open with them about changes to a schedule! It saves everyone time in the long run.

For Arts Council grants, it is advisable to enter a start date in the near future. Securing funding for a project that is due to start in a year's time is not impossible, but more difficult as there are so many things outside your control that can happen in a year. As you should have got most things provisionally into place when you submit your grant, you should be in a position to begin once a 'yes' is received. This can be frustrating, as many people can't plan time off work or other commitments until they know they have the funding. Try your best to factor it all in. If you need four weeks to let a job know you will be taking some time off, then make the start date of the project at least twelve weeks after the date of applying, or however long the organisation says it takes to respond to your application.

Are there time-sensitive elements to your project? Do you need it to happen on or around International Women's Day, for example? If so, make this really clear in your application and in the timeline. Plan for enough time to make this possible. Despite frustrations around practical uncertainties, I see this one as a boost of positivity in what can be a tiring process. It moves your project beyond the confines of a daydream – it is no longer if, but when.

EXAMPLE

I will begin researching on and writing the first draft on 5 May and have my first meeting with the director about the script on 10 June. We will be workshopping with the actors from the start of July and I will rewrite the script following that process by the start of August and aim to present a rehearsed reading by the end of August.

SOME PRACTICAL TIPS WHEN APPLYING

WORD COUNT

Word counts for most online funding applications are notoriously low and hard to stick to. However, we are in the age of social media word limits, and you know how to do this even if you think you don't! I use bullet points to help me keep my application answers to the minimum word count. When I write in bullet points, I stay as succinct as possible. Once I've written out the major points, I take the bullet points away.

Be on guard against repetition. If you've already mentioned something in one of your answers, there is no need to repeat it in another, unless it is essential and even then, it should have a different focus or add some new light to the project as a whole. Read and re-read again and again with a bit of time in-between to best spot these repetitions.

Have a friend who has no idea of what it is you're doing review your application and see if they can grasp your project from what you've written. You can't cover everything in 250 words, but you can get the fundamentals in.

Sometimes the struggle is the opposite, in that it is hard to find enough words to fill a box on some areas of a project. I would advise you to always make sure that you have enough to fill at least 75% of the word count for each question. This form might be the only information a funder has about your previous work and your new project. If you are unsure, ask for advice

on exactly what that question is delving into and think if there is anything you can add that might be of interest.

BUDGET

This is often where people who have up to now been confident start to think 'I can't do this'. You bloody well can! Working-class identity comes with a whole heap of issues about money, as it has usually played a pivotal part in almost every decision working-class people make. The most common remark participants at the Great Wash Workshops have said to me about budget is 'I just don't feel like I can ask for money to do this'. 'This' is work. It may be work that you love (sometimes) and work which you feel lucky to be able to do, but work it is. The UK creative arts industry is second only to the financial services industry in terms of generating income for our economy. I highly doubt bankers and insurers feel guilty about getting paid a daily rate for the work they do.

Most Arts Council England grants you'd be applying to will be for under £15,000 and from submission to decision will take around six weeks. Over £15,000 grants are available but would need significant partnerships and experience to be accepted, so it is advisable to go for under £15k at first. Other funders have differing amounts available, but around £5-10k for arts projects would be considered quite significant. Smaller ones of under £3k are offered regularly from individual organisations for different art forms.

For your application, work out the budget for all the project costs.

EXAMPLE

If you want to produce a first sharing of a play, your budget should include:

- *Writing time*
- *Fees for all collaborators*
- *Travel costs*
- *Venue hire*

- *Refreshments for the public audience at the sharing of the work*
- *Equipment needed (although not all these will always be eligible, like a laptop for writing, so check with the funder before including them).*

The budget for this project would not include promotion or rehearsal for the eventual production, as this is outside the specific project application, which was just for the first stage of the play.

It is easier than you think to pull together a fairly accurate budget. Ask the relevant people for quotes: how much would it cost for me to hire out your space at these times? They will be happy to give them to you. You will be bringing them work if the grant goes ahead. Times the daily rate by the amount of days you need and put the total down. Some applications will need to see how each cost has been worked out and where you have found the costs from. Make sure you keep a note of everything you research so that you can easily find it and refer to it again at a later date. Try to keep costs as low as is realistically possible, such as quotes for travel fees that are booked far in advance. You will need to include your plans for generating your own budget outside of what you are asking for from the funder. This would usually need to be around 10%. If you're applying for £8,000 you need to have plans in place to have £800 being raised from another source. This could include raising funds through ticket sales, hosting events, charging for workshops or crowdfunding. In-kind support also counts towards this amount, but it always helps to have income generating ideas to present.

How much should you earn for a day's writing? The Writer's Guild would say at least £150. Write that down. Every profession has a recommended minimum daily rate which can be found online. Simply search for the relevant organisation, such as The Society of Editors and Proofreaders for editing and proofreading text, or The Independent Theatre Council for theatre professionals.

Nobody involved in your project should be getting less than the minimum rate or wage (unless giving their time 'in-kind') and it is perfectly acceptable for those with experience to be charging more than the minimum and for you to be paying them that. The Arts Council or the relevant funding body can advise you, but £200-£300 per day is a standard industry fee for a specialist. Fees for those involved is usually the main budget oversight and without these your application won't be viable – and neither will your project!

You can include pretty much anything related to the idea you are proposing – travel, time, collaborators, materials etc. This is the area that I'd most strongly advise you check with someone from the organisation, or someone from your industry who has experience with budgets, prior to submitting for the grant.

IN-KIND SUPPORT

Some Arts Council applications operate on a percentage system, so 10% of whatever you're applying for must be covered from outside Arts Council funding. The higher that percentage goes, the more favourable your application looks. This might seem unfair, but it gives donors confidence if you have already got the support of others who might know you or your work already and want to help take it forward. You can add money from your own earnings or from other funds you have applied to or been given.

You can also add 'in-kind' support. This means that you are getting something which has a clear monetary value for free. You put the monetary value of it down on the application and it counts towards your percentage. People I help with applications often tell me they feel they have no relevant contacts or network to support them, but when we start talking about it, everybody knows someone who can help, even if they're not in the arts themselves. A mate who might lend you a camera, a colleague who has a considerable hat collection who might help with costume, a local library that offers spaces for meetings for free. Write down what you need and see who might be able to help you out, in a way that isn't a burden to them of course, so you'll need to use your judgement on this!

EXAMPLE

You need £8,000 for a play. You will need to show that you have at least £800, 10%, coming in on top of that from other sources. This could be:

- *£250 in kind as a theatre has offered to give you a day's feedback;*
- *£200 in kind from a venue giving you two days' hire for free;*

- *£200 from planned crowdfunding*
- *£150 from your own earnings*

It could be much more than that and most funders will be happy to see applicants attempting to raise funds in various ways.

EVALUATION

Most funds will ask how you are going to evaluate your work at some point in the application. Sometimes this will be required during and after the project, sometimes just afterwards. Each funder will have more details on the kind of feedback they require, but in general be prepared to have thought about how you'll assess the progress of the project and its outcome.

If there is no public engagement, how will you evaluate your work? Will you send drafts to a mentor, a director or an editor? Will you film extracts and post them online for comments? Will you invite a specialist to give you feedback? If your work is going to be seen by the public, how will you know what they thought? Once you have this feedback, what will you do with it? How will it help you in the future – for this project or the next?

STAYING ON TOP OF THE ADMIN

There is no set amount of time that an application will take, as it all depends on how much planning has already gone into your project when you start the application process. The quickest one I have ever done was for a play which I had been researching and preparing on and off in spare moments for over a year, but I only applied for funding when I was ready to start writing. It took around two days of full-time work. Others have taken me up to five or six days. This is a huge amount of time, particularly for freelancers, as it is completely unpaid and as yet it is not something you can work into most applications (always worth checking as some organisations are beginning to take this labour into account, particularly

for marginalised artists). It is far from ideal, but one way to mitigate the time required is to plan as much as you can over a long period of time, between other things, so the actual writing of the application should hopefully be more straightforward.

Registering on the application site, or 'portal' as some are called, can take a lot of patience – so try to do that a week or so before you plan to apply and always call the helpline if you are having difficulty registering or with any of the online resources.

Save your drafts! Many of the sites have unclear saving systems, so I always write my text out on a word document and then copy and paste over onto the online application and save both every five minutes or so. Also, some material you may decide to delete from the application due to word count or a change of mind might be useful later on. It's good to have a record of your thought processes and plans.

Ask a couple of people you trust to read through once you've filled it in and see if it is clear. They don't need to be in the arts, it might be better if they're not. Do they understand what the project is? Do they have any questions which suggests you need to go back and clarify some points? Always send to someone at the funding organisation first if this service is available, which it is with all the Art Councils. Save their feedback and advice, not only to incorporate it into your application but it also might be helpful for future projects.

Once you submit your application, you will hear back within the timeframe the funder states on their website. If they are delayed they should let you know. For Arts Council applications this is typically six weeks for under £15k, but some funders may take up to three months. Keep these dates in mind when planning your schedule – the project can't begin before the funder has replied with a decision. You can check in on an application if you haven't heard anything after the specified date and nobody has been in touch regarding any delays.

Hopefully, you'll get a YES! And everything can begin. The funder will send all relevant instructions on bank details and forms etc. Usually the amount will be paid in instalments, with part of the fund being held until the project has been completed and evaluated.

If you don't get the funding, there are so many reasons why this might be and the most unlikely one would be that your project didn't sound 'good'. It could be that other projects were similar in that round of funding

and they seemed more planned out or offered the artist applying more of an opportunity to grow professionally. This is one of the key reasons I have been told applications aren't successful, because the artist hasn't articulated how the project will help them to progress in their artistic career and practice. So always make sure that thread runs clear throughout the application, as well as making sure your project is as unique as possible, something only you could do.

You can usually request feedback on your application and discuss whether it is something that can be resubmitted if changes are made to reflect the feedback. If you'd like to submit a new project, this is usually fine once a decision has been given on the last one, regardless of what that decision is – but again, always check with the funder.

HELP!

As much as I hope that this guide is helpful in making you feel a little more equipped to start applying for funding, nothing beats speaking to a real-life person. The Arts Council has 'Relationship Managers' in all regions, in all mediums. If you live in Birmingham and want funding to write a novel, for example, you can call the customer service number from the ACE website and ask for the email address of the West Midlands Theatre Relationship Manager. They will give it to you. Depending on their availability, you may be able to go in to the offices to meet them. Some come to meet you, others can offer advice over the phone or email. PLEASE do this. It is a service provided to help artists get money, by guiding them through what will be needed in the application, so when the assessment happens, there is no reason for your application to not be granted a fund. If it is as strong as it can possibly be and still not awarded a fund, then the reason is often over-subscription, which can be extremely deflating, but funders will usually let you know if this is the case and encourage you to submit again with some slight changes at a quieter time.

Other funds might not have a relationship manager, but they will have someone who can clarify things for you prior to applying. Use the phone numbers and emails provided. If nobody replies after a week or so, remind them. Everyone is overloaded with work and not replying is not a cowardly

way of letting you know they are not interested. It might be frustrating but persist! Don't forget that these funds exist because they want to fund projects. They are looking for a way to make this happen. They are not set up to try and trip you up or ask trick questions. As one senior funding manager told me – 'we want the money out, not in!'

DIFFERENT FUNDS

Those with funds to give out often have a number of different strands. Read all the details about what each one is for and if you are in any doubt at all where your project might best fit, contact the organisation to check with someone, or ask someone who has applied before. Many applications are completed with love, skill and dedication, but are not submitted to the right kind of fund and so can't be given the money they deserve. It's worth a quick phone call to check, considering it could mean you being able to make your project become a reality!

Applying for funding is a challenge, but as Madani Younis said to me when I started out and wasn't sure if it was worth the heartache of rejection and financial instability, 'If you don't write your story, someone else will write it for you'. Think of these applications as a step to telling the story you want to tell in a way nobody but you can do. It might mean conforming in some ways to expectations initially, but ultimately it can allow you to defy all expectations and make sure the art you want to see is out there in the world.

PLACES TO GO

The Creative Society (thecreativesociety.co.uk) is a charitable organisation that supports young people wanting to work in the creative and cultural sectors by helping to remove the barriers that prevent them from progressing. There are branches in London and in Teeside and their services are available online. Someone described it to me as 'a job centre for the arts', so definitely check them out if you're aged 18–30 and looking for training opportunities, mentoring and other networking or employment opportunities.

The Arts Council have weekly or daily newsletters with jobs relating to your areas of interest and within the regions you select. The jobs are at all levels and it's great to see the kinds of roles that are out there, even if you're not ready to apply. You can sign up for these on the websites below.

Local councils often host free arts events or training opportunities – check in at your local library or go on to the council website to see if there are any upcoming events.

Search online for bursaries relevant to your art form. You can narrow the search by choosing your art form + bursary + your region/area. There are quite a few out there which you won't have heard of until you start searching. They might cover a creative retreat for example, or travel expenses to interviews or even housing, as The Book Trade Charity does.

There are too many places to list which offer sporadic or occasional arts

funding. The best way to find out about these is to check notices at the library and sign up for newsletters from as many arts organisations as possible. The below are examples of regular arts funding organisations who generally have year-long submission windows:

Arts Council England (artscouncil.org.uk): This is the main organisation for funding of the arts in England.

Arts Council Northern Ireland (artscouncil-ni.org): This is the main organisation for funding of the arts in Northern Ireland.

Arts Council Wales (wales.arts): This is the main organisation for funding of the arts in Wales.

Creative Scotland (creativescotland.com): This is the main organisation for funding of the arts in Scotland.

Wellcome Trust (wellcome.ac.uk): This is a science-focused charity, which funds arts projects which bring awareness of scientific issues and research to a wider public audience, so worth applying to if your project can be linked to science. This could range from climate change to health conditions.

Jerwood Foundation (jerwood.org): Jerwood is a Foundation dedicated to funding the development of the arts in the UK. They do call outs for specific art form applications and are significant supporters of works in progress and research-based projects.

Peggy Ramsey Foundation (peggyramseyfoundation.org): Peggy Ramsey Foundation offers grants to theatre makers for all sorts of projects and needs, including a writer needing a new laptop for example.

Society of Authors (societyofauthors.org): This society offers grants for writers to finish or start projects and also for those in financial difficulty for a range of reasons and grants for residential stays during a writing period.

Organisations with a focus on working-class artists (UK):

COMMON (commontheatre.co.uk): COMMON runs workshops and events around making theatre more accessible to working class artists

Arts Emergency (arts-emergency.org): A cross-arts charity that provides mentoring, training and occasional grants to assist working class artists to progress in their careers.

Create London (createlondon.org): Create London commission public art projects and reports into the arts.

Joseph Rowntree Foundation (jrf.org.uk): Though not arts-focused, the JRF is an organisation working to inspire social change through research, policy and practice, so is an excellent resource for statistics on social issues in the UK and events that address working class marginalisation in great depth.

Published 2019 by The Westbourne Press

Copyright © Sabrina Mahfouz 2019

Sabrina Mahfouz has asserted her right under the Copyright,
Designs and Patents Act, 1988, to be identified as the author
of this work.

Copyright for individual texts and artworks rests with the
authors and artists.

ISBN 978 1 908906 40 3
eISBN 978 1 908906 41 0

A full CIP record for this book is available
from the British Library.

Printed by PBtisk a.s.

The Westbourne Press
26 Westbourne Grove
London W2 5RH

www.westbournepress.co.uk

Supported using public funding by
ARTS COUNCIL
ENGLAND
LOTTERY FUNDED